3D PRINTING

FOR ARTISTS, DESIGNERS AND MAKERS

Acknowledgements:

I would like to thank the following people for help with putting this book together. First and foremost without the help of Jesse Heckstall-Smith and Alison Davis the book would never have reached the publication stage. I would also like to thank Dr Peter Walters for checking the accuracy of my thoughts on 3D printing and for helping with the technical details, plus David Huson and Joanna Montgomery for their help and support. I would also like to thank Susan James and Davida Forbes for their patience in commissioning and editing this volume.

My thanks go to all of the case study artists and I hope that I have done them justice; Assa Ashuach, Professor Keith Brown, Michael Eden, Dr Lionel Dean, Marianne Forrest, Jonathan Keep, Tom Lomax. In addition thanks go to Rick Becker for his help and images of his sculpture, Rita Donagh for her kind permission to use the Richard Hamilton images. Gary Hawley from Denby Pottery, for his help and assistance.

For kind permission for the use of images, Heather and Ivan Morison, Karin Sander, Peter Terezakis, Masaki Fujihata, Freedom of Creation, Professor Neri Oxman from MIT, Jessica RosenKrantz from Nervous System, Charles Csuri, Aardman Animations, Bristol and LAIKA Digital from Portland Oregon, Peter Ting, Counter Editions, the Spira Collection, 3DRTP, Envisiontec, Objet, 3D Systems, EOS, Mcor, Renishaw, Stratasys, Viridis, Daniel Collins, Mary Visser and Christian Lavigne, Unfold, EADS Bristol and Markus Kayser. I would also like to thank all of those people I spoke to during the course of writing this book.

I would like to thank the UK Arts and Humanities Research Council for the research funding from which this book is an outcome.

Finally I would like to dedicate this book to both Mrs Hoskins Snr and Jnr.

Bloomsbury Visual Arts
An imprint of Bloomsbury Publishing Plc

50 Bedford Square
London
WC1B 3DP
UK

1385 Broadway
New York
NY 10018
USA

www.bloomsbury.com

Bloomsbury is a registered trade mark of Bloomsbury Publishing Plc

First published in 2013 by Bloomsbury Publishing Plc
Reprinted 2014

British Library Cataloguing-in-Publication Data
A catalogue record for this book is available from the British Library.

ISBN: 978-1-4081-7379-4

Library of Congress Cataloging-in-Publication Data
Hoskins, Stephen
3D Printing for Artists, Designers and Makers/Stephen Hoskins
p.cm
Includes bibliographic references and index.
ISBN 978-1-4081-7379-4 (pbk.)
2012045678

Printed and bound in China

3D PRINTING

FOR ARTISTS, DESIGNERS AND MAKERS

STEPHEN HOSKINS

B L O O M S B U R Y

LONDON · NEW DELHI · NEW YORK · SYDNEY

Contents

Michael Eden, 'Wedgwoodn't Tureen, Blue and Green'. © Michael Eden

Preface

3D printing has received a great deal of publicity recently, much of which has had a tendency to skirt over the practical information of how the process actually works and totally ignores the fact that it is actually a number of 3D processes that contribute to the field of 3D printing. This preface will define what I understand is meant by the term 3D printing.

Before we delve into the history and development of 3D printing we need a description of what the process actually entails. First and foremost all 3D printing processes are additive by nature – in other words you build up an object by adding material. 3D printing is a relatively recent innovation that allows physical objects to be fabricated directly from a 3D virtual model created in computer design software or by scanning the shape of an existing object. In 3D printing, objects are fabricated by computer-controlled machinery, which deposits or solidifies material one layer on top of another in a way that could be described as analogous to the building of a traditional coil pot. Objects can be built in a range of materials including plastics, ceramics and metals. The layer-by-layer fabrication process of 3D printing frees the artist, designer or engineer from many of the constraints of traditional fabrication methods – hence the process is sometimes referred to as 'solid free form fabrication.' Visually oriented artists and designers are beginning to explore the exciting aesthetic possibilities and implications of 3D printing as a medium for creative practice, and the purpose of this book is to provide an introduction to 3D printing from a visual arts perspective. This book introduces the historical and technological context of 3D printing and provides state of the art case studies from creative practice in the fine and applied arts, crafts and design.

CHAPTER 1 begins by introducing the history of 3D printing, paying particular attention to how that history relates to a visual arts context. It traces a dual path of development, starting with James Watt and his sculpture copying machines, through developments in rendering maps in three dimensions to a 1950s method of copying sculpture in an analogue manner. The parallel track follows the development of light-sensitive gelatine materials in early Victorian photography and printing processes, through the

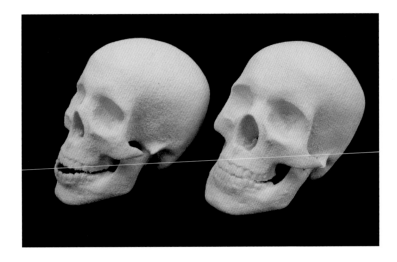

3D-printed ceramic skulls, printed by
Centre for Fine Print Research,
© CFPR 2010.

development of Photosculpture, to the creation of bas-relief printing and into photo-polymeric emulsions, which finally lead to the photo-initiated 3D printing processes. The chapter then describes how visual artists have interfaced with, and then adopted, the processes to the benefit of artists, designers and craftspeople.

CHAPTER 2 outlines the history of 3D printing as a process and details the various technical developments of the machinery involved. It then details a selection of 3D printing machines currently available and presents the wide range of different processes that the current diverse field is comprised of, that fall under the umbrella term 3D printing. Where possible it also details some of the visual arts practitioners that have used each of the various processes.

CHAPTER 3 covers crafts and how they interface with 3D printing. This chapter details some of the philosophical approaches to the discipline and how those approaches interface with methodologies necessary to develop a practitioner approach to 3D printing. Three case studies of crafts practitioners who use 3D printing as an integral part of their work are presented, including details of how they deal with the process technically and how they approach the process philosophically from a practitioner perspective.

CHAPTER 4 describes the relationship between the fine arts and 3D printing. It also details how artists

have worked with the technology almost since it was first made commercially available as a process. It presents two case studies of fine art practitioners, both of whom have a long history of working in the digital arts field.

CHAPTER 5 explores the implications of 3D printing for designers and design practitioners. It describes the field and differentiates the types of practice between those designers working within large companies and those who work independently. The chapter presents three case studies of skilled designers who each have very different approaches to 3D printing.

CHAPTER 6 examines the public perception of 3D printing through literature and mainstream press and how this in turn impacts upon the creative arts. This includes fashion designers and stop motion animation, both of whom reach large public audiences. This chapter also details the rise of the Hackspace and Dorkbot cultures, then describes how the future might look illustrated by examples of current research.

Finally, the book summarises the future potential of 3D printing for the visual arts and draws a conclusion upon how artists, designers and craftspeople are embracing the technology.

Introduction

This volume will be of interest to a broad range of academics and 3D print users from across the arts, industry and science disciplines. It is aimed at artists, designers and people from the creative industries, but it should also appeal to a more general audience who have an interest in the new developments in technology.

In the last twelve months there have been general articles on 3D print featured on BBC radio and television, in *The New York Times*, the *Telegraph*, *The Guardian*, *The Independent* and *The Economist*, in addition to specialist articles in magazines such as *Wired*. For the 3D print industry there is the specialist magazine *tct* and an academic publication the *Rapid Prototyping Journal* which both cover the engineering and medical aspects of 3D printing. Moreover, numerous websites service the growing 'maker' community who use low-cost 3D printing, along with comprehensive sites dealing with digital sculpture and rapid prototyping in the arts (such as www.additive3D.com). However, to date there is no specific publication or book that references or describes how the creative industries are interfacing with and using the technology.

Globally many universities and research institutions are working with and developing 3D printing as an additive manufacturing process and most believe the technology is on the cusp of the next big breakthrough. The big research goal is to move the technology from the arena of rapid prototyping – where it is possible to produce a plastic replica of a part, to the arena of rapid manufacture – where it is possible to produce a fully working part. Already it has proven possible to 3D print a fully working nylon bicycle, gold and silver jewellery and titanium teeth. The authors' research team (at the Centre for Fine Print Research (CFPR) at University of West England, Bristol) are leading the field in printing three-dimensional ceramics, producing cups, plates, bowls and sculpture using the process.

In a broader context there is a rapidly growing population of Fab Labs – at the last count, 57 exist globally with three new Fab Labs being added every month. Fab Labs are a community spin-off of open access high technology workshops based around

3D printing. Another new phenomenon are the Tech shops, which are a more commercial alternative to Fab Labs. Hackspaces are physical places for the technologically aware community where people can meet to learn, socialise and collaborate on projects. All of these are rapidly spreading the concept of this new technology to an ever-growing audience of users, who are looking to situate this technology in their everyday lives.

In this book, I aim to demonstrate that 3D printing is now becoming an integral part of the canon of arts practice. I have two clear aims: the first is to introduce to an arts-based audience the potential of the process now commonly known as 3D printing; the second is to place the sequence of processes that make up the discipline into some sort of historical perspective and timeline in relation to the visual arts.

I intend to demonstrate objectively how these new processes have been accepted by using a number of case studies of current practitioners and explaining how their diverse practices are creating new methods of working for others to follow.

One could argue that any new process is beginning to gain capital and acknowledged credibility in the world when it starts to accumulate a variety of names. 3D printing is currently in this phase, alternative names include: free form fabrication, rapid manufacture, additive layer manufacture (ALM), selective laser sintering (SLS), stereo-lithography (STL), rapid prototyping (RP) and fused deposition modelling (FDM).

Often a change in the cultural acceptance of a new process can be traced to a single event, which in itself may not have been significant at the time, but in retrospect serves as an indicator of changing perceptions. In my opinion an issue of *Wired* magazine with a feature article by editor Chris Anderson[1] entitled *'In the Next Industrial Revolution, Atoms are the New Bits'* highlights this changing perception. When this article was published I began to understand that a fundamentally different approach to manufacturing was beginning to take place.

Perhaps the most perceptive comment within the article is the following: 'Here's the history of two decades in one sentence. If the past ten years have been about discovering post-institutional models on the web, then the next ten years will be about applying them to the real world.' However, Anderson

'Dot', the world's smallest 3D-printed animation made in conjunction with the Nokia N8 microscope. © Aardman Animation

was probably talking more about the influence of social media, how society approached problems collectively, and how this collaborative approach would operate beyond the web.

The article went on to highlight a number of new ways of working inspired by 3D printing, such as a crowd sourced car and the phenomena of Fab Labs and Tech Shops. It is that real world application of digital technology that describes the current excitement over 3D printing. The prospect of designing a virtual object on your Mac or PC and then just pressing a button to print it out in real materials is very appealing and futuristic. The reality is in fact very far from this – at least in the next few years. At the time of writing, the only processes within the field of additive layer manufacture that even approach the reality/quality of a finished article in real materials are laser-sintered titanium, steel and nylon. In the field of the visual arts two research projects define new directions in real materials. The collaboration between Cookson's and Birmingham UCE Jewellery Innovation Centre to print gold and precious metals and the work of the author's own research team at the University of the West of England, Bristol in 3D-printed ceramics. All of these processes still require a great deal of cleaning and finishing after printing; you cannot just take them as finished items straight from the printer. I can quite safely say at this point that currently no process offers what the user requires, and I say that as a fan and advocate of 3D printing!

There is no doubt that these processes, in the long term, do have the ability to create a disruptive technology as articulated by Chris Anderson. 3D printing's disruptive path may well happen in a similar way to the introduction of web-based communication which superseded the traditional newspaper printing industry. This takes time, the revolution in printing and communication took nearly 30 years from the initial introduction of computer typesetting. This was exemplified by the Wapping dispute with the Murdoch press in the early 1980s. The print unions struggled with management over job cuts because the journalists could now type their copy directly into a computer and the printed page could be made up onscreen, without the need for trained typesetters. There was no longer a requirement for the legions of typesetters, platemakers and reprographics departments. Here the catalyst for change was the advent of desktop publishing software such as Aldus PageMaker for the Apple Macintosh, developed in the late 1980s. Another catalyst was the spread of the home PC and the widespread adoption of the Internet in the 1990s. This has led us to the smart phone and Apps in the last few years, which have enabled consumers to not only read a newspaper but also get the news in different forms on their phone or iPad instantly, without any physical object ever having existed and with no waste product to throw away after you have finished reading. Collectively, all of these developments, which grew from the development of one digital technology, have resulted in the steady decline of the traditional newspaper industry.

If we assume that 3D printing, as a disruptive

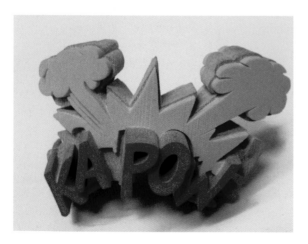

Brendan Reid, 'Kapow', 2009. Z Corp 510 colour powder deposition print. © Brendan Reid. CFPR Labs 2009.

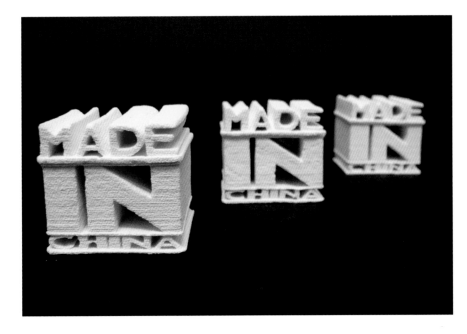

Paul Laidler and Brendan Reid, 'Made in China', 2010. 3D ceramic powder deposition print. © Paul Laidler and Brendan Reid. CFPR Labs 2010.

technology, is following the same path, I believe we are not even in the 'Wapping' phase. I came to 3D printing relatively late, around 2005, when commercial machines had been on the market for almost two decades. And yet, at that time no major industry had adopted 3D printing as a primary manufacturing technology. However, there were examples where the technology was gradually beginning to be used. Today, in aerospace 3D printing technology is used to produce titanium parts that have convoluted gas flow paths through the part, with no casting and joining seams. 3D printing these parts has the further benefit of increasing space and cooling capacity. In Formula 1, 3D printing is used for parts tailored specifically to the individual car and driver, as most of these parts are one offs or at most manufactured in double figures. The dental industry also increasingly employs 3D printing technology for the manufacture of replacement teeth, because these are individually tailored but printed en masse in one build of the 3D print machine.

Finally 3D printing is beginning to be used in planning medical surgery such as orthopaedic surgery – for example, CAT scans can be turned into 3D-printed replicas of fractures enabling surgeons to work out how an operation might be undertaken – and particularly in veterinary surgery, where the medical

governance restrictions are less stringent. None of these applications are geared up for large-scale manufacture, but this may come in the next few years.

Many people will point to the influence that the cheap home printer (such as the RapMan, MakerBot, Cubify or 'Fab at home') is beginning to exert on the future of 3D printing and its general acceptance as a technology. This phenomena has certainly done much to promote the cause of 3D printing, but it also adds to the hype, perhaps exemplified by popular books such as the novel *Makers* by Cory Doctrow (see p. 107), where the chief characters print everything from fairground rides to electronic parts using a 3D printer and 'Goop' (theoretically an epoxy-based material)! All of this publicity is not a bad thing – any publicity is good publicity.

The future of 3D printing may well lie within the hackspace, 'maker' and 'geek' communities that currently use the web and the ability of open source communities to push and extend the potential of do-it-yourself 3D printing.

It is always difficult to predict the future, but in my mind 3D printing will probably develop in a number of different ways. The 'high end' of the 3D print industry that involves the metal fabrication of parts will remain high-end and will be used mainly by the big industrial manufacturers to make specialist parts on

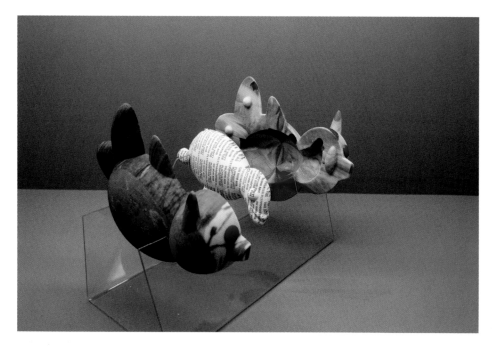

Paul Sandammeer,
'Fish pig', 2008.
Z Corp 510 colour powder
deposition print. © Paul
Sandammeer.
CFPR Labs 2008.

high-tech machinery that will continue to cost many hundreds of thousands of pounds. These machines will become more and more specialised and will only be capable of manufacturing very high quality parts within a very narrow spectrum.

I also think, at least in the interim, that the middle ground will be occupied by bureau services such as Shapeways, Sculptyo and Imaterialise (see Chapter 2). You can use these services to order a part you need online, in the same way that you might order something from Amazon, and it will be printed, finished and then dispatched to you. Bureau services marry the ability to mass customise a bespoke printed object with economies of scale, thus reducing the need for warehousing, transport and stocking – truly creating just in time solutions. I see this as the largest potential growth area; many products in this sector will be manufactured and dispatched without the customer even knowing they are 3D printed. To return to our digital printing analogy, this method of manufacture will be 'print on demand' much the same as current online book production websites, such as Lulu or Blurb, or Amazon's out of print books service, where the copy is printed and bound only when the order is received and dispatched direct to the customer. So even though the book is produced on a high-volume large-scale machine it is a tiny segment of a continuous printing process.

I can envisage at the 'low end' of the 3D printing market where the cheaper machines will fulfil the toy, hobby and schools market, something akin to Meccano in the middle part of the last century. It is inevitable that the MakerBot type machine will be made available as a quality educational tool or as an expensive toy with recyclable materials. I have reservations about whether these machines will fulfil a long-term manufacturing role apart from niche areas such as printable foodstuffs. In fact it is already possible to print using chocolate and icing sugar from a pressure-fed head on cheap fused deposition modelling (FDM) machines.

But where then does this technology fit within a creative arts context? Its influence is slowly gaining ground. Early adopters such as Assa Ashuach in the design field or Keith Brown within the visual arts field are slowly being joined by many more visual arts practitioners as the learning curve for entry gets easier and more affordable. 3D printing will become more mainstream as artists and creatives adopt these processes. At this point in time the majority of users are primarily concerned with the technology rather than the specific objects that 3D printing tools can create. While artists are seldom the leaders in a new technology, established artists tend to push the

boundaries of new technology into new, interesting areas. It is at this stage that the technology becomes more mainstream and functional, rather than simply creating artefacts that are primarily products of the technology.

I firmly believe that this technology has the potential to be a catalyst for breaking the arts and science divide, as first articulated by C.P. Snow in the 1950s.[2] Snow explained that historically the two disciplines were not separated but by the 1950s the arts and science had become two completely different philosophical approaches. Most of the recent interventions of the arts with industry have been attempts to create an artificial marriage between the two. Conversely, the underlying philosophy of this book is to directly link arts and industry, an approach employed by the author at the CFPR that has caught the attention of government and national research councils.[3] This research provides a case study of how this new technology will influence industry in the future and create wealth and capital for the UK economy, and is also an exemplar of the possible interface between the arts and industry.

Finally to return to the visual arts, the potential of 3D printing is its function as a new tool. The technology in itself will not make art; it is inanimate and subservient to the user, although, this subservience is not always obvious in the objects that one makes with the process. However, I am sure there will be a new breed of artists who will run with the technology in ways that are different to anything of which I can conceive. In writing this book I have encountered work that has surprised and delighted me for its combination of innovation and elegance, using the technology in ways that transcend the actual process. In particular for me, Karin Sander, Stephanie Lempert, Marianne Forrest, Neri Oxman, Assa Ashuach and Iris van Herpen have all created works that I would want to own and live with – and not because they are 3D-printed but because they in themselves are inherently beautiful works of art. I also believe that there is a suprising democracy to 3D printing. Traditionally most observers of technology would assume that a 'geek' and digital interface activity, requiring knowledge of both software and engineering, could only be the domain of the young male. However, the fact that five of the six practioners of 3D printing I have cited above are female illustrates that, in the creative sphere at least, the users interfacing with the technology are not necessarily following the expected historic norm associated with digital technologies.

The case studies

For this book I interviewed a number of leading practitioners in their respective disciplines. I have divided these into four primary categories: Designers, Fine Artists, Craftspeople and 'Other disciplines'. As a practitioner myself I firmly believe in interdisciplinary working and do not like the traditional artistic labels. However, it would have been difficult to divide the chapters in any other way. I deliberately chose practitioners with an established history of practice in 3D printing. In some cases, such as Keith Brown, this goes back almost 20 years to the earliest days of the availability of commercial 3D printing. I tried to ask all practitioners the same set of questions starting with how they would describe themselves and their personal practice. Whilst the intention was to draw consistent information, each individual's priorities were different. Therefore I have transcribed the interviews in a more informal manner in order to show how each individual has a personal approach to 3D printing. This also demonstrates how each creative practitioner tailors the process of 3D printing to their own requirements and how they use the technology in a manner that is not necessarily prescribed by the manufacturer.

The questionnaire, along with biographies of the artists, can be found in the appendices at the back of this volume.

1 Anderson, Chris (2010). 'The Next Industrial Revolution, Atoms are the New Bits', *Wired*. Feb 2010 Volume 18 Issue 2 p. 58. ISSN 1059-1028

2 Snow, C.P. (1959). *Two Cultures and the Scientific Revolution University of Cambridge Rede Lecture*. London: The Syndicate of the Cambridge University Press.

3 RCUK, (2011). 'Big Ideas for the Future, UK Research that will have a profound affect on our future.' Research Councils UK Report 2011. pp. 103, 108.

3 AHRC, Centre for Business Research. (2011). 'Hidden Connections Knowledge Exchange between the Arts and Humanities and the Private, Public and Third Sectors.' Swindon: AHRC. pp 13, 16, 38.

1

The history of 3D printing in relation to the visual arts

This chapter will outline the history of 3D printing technology, its rise as an industrial prototyping process developed for engineers and industrial designers and its parallel history as a medium for visual artists.

In this book I will deal with only the physical ouputs of the technology because there are many other excellent texts that deal very particularly with the rise of screen-based digital technology and its relationship with the visual arts. *A computer in the art room*[1] is one of the best examples. I propose to take that set of virtual technological developments as read, including most of the software developments, and concentrate on the three-dimensional physical output generated by 3D printing hardware. It is specifically those developments in physical output that can be generated from a digital file, which will be covered here. Therefore by necessity, I will try to give a comprehensive view of the history of the technological hardware developments, and their contribution to the development of 3D printing. I will then illustrate that history with examples of arts-based practice, in order to create a timeline to show how artists have interfaced with the technology and how this runs in parallel to the industry.

In common with many commercial processes adopted by artists and subsumed into the canon of artistic practice, the origins of 3D printing can be ascribed to one of many historic contexts and starting points. 3D printing in particular is a young enough technology to have several tracable development patterns. However, it does not yet have a clearly defined history beyond that of a straightforward engineering technical development. The current history, quite rightly in my view, begins post-1976, but we should be aware of the speculation that developments in earlier technologies were actually made from the 1850s onwards.[2] It is those earlier technologies which we will speculate further upon here before we then try to document 3D printing's history as it relates to the visual arts.

The manner in which one creates an historical perspective of the visual arts' interaction with 3D printing is interesting if only for the fact that, in truth, the majority of the 3D printing industry is only just becoming aware that there could be an arts perspective to the technology. This is separate to the fact that artists themselves are very keen to adopt the technology. Clearly, as we document each process we

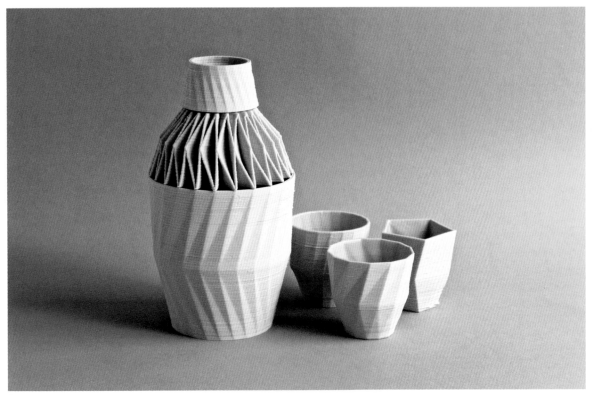

1

2

1 Unfold, 'Stratigraphic Porcelain',
2011. This is from the Belgian
company, Unfold, who first
extruded clay from an FDM type
printer, and is part of a bigger
project about a distributed
production system called
'Stratigraphic Manufactury'.

2 Jonathan Keep, 'Noise
Morphology 5', 2012. High-fired,
glazed stoneware clay, printed on
RapMan 3D printer.
© Jonathan Keep.

have no proof that each subsequent invention was directly informed by the previous work. However, once a process is in the public domain, then developments occur both from what is generally available and from the sparks of pure innovation. Therefore, in order to create a visual history, to delve into 3D printing's earliest origins we can liken its earliest history to the development of the coil pot in Neolithic culture. The coil pot, unlike almost any other making or craft process, is a directly additive process. In plain terms, one builds the pot by adding clay one coil at a time until you have built a complete object. This hand-built process has direct parallels to the fused deposition method (FDM) of building a 3D object with a coil of heated plastic wire and can be said to be in complete harmony with the process of extruding clay to build a 3D-printed pot.

The clay extrusion process was first developed as a 3D process by Unfold in Belgium[3] and additionally taken up by Jonathan Keep,[4] and also Peter Walters, et al;[5] where the heated FDM head and plastic are replaced with a syringe filled with clay or slip.

Until the advent of 3D printing, most three-dimensional manufacturing processes were subtractive: in other words, based on carving or machining the object from a larger block of material. Whilst I am aware this is a fairly subjective statement, as casting processes are additive, invariably in order to create the mould or make a die – a positive pattern (or electrode used in spark erosion) has first to be created, usually by subtractive means. In the case of spark erosion, where the metal is eroded by an electric current creating a spark to eat away the material, a positive block first has to be milled in graphite or copper in order to create an electrode. This in itself relates directly to engineeering practice and therefore, in artistic terms, it may be easier to talk about the traditional fine art processes of carving and modelling where carving is the subtractive process, such as carving a block of wood or marble, and modelling is the additive process, such as modelling a head from clay for bronze casting, where one slowly adds clay to model the form.

To return to the earlier histories of 3D printing, in 2001 Joseph Beaman from the University of Texas in Austin,[6] traced the dual chronology of 3D printing technology from the mid-nineteenth century up to the 1970s with two approaches, 'topographic' and 'photosculpture'. To define the processes involved in these two historic approaches: topography plots a surface in a linear manner and then reproduces that surface from a linear form. Photosculpture uses the camera and lens to capture a surface and then analogue photomechanical processes are used to reproduce it. Beaman uses this technological divergence to define the growth of 3D printing into two primary approaches. The first approach is the powder deposition and layered-object manufacture methods of 3D printing, such as the Z Corp process, which are akin to the topographic approach. Whilst the second photosculpture approach addresses all of the methods that use a photopolymeric liquid, hardened by light such as the Objet 3D printing method.

1 American, 'Ulyses S. Grant', c. 1870. Ivory painted plaster cast statue of Ulyses S. Grant in military uniform, seated on a cloth-draped chair smoking a cigar, the wood grain painted base with the initials 'U.S.G.' and 'Photosculpture' on the front; the back with 'Pat. Aug. 27, 1867'. 53 cm high. The subject is seated in the centre of a room surrounded by 24 cameras. From the 24 profiles a pantograph is used to construct a clay model from which a mould is made to cast the statuettes. A similar patent was granted F. Willeme, on 9 August 1864.

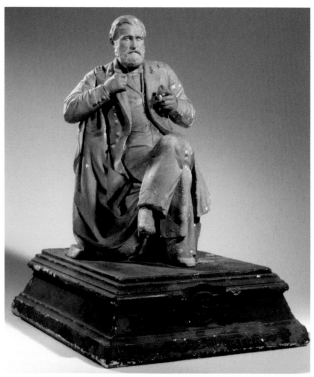

1

2

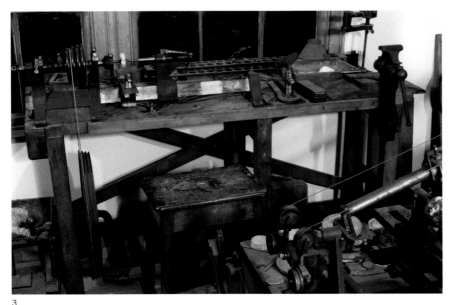

3

2 Francois Willème, 'Portrait of a Woman', c. 1860.
Photosculpture 1985:0517:0001.
Courtesy of George Eastman House, International Museum of Photography and Film.

3 'James Watt's studio', preserved and recreated for visitors at the Science Museum, London. Photo © Science & Society Picture Library, Science Museum Group Enterprises Ltd.

4 Benjamin Cheverton's sculpture copying machine, patented in 1884, is on display at the Science Museum in London. © Science & Society Picture Library, Science Museum Group Enterprises Ltd.

Beaman's photosculpture track begins in 1863 with the Willème photosculpture patent, and his topography track begins in 1890 with a patent from Blanther "who suggested a layered method for making a mould for topographic relief maps. The method consisted of impressing topographical contour lines onto a series of wax plates and cutting these wax plates on the lines."

Whilst I agree with the rationale for these tracks, there is much overlap between the two. I would start the topographic track much earlier, at the turn of the nineteenth century, beginning with the sculpture copying machines of the inventor of the steam engine James Watt, who from his retirement in 1800, to his death in 1819 developed a series of machines for copying sculpture, which he never patented.

The extant machine can still be seen in his workshop, which is preserved in the Science Museum in London.[7] In my opinion, these machines are definitely the forerunner of the topographic machine described by Beaman. The sculpture copying machine was improved upon by Benjamin Cheverton[8] who in 1884 patented a sculpture copying machine for reducing sculpture, much like a three-dimensional pantagraph. A copy of Cheverton's machine may also be seen at the London Science Museum.

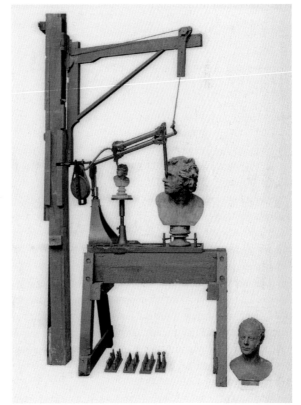

4

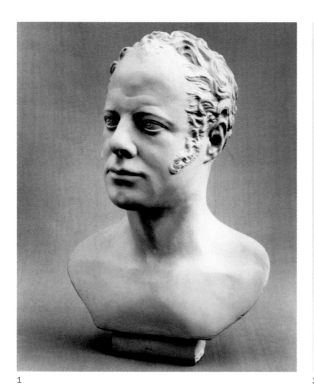

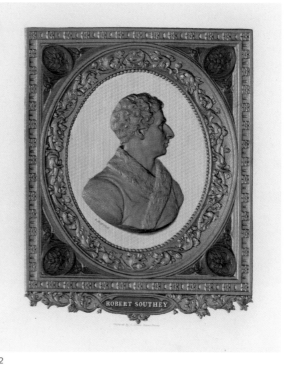

1

2

1 Benjamin Cheverton's copy of 'Theseus' from the Elgin Marble collection at the British Museum, 1851. Parian sculptured bust of Benjamin Cheverton. In the early nineteenth century, the middle classes liked to display busts of famous figures in literature and music, or copies of famous antique sculptures. A new material, Parian ware, was introduced in the 1840s by the firm of Copeland and Garrett, closely followed by Minton. This unglazed, fine-grained porcelain had a slight sheen and soon replaced plaster of Paris. James Watt (1736–1819) had

developed a machine to produce scaled-down copies of original works. Cheverton perfected the machine for commercial use in 1836. © Science & Society Picture Library, Science Museum Group Enterprises Ltd.

2 Achille Collass, bas-relief engraving of Doctor Robert Southey, made c. 1838 using a pantagraph. © Centre for Research Collections, Edinburgh University Library.

Cheverton's machine was fitted with a rotating cutting bit which was used to carve reduced versions of well-known sculptures. Cheverton demonstrated his reducing machine at the Great Exhibition in 1851, winning a gold medal for his copy of 'Theseus' from the Elgin Marble collection in the British Museum. Many copies of Cheverton's sculptures still exist today and a large collection of over 200 busts can be viewed at the Art Gallery of Ontario, Canada. Concurrent with Cheverton was the French engineer and designer Achille Collass[9] who also produced a method of reproducing sculpture using a pantagraph. I would argue these machines were the forerunners of today's CNC milling machines, which in turn were the forerunners of 3D printing.

The other track, as postulated by Beaman, relates directly to photography and its descendent photosculpture. This in some ways makes it easier to draw a parallel in artistic terms, as it is possible to trace developments of 3D sculptural creation in relation to photography back to the early nineteenth century. Walters and Thirkell[10] argue that the origins of 3D printing are to be found within photographic scanning and recreation processes, such as the aforementioned process of photosculpture, developed in France in the 1860s by François Willème[11] and the 'Photographic Process for the Reproduction of Plastic Objects', for which Carlo Baese filed a United States patent in 1904.[12]

Willème situated his subject in the centre of a circular room and photographed them using 24 cameras placed around the circumference of the room. From these photographs silouettes were created and the outline of each photograph projected onto a screen. The outlines were then used by an artisan who, with the aid of a pantagraph which had a

knife or carving tool attached, carved the bust from a cylindrical block of plaster, or clay, thus using each of the 24 photographs to create the form. The resulting sculpture was then smoothed out by eye, before casting in plaster to make a mould. Willème's process had a well documented commercial life and his large Paris studio was in operation from 1863 to 1868.[13]

Willème in fact had two approaches to his process, documented in Sobieszek's article about photo-sculpture in France.[14] There was an earlier process, which Sobieszek calls mechanical sculpture. Fifty photographs were taken in a circumference equidistant from the sitter. The photos were then developed and individually outlined on wood, then cut in half and each wooden profile half section cut to an individual wedge. Finally all 100 wedges were assembled as a circular bust. This is one of the earliest demonstrations of slicing an object in exactly the same way as most current 3D printing processes. An extant example of this process may be found in the Eastman Kodak Museum in Rochester, New York State.

In the United Sates, Carlo Baese, proposed to allieviate some of the carving undertaken in the Willème process by using the properties of bichromated gelatine in his development, which were well known from the work of Fox Talbot and Walter Woodbury. He proposed to use layers of swelled gelatine, laid one on top of the other, to create the relief as he photographed around the head. It is not clear if Baese actually managed to use or commercialise his process. However, from a twenty-first century perspective, as well as my own experience of working with bichromated gelatine processes, it does not seem likely this was a workable process (beyond the theoretical). The technical challenges of handling many layers of gelatine and the added difficulty of previous layers shrinking and hardening as you apply new layers seems too problematic and time consuming. It is, however, a very forward-looking concept, and as Baese patented the process he must have achieved some level of practical success, thus securing its place as a forerunner to a new technology.

My view is that the Willème method relates more to a topographic approach, whereas the Baese method definitely uses a light-sensitive gelatine and can therefore be defined as a photographic approach. Gelatine is in itself a bio-polymer, a precursor of the polymers now used in 3D printing. If we look back to the early Victorian history of photography we can see the the development of a light-sensitive material from Mungo Ponton, who discovered the properties of using a chrome based hardener material in 1839. "Ponton found that paper dipped in pottasium bichromate was coloured brown by the rays of the sun, but that unexposed bichromate would dissolve out of the paper in water."[15]

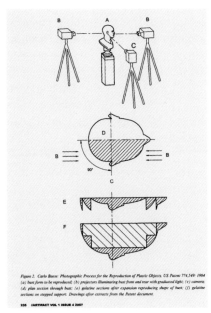

Figure 2. Carlo Baese: Photographic Process for the Reproduction of Plastic Objects. US Patent 774,549: 1904 (a) bust form to be reproduced; (b) projectors illuminating bust front and rear with graduated light; (c) camera; (d) plan section through bust; (e) gelatine sections after expansion reproducing shape of bust; (f) gelatine sections on stepped support. Drawings after extracts from the Patent document.

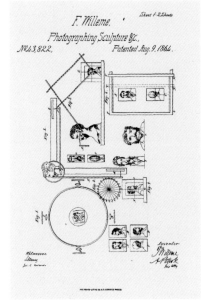

F. Willeme.
Photographing Sculpture &c.,
Nº 43,822,
Patented Aug.9.1864.

3 Carlo Baese's patent diagram for the 'Photographic Process for the Reproduction of Plastic Objects'. US Patent 774,549 (1904). Reproduced in Artifact, Vol 1, Issue 4, 2007.

4 Willème's patent diagram for 'Photographing Sculpture'. US Patent 43,822 (1864).

3

4

1

2

It is possible to create a clearer logical chronology if we put Ponton's work in context with the photorelief process invented by Walter Woodbury (in 1865) and follow those developments through to the photoceramic relief tiles of George Cartlidge (from the early 1900s). There is little doubt that these processes mark the birth of the photopolymeric relief processes, which are an integral part of contemporary 3D printing.

Ponton had discovered the light-sensitive properties of chrome salts, and this discovery was built upon by William Henry Fox Talbo. In 1847, Talbot filed a patent for combining gelatine with Pottasium Dichromate.[16] These two factors were to form the basis for all photomechanical printing processes for the next century and would consequently lead to the birth of modern photopolymeric 3D printing.

These developments become even more relevant to the future of 3D printing when, in 1865, Walter Woodbury[17] created a continous tone photographic relief process that transcribed a black and white photograph into a tonal relief surface. Woodbury created a slab of gelatine approximately one inch thick (25mm) to which was added a 3.5 per cent solution of potassium bichromate, making the gelatine light-sensitive. When exposed to a photographic negative the gelatine hardens in direct proportion to the light it has received. Once washed with water the gelatine forms a tonal relief 'bump map topography' in three dimensions, with the white areas standing proud and the dark areas forming the valleys. Woodbury then made a lead matrix from the gelatine and could create continuous tone prints in hot liquid translucent gelatine ink from the matrix. When cool,

1 Woodbury image from 'Men of Mark' 1877. Photographs by Lock and Whitfield © CFPR Archive Bristol.

2 Woodbury image from 'Men of Mark', 1877. Photographs by Lock and Whitfield © CFPR Archive Bristol

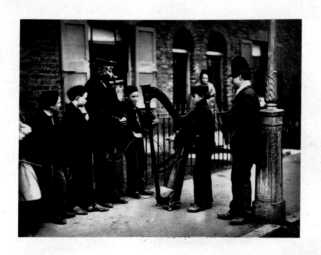

3

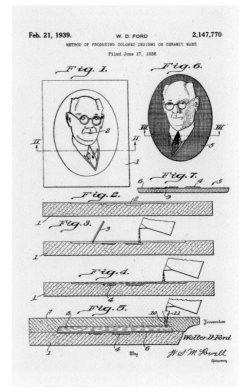

3 John Thompson, 'Italian Street Musicians: Street Life in London', 1877–8. Woodburytype. Given by Mrs D. Crisp © V&A Images, Victoria and Albert Museum.

4 Walter Ford's patent diagram for the Photoceramic process using bichromated gelatine. US patent 2,147,770 (21 February 1939; filed 17 June 1956).

4

the tonal range of the prints was entirely dependent on the depth of gelatine, i.e. the thicker the gelatine, the darker that section of the print. Even though this was only in low relief what is important here is that this was the first time ever that a photograph was transcribed directly, without an analogue transcription process, to a three-dimensional surface.

The results were spectacular and are perhaps best represented in John Thompson's 'Street Life of London' from 1877,[18] which are also some of the earliest examples of social documentary photography. However, the process was problematic in that it not only required a highly-skilled workforce to make the matrices and print the images but also because the hot liquid gelatine squirted out from the sides of the matrix as the pressure increased during printing, the prints had to be cut down and pasted into the published books by hand. This effectively killed the process as a commercially viable mass production entity despite its obvious high quality printing results.

Let's now leap forward 60 years, to the 1930s and the industrial ceramicist Walter Ford of the Ford Ceramic Arts Company in Ohio. Ford successfully built upon Walter Woodbury's gelatine process to create low relief ceramic moulds. Instead of creating a lead matrix he used the light-sensitive gelatin slab to create a plaster mould and from this mould he cast ceramic relief tiles which, when 'biscuit' fired and had a translucent glaze applied, created the photographic tonal relief. Where the glaze pooled, it became thicker in the low areas and created the dark tones. The high areas then, had a very thin glaze and the combination of the two produced photographic highlights. Ford was granted a patent for the process in 1936.[19] What is important here is that Ford created a physical relief photographic image in a permanent material that did not require the intervention of a craftsman to realise the image.[20]

1

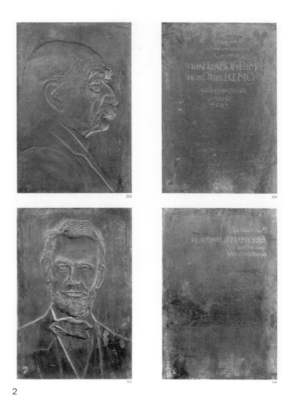

2

This process was a direct descendent of the photoceramic relief tiles created by George Cartlidge between the 1880s and the late 1910s. The tonal range was again dictated by the height of the relief where the white areas were high and the black areas were low. Once translucent glaze was applied, the tiles exhibited a very photographic quality, with rich black and a subtle tonal range through to white, dictated by the relief height of the tile. Created primarily for the company Sherwin and Cotton, it is generally believed that these tiles were photographic precursors to the Ford Tiles.[21] My own discussions with Cartilidge's nephew and research undertaken at the Centre for Fine Print Research in Bristol between 2003 and 2006 confirms that the tiles were actually sculpted in wax from photographic negatives, in the same way as the photolithophanes were created in Limoges in France from the same period.[22] The reason for discussing Ford before Cartlidge is that Ford is the direct descendent of Woodbury – in terms of photomechanical process. Although the Cartlidge tiles have all of the attributes and appearance of a true photomechanical process, they were in fact completely autographic. There is no doubt that these tiles were the primary influence for Ford and his subsequent photoceramic work. In consideration of these processes we now have the groundwork for a directly transcribable photographic process that can be realised into a three-dimensional photorealistic object.

To return to the topographic track, in the 1950s the London-based sculptor George Macdonald Reid developed an extension of the Willème technique by using army surplus map-making machinery to produce a series of portrait busts. The process was a combination of hand, photography and an adapted lathe. In particular, Reid's technique mapped a surface contour, in much the same way as Willème, to produce the 3D model.

To capture the data, the subject was placed on a revolving chair and up to 300 profile photographs were taken. These were then transcribed to an outline profile which was then milled into a plaster block. The full process can be viewed in two Pathè News films, one from 1957 entilted *Robot Sculpture*, which features the creation of a portrait head of the

Danish actress Lillemore Knudsen[23] and *Instant Sculpture* from 1963, which features the racing driver Graham Hill.[24] From the two films it is possible to see that Macdonald Reid made many adaptations to the process in the six years between the recording of the two films.

In 1956 Otto Munz filed a patent that predates most 3D printing technologies by 30 years,[25] but Beaman argues this patent clearly represents the link between photography and the current technologies. In his patent, Munz postulates an idea he calls 'Photo-glyph recording' where:

A layer of a photo-emulsion of the silver halide type in a transparent medium suspension, of exposing said layer at a predetermined focus with said radiation, of developing and fixing said photo-emulsion, of covering the said fixed layer of photo-emulsion with another layer of unexposed photo-emulsion and of bringing said unexposed layer of said photo-emulsion into said predetermined focus with said radiation and of repeating said cycle, the number of repetitions being controlled by the third magnitude recorded.

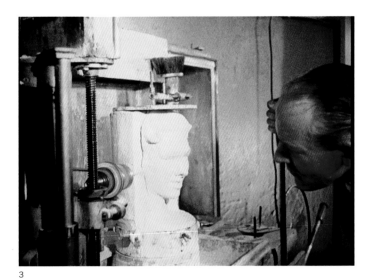

3

1 George Cartlidge, 'Sophia', 1904. The image of a New Zealand Maori woman on a photoceramic tile. © The Potteries Museum & Art Gallery, Stoke on Trent.

2 Lead casts of the original Cartlidge moulds sculpted in wax by George Cartlidge. © Archive Tony Johnson

3 George Macdonald Reid creating a bust of the Danish Actress Lillemore Knudson. 1957. Still from Instant Sculpture. © Pathè

4 George Macdonald Reid creating a bust of the racing driver Graham Hill in 1963. Still from Instant Sculpture. © Pathè

5 Otto Munz patent diagrams for 'Photo-glyph recording'. US Patent 2,775,758 (25 December 1956).

4

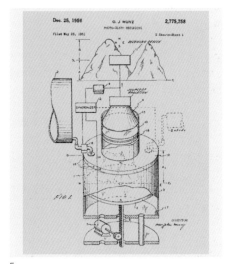

5

In simple terms, he is proposing to create a 3D object by exposing layer upon layer of photographic emulsion, which is hardened by light one layer at a time! Thus spanning the divide between processes such as Woodbury type, Baese and the current additive technologies for 3D printing, which use a photographic image for exposure with a photopolymeric resin that cures by exposure to light, such as those used by Objet and Envision Tech (outlined in Chapter 2).

It is in the 1960s that photopolymer emulsions began to be used extensively in the printing industry, in particular for the flexographic process.[26] Originally known as 'aniline printing' the process was renamed 'flexography' in 1952. It is now one of the most commonly used printing processes and everything that is part of packaging is printed by flexography, from your milk bottle and your cereal packet to the box your fridge arrives in. These are direct descendants of the light-sensitive gelatine processes such as Woodburytype and photogravure. These emulsions now come in many forms but can create a multitude of printing plates, which can vary in size, from a plate an inch thick to a thin coated roller and, dependent on their composition, they can be hardened to produce printing plates from very soft through to extremely rigid. It is this photo-polymeric emulsion chemistry

that has formed much of the basis of the 3D printing industry, where photo-polymeric plastics can now be hardened by light to create physical objects.

However, the development and history of any process or set of processes is never linear and it is therefore perfectly valid to trace a number of other histories or timelines that relate to the processes of 3D printing. Most developments occur both in isolation and in tandem with peer developments in the field. For example, the developments in photopolymer light-sensitive emulsions and photography are both relevant to the field of 3D printing, but we also need to consider other developments in engineering, specifically CNC milling (Computer Numeric Control) and CAD (Computer Aided Design) technologies.

If one follows the documented development of the process from an engineering standpoint, 3D printing is also a direct descendent of Computer Numeric Controlled (CNC) milling. The process involves transcribing numeric data into a file that will then subtractively cut away a solid block to create an object. CNC was first developed during the 1940s and the numeric control part (which came first) is attributed to an American engineering machinist and salesman John T. Parsons. The process continued to develop thoughout the 1950s and 1960s.[27] With

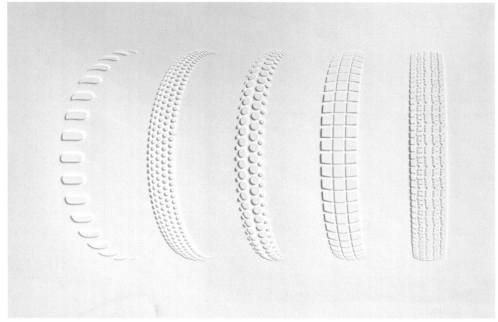

1

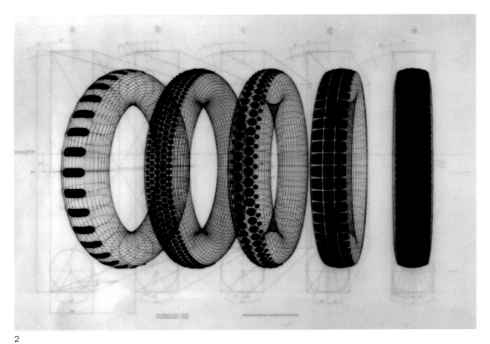

1 Richard Hamilton, 'Depth of Cut', from the series of work 'Five Tyres Remoulded', 1972. This is the final cast. 3D relief cast in silicone. © Richard Hamilton Studio 1972.

2 Richard Hamilton, 'Circumferential Sections', from the series of work 'Five Tyres Remoulded', 1972. Screenprint on polyester film. © Richard Hamilton Studio 1972.

2

the price of computers and CNC machinery dropping rapidly in the 1970s CNC soon became the bedrock of industrial manufacturing processes. The natural progression was the advent of CAD (Computer Aided Design) because, as in many other arenas where computer design tools were introduced, they allowed a seperation between the draughtsman or designer and the machine. The ubiquity in industry of three-, four- and five-axis milling machinery is hard to describe to a non-specialist. Perhaps the best description is that if you buy almost any part or piece of machinery, whether metal or plastic, if it has not been milled by a CNC machine then the tool or mould that made that part or piece will have been milled by a CNC machine.

Firstly, I will provide a short description of milling. Milling is a subtractive process. In essence it is the process of drilling out an object from a solid block of material. Historically this would have involved using a lathe to which a block of wood or metal is clamped in a horizontal 'chuck'. The block is then spun and a chisel or cutting tool is applied to the spinning block to cut away parts of the block. The best example of lathe use is the traditional round chair leg, which is created from a rectangular block of wood.

The next technological development in milling is the milling machine, where the block is mounted either horizontally or vertically. Crucially, in the milling machine it is the tool and not the block that spins – in this case drill or router is used as the spinning tool to cut away parts of the block.

The next development in milling technology was to be able to move the drill or router forwards and backwards horizontally as well as vertically. With the advent of the personal computer in the early 1970s the cutting paths of the tool no longer needed to be controlled by the operator, but could now be controlled by a computer program, hence the introduction of Computer Numeric Control (CNC).

Artist's have for many years actively used CNC milling in their work and its influence spreads widely through laser cutting, routing (for this book I shall define a router as a machine that mills in two dimensions or three dimensions with a very small Zaxis) and of course 3D printing.

With the introduction of CAD packages, in the 1980s, it becomes difficult to separate arts practioners that used CNC as part of their artistic production methods from those arts practitioners that used the early forms of 3D printing. As both processes can often share the same digital file, the two processes overlap and artists tended to use both in the early days of 3D printing. Many still do.

In my opinion one of the first extant examples of a physical digitally printed artwork of any note occurred in 1976, with the artist Richard Hamilton's piece 'Five Tyres Remoulded'. Before his art career Richard Hamilton had trained as an engineering draftsman and this grounding manifested itself frequently throughout his career, from the aluminium joints he created for his stretcher frames through to 'Five Tyres' and his love of digital technologies. Hamilton was an early adopter of Quantel Paintbox and Harry (computer generated image design systems). In my personal discussions with Hamilton between 2003 and 2010, he explained how he had originally created 'Five Tyres Abandoned' in the early 1960s as a collotype print, but had been frustrated that the engineering drawing was taking him so long to create. He abandoned the project after printing the single collotype print in 1966.[28] In 1976 he discovered that it was possible to create a computer-generated CNC file to route a brass plate, which would form a mould for a silicone elastomer material. The resulting two and a half dimension print became part of a boxed set of seven prints, which formed the 'Five Tyres Remoulded' set. The route he took to find a programmer seems a little unclear, but in my personal discussions with Richard Hamilton in 2007 he stated that he had been helped by MIT to create the CNC files. However the AHRC website states:[29]

The project had been revived when an American dealer offered to find a US computer programmer interested in plotting the perspective with a computer. Sherill Martin at Kaye Instruments organised the computer formulation of the perspective, using a general FORTRAN program called CAPER (Computer aided perspective). The screen prints were printed by Frank Kircherer in Stuttgart and the collotypes by E. Schrieber nextdoor.

It is the creation of the 3D copper plate and the subsequent moulding in silicone elastomer of the tyre print, that I view as the first functional 3D artwork of note. Hamilton produced an edition of 75 boxed sets of the seven prints and a further individual edition of 75, which just included the silicone print. Importantly, in both editions of this print the process was completely subservient to the image. The computer and CNC milling route created the result he was aiming for, one until then he had been unable to achieve by any other means.

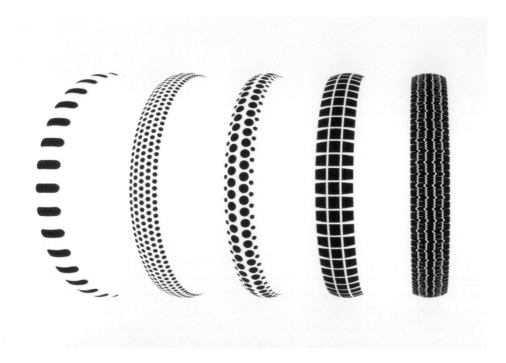

Richard Hamilton, 'Treads (Area)', from the series of work 'Five Tyres Remoulded', 1972. Screenprint on polyester film. © Richard Hamilton Studio 1972.

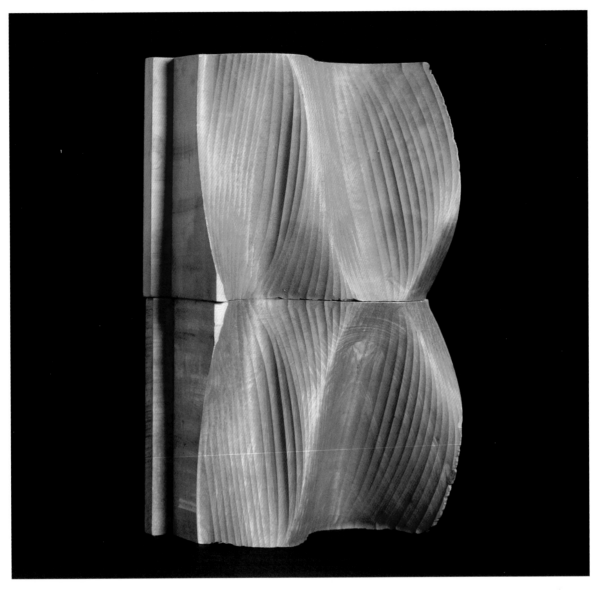

Charles Csuri, 'Ridges Over Time', 1968. CNC milled wooden sculpture. © Charles Csuri.

There is no doubt that concurrent to this, other artists were beginning to use CNC technologies to create artworks from digital files. The earliest among them was Charles Csuri from the Department of Art, Ohio State University in 1968 who created the works 'Ridges Over Time' and 'Sculpture Graphic'. As an artist with a consistent record of early digital work exhibited via Siggraph (the special interest group for graphics and interactive work. The Siggraph conference, which is attended by thousands of computer professionals, has long been the benchmark of innovation in visual digital arts) Csuri says on Siggraph's dedication to him: "This work made use of the Bessel function to generate the surface. The computer program then generated a punched tape to represent the coordinate data. Included were instructions to a 3-axis, continuous path, numerically controlled milling machine (CNC)." To quote further from Csuri: "While the device was capable of making a smooth surface, I decided it was best to leave the tools marks for the paths."[30]

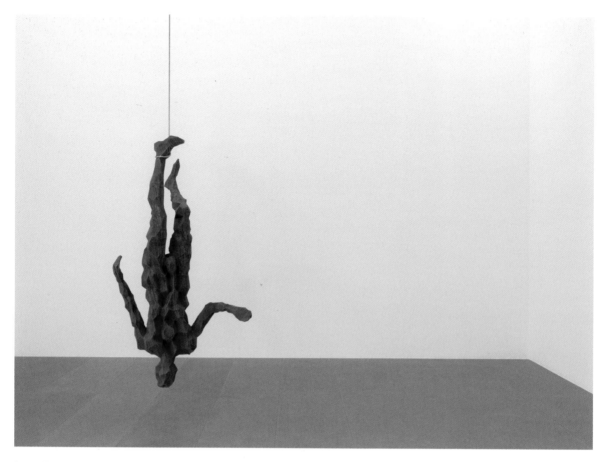

Antony Gormley, 'CORE', 2008. Cast iron, 191 x 96 x 95 cm. Installation view, Galerie Xavier Hufkens, Brussels, Belgium. Photograph by Allard Bovenberg, Amsterdam. © The artist, courtesy White Cube.

Perhaps one of the best recent examples of art practice using CNC milling is Anthony Gormley's 'Core' made by Metropolitan Works, a fabrication and digital technology workshop that is part of London Metropolitan University.

To quote, *De Zeen* magazine in reference to the making of 'Core':[31]

Antony Gormley made use of digital manufacturing for the first time to cut the master for his figurative sculpture. Previously made by hand, the process would often take up to three weeks. Using digital technology was both faster and resulted in a more accurate model. His stunning iron sculpture was CNC (Computer Numerically Controlled) routed from modelling foam, before being cast in iron and finished by hand. The figure is suspended from a beam adjacent to the CNC machine used to create it, within the Centre's imposing machine hall. "The idea was to see if the volume of the body could be re-described as a bubble matrix: a tight packing of polyhedral cells that transform anatomy into geometry," says Gormley.

Whilst over the years many artists had begun to use CNC technology for generating imagery, very little of this actually related to 3D printing. It was not until the advent of the first machine – the 3D Systems Stereolithography SLA 1 in 1986[32] – that artists could actually turn a 3D file into a 3D additive printed object. Artists began to use the technology within three years of its introduction. Whilst the 1980s was the era of industrial development of 3D printing

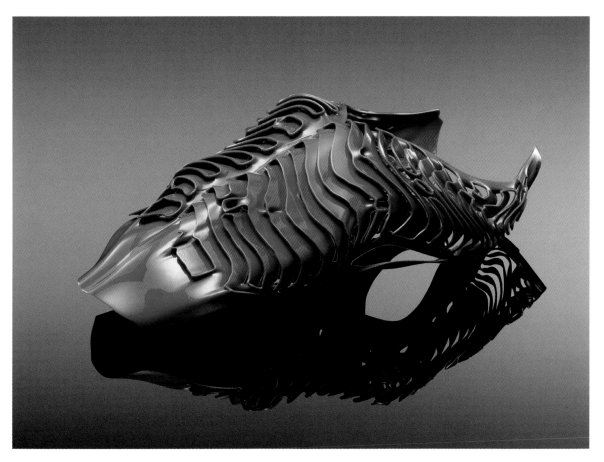

Neri Oxman, 'Leviathan 1', from the 'Armor Imaginary Beings' series, 2012. Digital Materials Fabrication: Objet, Ltd. Neri Oxman, Architect and Designer, MIT Media Lab, In collaboration with Prof. W. Carter (MIT) and Joe Hicklin (The Mathworks) Centre Pompidou, Paris, France. Photo by Yoram Reshef, © Neri Oxman.

technologies; the 1990s was definitely the decade that marked the birth of relationships between artists and rapid prototyping. However, most of these artists were bound into the academic research culture of large universities, where they had the resources and ability to access the new and expensive research tools that were being developed. One must remember that this is still a new and developing technology.

It is only very recently that well-known artists and designers, such as Iris van Herpen[33] and Neri Oxman,[34] have begun to incorporate 3D-printed items to their practice and to consider them to be integral for material results. In 2012 Neri Oxman, Director of the Mediated Matter Research Group and Assistant Professor of Media Arts and Sciences at the MIT Media Lab, exhibited a whole new show

commissioned by the Pompidou Centre in Paris. 'Imaginary Beings: Mythologies of the Not Yet', consisted of 18 new pieces which pushed the boundaries of 3D printing technologies and required advanced R&D from Objet (who 3D-printed all the pieces in their Connex material and sponsored the exhibition). Iris van Herpen, a Dutch fashion designer known for stunning 3D-printed garments, started her own label in 2007. She studied at Artez Institute of the Arts Arnhem and went on to intern for the late world-famous fashion designer Alexander McQueen in London, and acclaimed designer Claudy Jongstra in Amsterdam. Iris van Herpen has recently created her second catwalk show containing garments that are entirely 3D printed. 'Hybrid Holism' was presented at the July 2012 Paris Haute Couture Week. A

3D-printed dress was made in collaboration with the architect Julia Koerner for show, and this was printed by the 3D print specialist bureau iMaterialise.

My personal view of any history of a process is that the initial developments that lead up to the first extant example are always somewhat speculative. True development always begins from the first extant example. In describing the processes that led to commercial machine development, I must sub-divide the first extant research machine from the first extant commercial machine. By doing this I mean to show that the first research machines created by Housholder and Herbert were capable of producing a 3D print, but the process was far from repeatable, whereas the first commercial machines had to be capable of producing a consistent result. Before we can examine that extant commercial machine or discuss how artists use the technology, we first need to explore the history of the first research machine.

In the article 'The Intellectual Property Implications of Low-Cost 3D Printing' Adrian Bowyer et al. postulate that the first patent for a 3D rapid prototyping process was filed by Wyn Kelly Swainson in 1977 for "using a laser to create covalent cross-linking at the surface of a liquid monomer where the object being manufactured rested on a tray that was gradually lowered into the vat one step at a time". Although this machine was never actually made, this patented process led to the development of the stereo lithographic machine, made by 3D systems. The next developments (according to both Bourella[35] and Beaman) include patents from Hideo Kodama of Nagoya Municipal Research Institute in 1981[36] and Herbert from the 3M corporation[37] both of which are developments of using a laser to crosslink a photopolymeric solution in a bath of liquid polymer. Another important research process in selective laser sintering, the basis of both metal fused and nylon sintering, was developed and patented by Dr Carl Deckard at the University of Texas at Austin in the mid-1980s.[38] With sponsorship from DARPA and collaborating with Joseph Beaman and Dave Bourell, Deckard came up with the idea of developing a manufacturing process where a powdered material was melted by the heat of a laser beam, one layer at a time. A similar process was patented without being commercialized by R.F. Housholder in 1979.

Apart from the patent filed by R.F. Housholder in 1981, which is the first description of a laser-fused powder 3D printing system, and a brief description in the book *Solid Free Form Fabrication* by Beaman et al., there is little further information available on this process.[39] However, crucially both of these machines were actually capable of making a part as illustrated by Beaman in *Solid Free Form Fabrication*.

If we move on to commercial systems, there is no doubt that the first extant commercial Machine SLA1 was made by 3D systems and patented by Charles Hull in 1986. This uses a laser to crosslink a photopolymeric liquid on the surface of a bath, one layer at a time.[40]

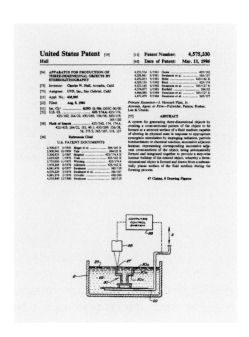

Charles Hull/STL 3D Systems patent for 'Apparatus for Production of Three-Dimensional Objects by StereoLithography'. US Patent 4,575,330 (11 March 1986).

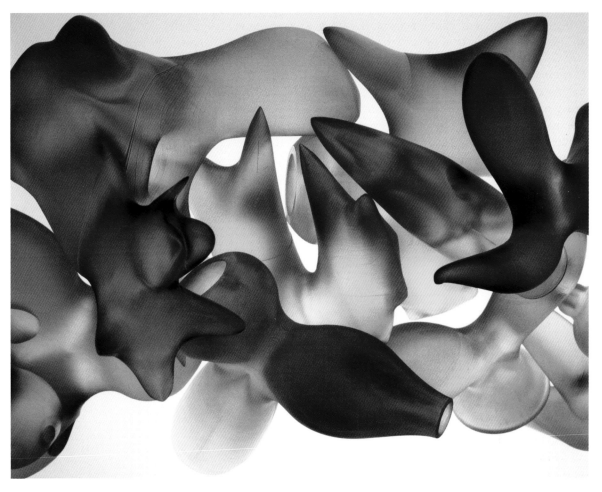

Masaki Fujihata, 'Forbidden Fruits', 1990. Digital photograph of stereolithographic objects. © Masaki Fujihata.

Similar to the 1976 Swainson patent, but using only one laser, the process uses a bath of photopolymeric liquid with a base plate that slowly drops through the liquid one step at a time as the laser hardens the object one layer at a time within the liquid. Like others before him, such as Gutenburg, Hull's biggest contribution was to bring all of the elements necessary to make a process work together in one place. Therefore another key contribution from Charles Hull was the STL file format – now the backbone of file transcription for 3D printing. It is the combination of file transcription and printing that make 3D printing such a disruptive technology.

The first extant examples of an artist's 3D prints created in a commercial stereo lithographic machine date from the very early 1990s. The earliest I have found are from 1989 when Masaki Fujihata created the work 'Forbidden Fruits'. Fujihata[41] is professor at Tokyo National University of Fine Arts and Music. Corresponding with Fujihata, he describes the origin of that first 3D-printed work:

It was in the late eighties [that] I made sculpture by using computer. I made shows in 1987, 1989. One was titled 'Geometric Love' 1987. It was made with a Numerical controlled machine. The next was titled 'Forbidden Fruits' 1989 which used so-called stereo lithography.

Another of the earliest 3D-printed artworks I could find is from the American artist Peter Terezakis[42] who produced 'The Burning Man' in 1992. In recent correspondance with Peter he reflected:

My interest in 3D printing has its origins in a fascination with the atom-by-atom movement of elemental metals in electroplating and began while studying Michael Faraday's experiments in grammar school. In my adult *life I began to experiment with electroforming. With the advent of the personal computer and CAD packages, I began using subtractive machining to create work. In 1993 I started teaching a program in what I termed 'Digital Sculpture' at New York City's School of Visual Arts. I presented several talks on CAD (and its recently arrived hand-maiden CAM) to several organizations in NYC a few years after.*

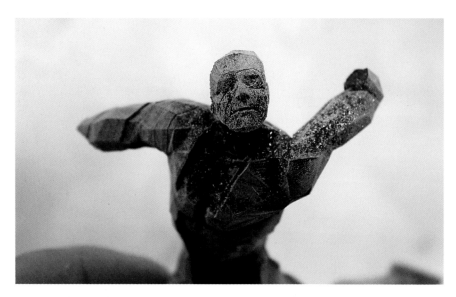

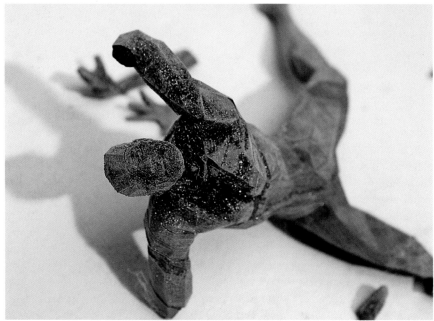

Peter Terezakis, 'The Burning Man', 1992–2012. Wax model.
© Peter Terezakis

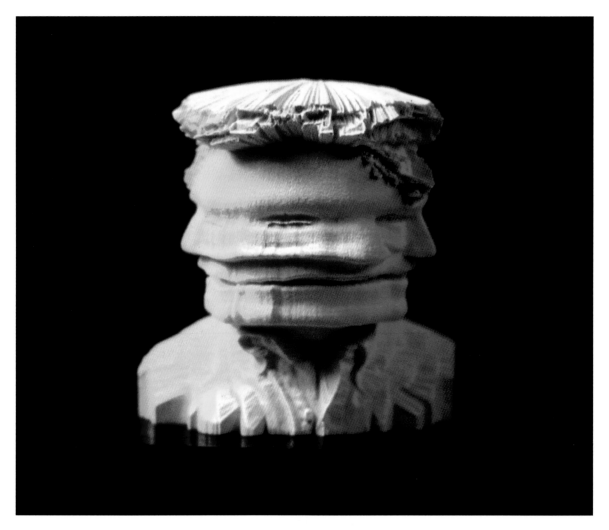

Dan Collins, 'Of More Than Two Minds', hydrocal, 1993. This sculpture was produced by capturing the movement of the artist using 3D laser scanning. The scanned data was then translated to a CAD model that was subsequently milled in wax using CNC milling. Wax prototyped translated into hydrocal casting. © Dan Collins.

These early pioneers in the 3D-printed visual arts emerged from just a handful of artists. A notable example is Dan Collins from Arizona State University. Dan runs the PRISM Lab, an interdisciplinary 3D modelling and rapid prototyping facility. In 1994 he created a 3D-printed artwork 'Of More Than Two Minds'.[43] Collins descibed the process he used:

I was using digital output in the early 1990s. My first show, entitled 'Digital Rhetoric', was in 1993 at the Lisa Sette Gallery in Scotsdale, Arizona. The first experiments translating 3D laser scanned heads was at least a year earlier than that. These sculptures were produced 'subtractively' using CNC milling. The RP stuff came a year or two later as those technologies became more affordable and available. I started a lab at Arizona State University in 1996 called PRISM (Partnership for Research in Spatial Modeling) that had one of the earliest 3D printers (RP) utilising a very BETA inkjet droplet technology. A year later we took delivery of an early Stratasys machine using fused deposition modelling.

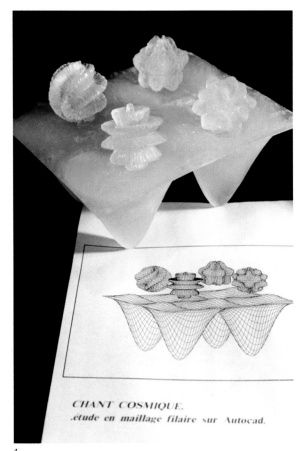

2

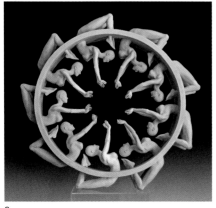

CHANT COSMIQUE.
étude en maillage filaire sur Autocad.

1

1 Christian Lavigne,
'Chant Cosmique', 1994.
Stereolithographic print. ©
Christian Lavigne.

2 Mary Visser, 'Circle of
Life', 2011.
© Mary Visser.

3 Bram Geenen, 'Gaudi chair', c.
2010. Laser sintered nylon.
© Freedom of Creation. All rights
reserved by Freedom of Creation,
image courtesy Freedom of
Creation.

The French artist Christian Lavigne created the first French stereolithographic print in 1994 and around the same time founded 'Ars Mathmatetica' in conjuction with Alexandre Vitkine and the American visual artist Mary Visser.[44] Lavigne outlined the origins of this:

Our non-profit association, Ars Mathematica, was founded 20 years ago, and we have accumulated considerable knowledge on techniques and artists of this new discipline, 'Cybersculpture'. We organized the first worldwide computer sculpture exhibition in 1993 at the Ecole Polytechnique in Paris, and then the exhibition became the biennial 'Intersculpt'. Personally, I started to use the computer in art at the beginning of the 1980s, and I first used a CNC machine in 1985. In 1994, I materialized the first digital sculpture in France, with the help of the Ecole Centrale Paris and the Association Française de Prototypage Rapide.

Originally, the sculpture (entitled 'Chant Cosmique') was planned to be built in 1990 with the RP process invented in Nancy by the Pr. Jean-Claude Andre. It's important to know that the sterolithography process was simultaneously invented and patented first in France and then in the USA.

Professor Mary Visser teaches sculpture and computer imaging at Southwestern University in Georgetown, Texas. She organized one of the first juried national digital art exhibitions for the Brown Symposium in the early 1980s. Visser received a Mundy Fellowship for rapid prototyping in 2002 where she completed a Partnership in Stereo Modeling with PRISM Labs, Inc. at Arizona State University. She was one of the curators for the International Rapid Prototyping Sculpture exhibition touring since 2003. Most recently she received a Cullen grant to work with Accelerated Technologies to produce large-

scale rapid prototyped works of her sculptures in polycarbonate and bronze materials.

Other significant early art pioneers include Alexandre Vitkine, Stewart Dickson, Michael Rees who is Associate Professor of Sculpture and Digital Media at William Paterson University, New Jersey and Keith Brown (see case study in Chapter 4) who is Professor of Sculpture and Digital Technologies at Manchester School of Art, Manchester Metropolitan University, UK. These artists are the earliest pioneers I have found in the course of researching this book and I apologise to any I may have missed. I do not feel it is my place, or is it particularly relevant to this book to create a complete list of all the artists who have filled the gap between the late 1990s and 2012. This list would probably run to hundreds of names and could only be viewed subjectively. I feel the case studies, correspondence and interviews have filled the gap and supplied some context.

Now that we have reached the second decade of the twenty-first century, there is little doubt that 3D printing processes have gained a much wider user base within the visual arts. A series of processes are now used in differing ways, dependent primarily on discipline and, to a lesser extent, on the manner in which individuals interface with the technology. I have interviewed artists, makers, designers and animators amongst others – based on this evidence. All have a particular view of the technology, but there is much common ground. Generally, most are somewhat frustrated that the technology does not produce an article with the material properties they

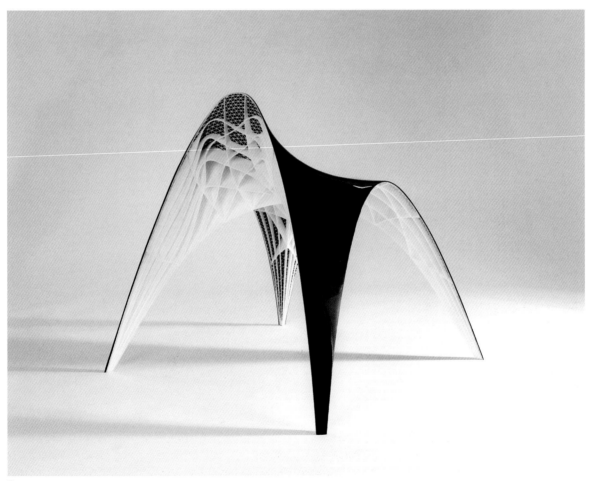

3

would desire, and many are concerned that the right materials are not even available.

An increasing number of artists and designers is happy with the results they get. In the design field Freedom of Creation are a company that makes and sells furniture printed in nylon and carbon fibre; Marrianne Forrest makes and sells watches printed in titanium; Jonathan Keep prints ceramics on his self-built 3D printing kit; and the sculptor Tom Lomax exhibits and sells printed sculpture that uses a plaster material printed in colour. The ability to print in 3D has come a long way in the last ten years and there is a new history yet to be told of the developments which will occur in the next ten years.

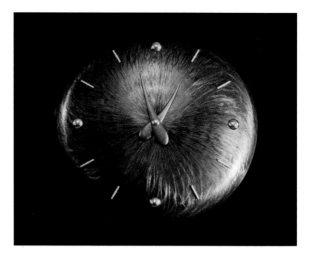

Marianne Forrest, 'Sargasso' wall piece. © M. Forrest.

1 Mason, C. ed., (2008) *A Computer in the Art Room: The Origins of British Computerarts 1950-80*, Norfolk: JJG Publishing Hindrigham.
2 Beaman, Joseph J., (2001) *Solid Free Form Fabrication: An Historical Perspective,* Solid Free Form Fabrication Symposium Proceedings 2001, University of Texas, Austin, Texas, USA.
3 Studio Unfold (2012) Stratigraphic Porcelain series. Available from www.unfold.be.
4 Keep, Jonathan, (2012) 'The form is the code', Towards a New Ceramic Future Symposium, Victoria and Albert Museum, London, January 2012. Available from: http://www.uwe.ac.uk/sca/research/cfpr/research/3D/research_projects/towards_a_new_ceramic_future.html.
5 Walters, P., (2012) 'Ceramic 3D Printing – A Design Case Study', Towards a New Ceramic Future Symposium, Victoria and Albert Museum, London January 2012. Available from: http://www.uwe.ac.uk/sca/research/cfpr/research/3D/research_projects/towards_a_new_ceramic_future.html.
6 Beaman, J. et al., (1997) *Solid Free Form Fabrication A New Direction in Manufacturing*, USA: Kluwer Academic Publishers.
7 Watt, James, (2012) Sculpture copying machine, Science Museum Website. Available from: http://www.sciencemuseum.org.uk/visitmuseum/galleries/watts_workshop.aspx and http://www.sciencemuseum.org.uk/objects/watt/1924-792.aspx.
8 Cheverton, Shrewsbury, J.C. and Burton, A., (2012) *Benjamin Cheverton (1794–1876) in the Thomson Collection: Artist in Ivory*. London: Paul Holberton Publishing.
9 Roberts, Helene E., (1995) *Art history through the Camera's Lens*, UK: Routledge. p. 63.
10 Walters, P. and Thirkell, P., (2007) 'New Technologies for 3Ds realization in art and design practice', *Artifact*. 1 (4), pp. 232–45.
11 Willeme, F., (1864) *Photo-sculpture*. Patent specification no. 43822. United States Patent Office, filing date 9 August 1864.
12 Baese, C., (1904) *Photographic process for the reproduction of plastic objects*. Patent specification no. 774549. United States Patent Office, filing date 1904.
13 Newhall, B., (1958) 'Photosculpture. The reconstruction of Willème's ingenious technique', *IMAGE Journal of Photography and Motion Pictures of the George Eastman House*. (61), pp. 100–5.
14 Sobieszek, R.A., (1980) 'Sculpture as the Sum of its Profiles: François Willème and Photosculpture in France, 1859–1868'. *Art Bulletin*. (62), pp. 617-30. Available from: http://www.jstor.org/stable/3050057.
15 Hammond, A.K., (1989) 'Aesthetic Aspects of the Photomechanical Print' in: Weaver, M., ed. (1989) *British Photography in the Nineteenth Century: The Fine Art Tradition*, Cambridge: Cambridge University Press.
16 Fox Talbot, W.H., (1847) *Improvement in Photographic Pictures*. Patent Specification no. 5171. United States Patent Office, filing date 1847.
17 Crawford, W. (1979) *The Keepers of Light Morgan and Morgan*, New York: Morgan & Morgan, pp. 285-288.
18 Thomson, John, & Adolphe Smith [Headingley] (1877) 'Street Life of London', London: Samson Low, Marston, Searle & Rivington.
19 Ford, W.D. (1936) *Method of Producing Colored Designs on Ceramic Ware* Patent Specification no. 214770. United States Patent Office, 17 June 1936.
20 Ford, W.D. (1941). 'Application of Photography in Ceramics', *The Bulletin of the American Ceramic Society*. Volume 20 (1) January, 1941.

21 Johnson, T. (2004) *The Morris Ware, Tiles & Art of George Cartlidge*, Isle of Wight: MakingSpace Isle of Wight.
22 Baron Paul de Bourgoing (1827) *Patent for the Manufacture of Photo Lithopane*. France, filing date 1827.
23 MacDonald Reid, G., (1963) *Instant Sculpture*. Available from: http://www.britishpathe.com/video/instant-sculpture.
24 MacDonald Reid, G. (1957) *Robot Sculptor*. Available from: http://www.britishpathe.com/video/robot-sculptor.
25 Munz, O.J., (1956) *Photo-Glyph Recording*. Patent Specification no. 2,775,758. United States Patent Office, filing date 21 August 1956.
26 Pipes, Alan, (2001). *Production for Graphic Designers*, London: Lawrence King Publishing.
27 Bradshaw, S., Bowyer, A. and Haufe, P., (2010) 'The Intellectual Property Implications of Low-Cost 3D Printing', *SCRIPTed, A Journal of Law, Technology & Society*. 7:1 (5).
28 Coppel, S., Lullin, E. and Hamilton, R., (2002) *Richard Hamilton: Prints and Multiples 1939-2002*. Düsseldorf: Kunstmuseum Winterthur.
29 Hamilton, R., (2012) *Circumferential Sections*. Available from: http://www.fineart.ac.uk/works.php?imageid=cn_046.
30 Csuri, C., (2012) Available from: http://www.siggraph.org/artdesign/profile/csuri/index.html.
31 De Zeen, (2009) Available from: http://www.dezeen.com/2009/02/04/digital-explorers-discovery-at-metropolitan-works/.
32 Hull, C., (2011) '25 years of innovation 1986-2011', *The TCT Magazine*, (2), pp. 20.
33 Iris van Herpen, (2012) More information available from: http://www.irisvanherpen.com/.
34 Sterling, Bruce, (2012) Design Fiction: Neri Oxman, Imaginary Beings: Mythologies of the Not Yet". Available from: http://www.wired.com/beyond_the_beyond/2012/05/design-fiction-neri-oxman-imaginary-beings-mythologies-of-the-not-yet/.
35 Bourella, D. L., and J.J.Jr Beaman, M.C. Leub and D.W. Rosen, (2009) *A Brief History of Additive Manufacturing and the 2009 Roadmap for Additive Manufacturing: Looking Back and Looking Ahead*, RapidTech 2009: US–TURKEY Workshop on Rapid Technologies.
36 Kodama, H., (1981) 'Automatic method for fabricating a three-dimensional plastic model with photo-hardening polymer', *Review of Scientific Instruments* [online]. 52 (11), pp. 1770–3.
37 Herbert L. Fielding, H.L. and R.T. Ingwall, (1981) *Photopolymerizable Compositions used in Holograms*. Patent Specification no. 4588664. United States Patent Office, filing date 1981.
38 Deckard, C.R., (1991) *Method and Apparatus for Producing Parts by Selective Sintering*. Patent Specification no. 5017753. United States Patent Office, filing date 1991.
39 Housholder, R.F., (1981) *Moulding Process*. Patent Specification no. 4247508. United States Patent Office, filing date 1981.
40 Hull, Charles, W., (1984) *Apparatus for Production of Three-Dimensional Objects by Stereolithography*. Patent Specification no. 4575330. United States Patent Office, 8 August 1984.
41 Fujihata, Masaki. Personal correspondence by email, July 2012.
42 Terezakis, Peter. Personal correspondence, email July 2012.
43 Collins, Dan. Personal correspondence, email July 2012.
44 Lavigne, Christian and Mary Visser. Personal correspondernce, email July 2012.

An overview of current 3D printing technologies, what each offers and how they might develop in the future

This chapter discusses the technology available today, following the path from conception of idea through to printed completion. It covers both the software and devices required to create a virtual model; through to the types of hardware currently available within additive manufacturing processes (3D printing) required to create a printed physical output.

The market for 3D printing has diversified over the past 10 years with ever more companies and machines entering the market. Therefore, to the novice user it has become almost impossible to understand the subtle differences and nuances between the rival technologies and manufacturers. To add to the confusion there are also a number of different technologies that come under the umbrella of '3D printing' and a number of alternative terms that refer to the process. To try and make sense of the characteristics and differences, in this chapter I will assume no previous knowledge on the part of the reader.

Firstly, to explore the terms which define the field, the collective processes now defined as 3D printing began with stereo lithography, which quickly became known as rapid prototyping. This term became popular because the first commercially available machine used a laser cured or cross linked light-sensitive photo polymeric material to quickly make prototypes for the automotive, aerospace, medical engineering and industrial design industries. (The term 'rapid' is a relative term based upon the slow speed of the previous model making technologies.) Until recently rapid prototyping was a very apt descriptive term for the collection of processes that grew around the technology, as rapid prototyping was what these machines were designed and used for. The term became less relevant more recently as the processes began to be used in the manufacture of objects for end-user application rather than prototyping. Furthermore, in addition to speed (of which more later) the manufacturing process offered other benefits, but a new term was needed. The primary candidates that emerged were: Solid Free Form Fabrication, Rapid Manufacture, Additive Layer Manufacture (ALM) and 3D Printing.

Rapid manufacture does not accurately describe the process because, as we have said, it is far from rapid. However, it is quicker than, for example, 'tooling up' which is used in conventional manufacture. Solid free form fabrication is quite accurate but it is not a very descriptive term of what actually happens. This term is used because you can theoretically create a complex, free form object that is free from many of the constraints of traditional fabrication processes. (e.g. you no longer need to consider whether the object can be released from a mould, or whether a milling cutter can get around the object). Beaman coined the term Solid Free Form Fabrication and says in the preface to his book. "Solid Free Form Fabrication is a set of manufacturing processes that are capable of producing complex free form solid objects, directly from a computer model of an object without part specific tooling or knowledge."[1]

Additive layer manufacture (ALM) has gained a lot of ground because it is more accurate and descriptive of the actual process: all of the processes do manufacture the object by adding one layer of material on top of another. Finally 3D printing is gaining common parlance as, again, it is accurate and describes the processes well. It also has the additional benefit of relating to other parallel processes in the 2D digital print field, for example, inkjet printing and traditional processes such as lithography, which already enjoy a general understanding and common parlance. There is currently debate amongst American 3D printing circles that additive manufacturing should refer to the higher-cost machines and 3D printing to the lower cost machines and open source technology, but this view does not seem to be gaining credence in the rest of the world.

Fundamentally, the technology splits between the hardware and the available software. Or, to use a more traditional analogy of printing terms, it splits between capture/creation and output. If one continues the traditional print analogy, then 3D capture is equivalent to photography, creation is equivalent to drawing software tools (such as Adobe Illustrator) and the final output is the digital print. The only difference between traditional print and 3D printing is that we have an extra dimension, namely the z-axis or physical height. Scanning an object in 3D is the equivalent of photography – with all of its attendant problems post-capture. The same analogy can be used for drawing tools. Initially, artists using digital printing adopted Photoshop for wide-format printing or desktop inkjet printers as the default software option. As a range of other design technologies became available such as laser cutting and textile printing, artists began to expand their software armoury and vector-based CAD programs have become increasingly important. In this chapter I will briefly cover the types of scanning and current design technologies available. However, as this volume is primarily about the physical creation of the artefact I will leave a more detailed description of capture and 3D model creation to others. We do, however, need to have an overview of what is involved in 3D printing in order to understand the whole process from conception to completion.

The 3D printing process chain

Table viewed from a corner, with 3 legs visible. Illustration.
© Peter McCallion 2013.

To be able to print in 3D, you have to be able to think in 3D. This might sound like a simplistic statement, but it is the main thing that 'trips up' many people. To give an example, if one views a table from the corner where you can see only three legs, to be able to draw a table in three dimensions, you have to be aware that there is a fourth leg that is hidden from

your view, or the table will not stand up. There is little doubt that to be able to successfully create objects from scratch using a computer and to model your own designs, you have to be able to conceive and develop an understanding of the form and structure of what you will finally create. The easiest way of getting one's mind around this is to imagine creating your object within a transparent cube. The bottom left-hand front corner of the cube represents zero (0).

Object
(50,50,50)

z 50 units

z 50 units

y 50 units

x 50 units

Origin
(0,0,0)

How co-ordinates are set in a three-dimensional box for XYZ 3D spatial awareness.
Illustration © Peter McCallion 2013.

A numbered scale is then drawn from the bottom left front corner, to bottom right front corner, across the cube from 0 to 100. This is the x-axis. Imagine another numbered scale from the bottom left corner to the back left hand corner at the bottom, front to back, from 0 to 100. This is the y-axis. Finally think of a numbered scale from the bottom left front corner to the top left front corner, from 0 to 100, and you have the z-axis. These three scales will always refer back to the same point (0). Any point on an object drawn within this cube can be assigned a number from each of the scales, so a point at the dead centre of the cube would have the reference x-axis 50, y-axis 50,

z-axis 50. Therefore it is possible to draw any object within the cube and all points on the object will have a set of mathematical coordinates that can easily be digitised. Once we have a means of recording the coordinates and digitising them it is then possible to go forward and create a model or virtual object.

In order to create the model or virtual object, unless one is a highly sophisticated programer, one has to create it within a software package. This is usually achieved by using CAD drawing software, which is made up of a number of different options that depend primarily upon its industrial and commercial function. The basics include 2D drawing packages such as Illustrator, Corel Draw and Autocad. The backbone of the industry is the engineering-based 3D solid modelling software such as Pro/Engineer, SolidWorks and Pro/Desktop. The software favoured by most artists and visually-oriented designers begins with 3D surface modelling CAD software. Examples include Rhino or Alias Studio Tools. Additionally, are a number of free 'open source' software options – the common ones being Google SketchUp, and Blender. Unfortunately, 3D drawing packages themselves represent one of the entry barriers to 3D printing, as there is a relatively steep learning curve and a requirement from the user to be able to think in 3D and extrapolate in their minds what the 3D object will look and feel like (form and function) when printed. The latest open source software available include Tinkercad, Autodesk 123D and 3DTin, which do have the advantage of being able to output the file in STL format. However, some of these open source solutions do not always transcribe well to the STL formats needed for 3D printing, and therefore can be a problem when it comes to creating files that have to be transcribed into the next set of software up the chain in order to produce physical parts. Moreover, a program like Tinkercad is a web-based software so will run on any platform – whereas 3DTin will only run in your browser and Autodesk 123D is Windows only. Plus 3D animation software e.g. Maya, 3D Max etc. are designed for virtual modelling but they only create surfaces – not solids – which have to be transcribed into another package to be able to create watertight images that will not fall apart when 3D printed.

Scanning

The other alternatives to modelling the design are to use a scanner or haptic arm. A 3D scanner will create a 'point cloud', which maps the surface being scanned and the point cloud is then triangulated i.e. turned into a mesh of triangles by the software.

Often scanners will only scan a section of the object to be scanned, and then each subsequent section has to be stitched to the previous scan. Finally, the whole scan has to be cleaned up to make sure the model does not have overlapping triangles and that there are no holes in the triangular mesh that has been created. If these remain then the scanned object will not transcribe to a 3D model without falling apart, or it simply won't print when the file is finally sent to the printer.

The cleaned up scanned file then has to be converted into a suitable file for 3D printing. This is not necessarily straightforward, because often all you have is a single layer of a surface map set of triangles, with no wall thickness or substance, so it is necessary to create a wall or thickness to the object before it can be printed. Practically, it is seldom a good idea to create a completely solid object, for several reasons, primarily cost – why waste material? Software such as Geomagic allows solid objects to be made hollow by adding a wall thickness. Secondly, the weight of the object and the structural integrity is not necessarily any better if solid. To overcome this, the scans have to be imported into a mesh-fixing software such as Magics which will fill in the gaps in the mesh – and resolve other problems such as intersecting triangles. Then the file would typically be imported into Geomagic or similar mesh-editing software to add the wall thickness. Finally, the file can be sent to the printer software to be rendered into slices for printing.

1

2

3

4

1 Point Cloud capture from a Z Corp Scanner viewed in Geomagics software. © CFPR Archive.

2 Image capture converted to polygon mesh in Geomagics software. © CFPR Archive.

3 Screen shot of Paul Sandameer's head, using Z Corp scanner. Several scans have to be stitched together to create a full image. © CFPR Archive.

4 Brendan Reid scanning Paul Sandameer using a Z Scanner 750. Photographed by Dr Peter Walters © CFPR Archive.

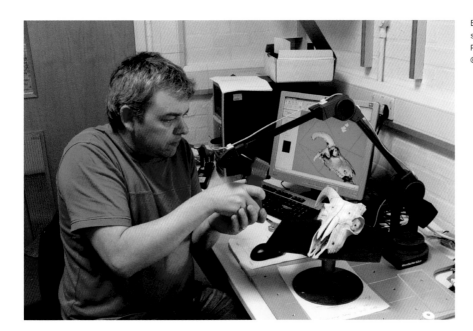

Scanners come in several forms. The simplest is known as a contact scanner, such as the Micro-Scribe, which is an articulated arm on a fixed base. The object is placed upon the base and a pointer at the end of the arm is brought into contact with the object to be scanned. The scanner works by referencing the point on the object that the arm is touching to an XYZ zero reference, thus plotting each point of contact. As the arm is moved over the surface the points of contact are plotted to create the surface model. The advantage of this process is its accuracy, the disadvantages are that it is slow and because it touches the surface of the object as it scans, this can be invasive to the object being scanned. For instance, if a museum artefact is being scanned then it may not be possible to touch the surface due to its rarity, fragility or value.

By contrast hand-held laser scanners such as the Z Corp or the Handyscan tend to work by triangulation. A laser dot or line is projected onto the object to be scanned and a sensor, (typically a charged couple device (CCD), which is a light sensor for capturing data, commonly found in digital cameras) measures the distance to the surface, by 'time of flight' or measures how the laser line is deformed as it follows the surface of the object. This measurement, coupled with a series of reference dots, allows the device to

orient itself in relation to an XYZ zero point reference. The dots enable the various multiple scans necessary to be stitched together to capture a complete object. However, these scanners are not always very good at dealing with reflective surfaces and objects with sharp edges because of the nature of capturing the data with a laser. A structured light scanner such as those made by GOM (*Gesellschaft für Optische Messtechnik*) projects a pattern of light onto a subject and then looks at the deformation of this pattern on the subject. This may be achieved either by a single line or by a mesh of lines or triangles projected to the surface and then captured. Structured light is a very accurate and fast way of capturing surface detail, as the scanner records a large amount of data at any one time. Some of these scanners can capture all of the necessary data in real time.

The other means of creating a 3D model is through a haptic arm. A haptic arm is a force feedback device, which attempts to recreate the sensation – the look and feel – of physically sculpting an object. It does this by recreating the sensation of interacting with the physical object, adding and subtracting (or pushing and pulling) virtual material using a tool. The haptic arm in some senses falls between a scanning and a drawing program, in that it creates a representation of the surface in relation

to the pressure you apply – somewhat like a three-dimensional mouse that returns a feeling to the hand as you are drawing or sculpting.

Once the 3D model has been created, either by modelling or scanning, it has to be converted into a format that the 3D printer driver software can read. This usually means transferring the file into a polygon mesh file (.STL), which is then sliced by the 3D printer driver software. Most of the software programs discussed in this chapter will transcribe the 3D model file to STL format. The standard software supplied with the 3D printer will then slice the STL file and generate the necessary code to control the 3D printer hardware in order to build the object. Having covered a wide range of the technical and software issues surrounding 3D printing an object it is now a good point to return to the history of 3D printing.

The influential Wolhers report[2] quantifies both the size of the 3D printing industry and its developments. The report is presented annually by Terry Wolhers to the industry at the 3D 'RAPID' conference and trade fair. In the most recent report (2012) Wolhers reported the industry had grown 24.1% in 2010 and was worth over US$ 1.714 billion (£1.08 billion). In 2007 Wolhers[3] produced a history of additive fabrication. Updates are regularly available. I will summarise the main points of this history in terms of technical machinery development, and as a complementary view to Beaman and the history discussed in Chapter 1.[4] Wohlers is perhaps more comprehensible as the report lists the date of introduction of each new commercial advance and machinery introduction, rather than presenting a timeline of patent filing. I have summarised these developments below, selecting those developments I feel are important to understand how we reached the current proliferation of machines.

TIMELINE OF 3D MACHINE DEVELOPMENT

Charles Hull's 3D Systems commercialise first stereo lithographic machine SLA1 solidifying thin layers of ultraviolet (UV) light-sensitive polymer using a laser

Sony/D-Mec produce version of stereo lithography

Three fundamental technologies are introduced:

1 FDM (fused deposition modelling) by Stratasys, extrudes a holt melted plastic in a thin bead to produce parts layer-by-layer as opposed to solidifying parts by laser which was the method of previous systems.

2 Helisys create LOM (layered object manufacture). In the Helisys process the paper was unrolled and then glued and cut one layer at a time.

3 Cubital produce SGC, (solid ground curing) where the whole layer was flashed with UV light to harden the polymer through a series of stencil masks created by electrostatic toner on a plate.

1987 — 1988 — 1989 — 1990 — 1991 — 1992 — 1993

Japan's NTT Data CMET Inc. commercialise a version of stereo lithography.

Electro Optical Systems (EOS) in Germany sell first rapid prototype system.

DTM introduce SLS (selective laser sintering) the heat from a laser fuses together a powder, such as nylon.

Soligen commercialise direct shell production casting, based on Massachusetts Institute of Technology (MIT) patents for ink jetting a liquid binder onto ceramic powder to form shells used in the investment casting process – fundamentally the same technology used by Z Corp and Voxeljet.

1, 2, 3 slicing an image into a 3D printable file ©
Peter McCallion 2012

Solidscape introduce
the wax printer using
an inkjet head to
deposit the wax.
Aimed at lost wax
and investment metal
casting e.g. jewellery,
dental applications.

AeroMet launch
LAM (Laser Additive
Manufacture) using
a high-power laser to
fuse powdered titanium
alloys. This is the first
company to introduce a
3D metal printer.

Envision Tech
launch their
Perfactory machine
using DL (digital
light processing)
technology using
a photopolymer
hardened one
complete layer at a
time.

2006 EOS
introduce laser
sintered cobalt
chrome and
stainless steel.

Since 2007 most of
the developments
and patents in the
industry have not been
in the area of new
processes or machinery
developments but are
concerned with improving
materials. Conversely,
there have been very
fast developments at
the very low end of the
market where there are
now over 50 vendors
offering machines that
are based on variants
of the basic RepRap
principle developed by
Dr Adrian Bowyer at
the University of Bath.
Popular examples include
MakerBot, Mendel, and
Bits from Bytes.

1994 **1996** **1997** **2000** **2001** **2002** **2006** **2007**

Z Corp is
launched using
MIT powder-
binder inkjet
technology.

Objet is launched in
Israel with an inkjet
printer that deposits
and hardens a
photopolymer with a
UV light source.

Z Corp introduce the
world's first commercially
available multiple colour
3D 510 printer.

EOS introduce first laser
sintered steel-based
powder machine.

Z Corp introduce
450 colour powder
machine with
automated removal
and recycling of
powder. This is
the first enclosed
machine meaning that
a finished item can be
retrieved at the end of
the process.

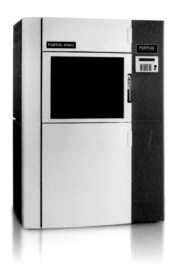
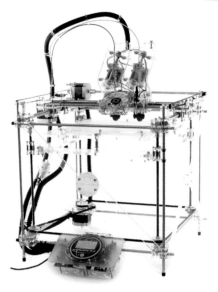

ProJet HD Plus SLA machine from 3D Systems.

Fortus 400 model, Stratasys machine.

Rapman from 3D systems, Bits from Bytes.

The current additive manufacturing processes

I shall attempt to cover those technologies and machines that I am aware are currently available and were on the market in 2012. This is not an exhaustive list by any means. I have covered only those developments that introduce a new process or a means of manufacturing 3D print.

Stereo lithography (SLA)

SLA machines are manufactured by 3D Systems. The original technological process as described in the first 1984 patent[5] consists of a liquid photopolymeric emulsion in a bath with a platform that sinks (or descends) through the bath, one layer at a time.

The process begins with the platform positioned just below the surface of the polymeric emulsion. The first layer of the object to be built is drawn onto the surface of the emulsion by the light from the UV laser, curing and hardening the layer by cross-linking the photo polymeric emulsion, which becomes solid when exposed to the light from a laser. Once the first layer is complete, then the platform is lowered and

the process repeats for the second layer, and then the whole process repeats again for each subsequent layer, until the object has been fully built. Then the platform is raised to the start position and the finished object can be removed and cleaned. Stereo lithography requires the use of support structures to aid the build, and to prevent some parts falling over or distorting during the build process. These support structures are built as part of the printing process in the same material as the part and are removed after the part has been built.

Fused deposition modelling (FDM)

FDM Machines are manufactured by Stratasys, Hewlett Packard, Makerbot, UP, Bits from Bytes, A1 Technologies and others. FDM is the most common 3D print process, partly because the original patents have now run out and partly due to the work of Dr Adrian Bowyer at Bath University (the developer of the RepRap, a self-replicating 3D printer – which is capable of self-replicating some of its parts). Dr Bowyer made the plans for the manufacture of the RepRap available as open source, therefore generating a whole new community of self-build 3D printing fabricators. In essence, the FDM process, originally patented by

MakerBot Replicator from MakerBot Up from Up 3D touch 3D systems

Stratasys in 1992,[6] is very simple. An XYZ platform, in itself the basis of all 3D printing, with the addition of a heated head, deposits a thin strand of melted plastic, one layer at a time. To use a simple analogy, we return to the coil pot – except this version is plastic. Whilst many simple models can be built with no support material, if a model contains an overhang then either a support material from a second deposition head has to be used or a support has to be built using the standard build material, which can be snapped off the finished model. FDM printers will use a variety of thermoplastic build materials including ABS (acrylonitrile-butadiene-styrene) Polycarbonates and PPSU (Polyphenylsulfone) PLA biopolymer (Polylactic Acid).

The technology is divided between the cheapest printers which are all in the £1000 to £3000 price range and made by RapMan, MakerBot, the Chinese company UP, A1 Technologies, Cube and Bits from Bytes (the last two machines are now both owned by the largest global 3D print company 3D Systems). Most of these printers are based on Adrian Bowyer's RepRap open source hardware. These machines have the advantage of being cheap and have readily available user groups and online support. The downside is that they frequently come as a self-build kit, with the result that the machines are temperamental and often difficult to program and run. The standard software available for running these machines is an open source program called Skienforge. This program translates an STL file from Rhino (or an open source program such as Blender) into G Code, or machine code, which are the commands that the 3D printer understands.

However, as mentioned earlier, the open source nature of the software can also be a barrier to entry. Because everything is available for you to change and alter at will – from the rate of extruding the heated molten material, the temperature of the head, to the speed of travel across the x and y-axis and the thickness of the z-build – it can be very difficult to work out what to change in order to correct a problem or even to get the machine working in the first place. The advantage of the majority of the proprietary software available with the more expensive machines is that it is locked up with a simple visual interface which is not available to the user, so that as many problems as possible are resolved and not presented as options to the user to try to change. This makes the open source machines great research tools (giving you the ability to change everything) but poor workhorses, if all you want to do is to produce parts.

The low cost of these types of open source platforms has also created a space for increased innovation of 3D hardware technology. The ability to buy a XYZ platform with the software and stepper motors to drive it for less than £750 (US$1000) such as the Bits from Bytes Rapman self-assembly kit (£750), means that small hobby, research and 'geek' (or 'technology hobbyist') users have already made multiple adaptations to the technology. There are many online open source examples where users have adapted the machines by taking the FDM head away and replacing it with a pressurised syringe system. This allows a much greater range of materials to be printed in paste form, from ceramics to food. Some good examples of this can be seen in the work of Unfold in Belgium, Exeter University and CFPR at UWE, Bristol in the UK.

The more expensive commercial FDM machines such as the Stratasys and Hewlett Packard (HP) are perhaps the closest to what might become an office-based printer. HP are particularly close to achieving this with the Designjet 3D printer, which has an additional enclosed support washing system. Parts can be built and cleaned with the minimum of direct user handling – the user only has to transfer the parts on a build tray from the 3D printer to the support cleaning station. This machine exemplifies the HP philosophy of creating user-friendly office hardware, with minimum of learning curve and, contrary to the above scenario of open source FDM printers, a completely locked system so that the user can make the minimum of alterations to the machine and therefore easily obtain finished parts with the minimum of fuss.

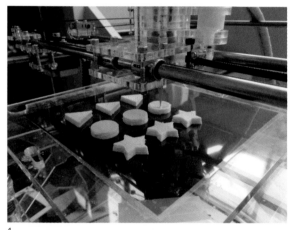

1

3

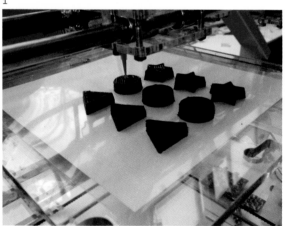

2

1 White vanilla icing printed by Peter Walters at CFPR. ©Peter Walters. Photograph David Huson, February 2013.

2 Chocolate fudge printed by Peter Walters at CFPR. © Peter Walters. Photograph David Huson February 2013.

3 Mcor machine. Samples printed on the Matrix 300 3D printer, manufactured by Mcor Technologies Ltd, www.mcortechnologies.com.

5

4 Samples printed on the Matrix 300 3D printer, manufactured by Mcor Technologies Ltd, www.mcortechnologies.com

5 Z Corp 510 colour print machine at CFPR labs, Bristol.

4

LOM (layered object manufacture)

This is one of the earliest 3D printing technologies, which was initially developed by Helysis Inc. in the United States, who manufactured the first production machine in 1991.[7] The early machines used a roll of paper that was rolled out, glued and laser cut for each layer. MCOR is the current incarnation of the process. The MCOR process uses single sheets of standard office A4 paper, which creates each individual layer; each sheet is glued to the layer below then cut one at a time with a knife, to slowly build the model. The printed model is then cracked free from the final stack of paper. This process has two advantages. First of all the paper acts as both the build material and support material and secondly, paper is a very cheap build material, therefore, although the initial cost of the machine is quite high, the cost of building parts is comparatively cheap. MCOR have recently offered a leasing option that includes all maintenance and materials to try and launch the technology into the higher education and Small and Medium Enterprise (SME) markets. MCOR recently demonstrated a printed colour process, that first prints a stack of A4 paper using a 2D printing process with a 3D

photographic image. The image is split into layers and then each layer is printed through a standard colour laser printer one layer at a time. The stack of paper is then fed into the 3D printer and printed, glued and cut. The resulting 3D print comprises a full colour, laser printed, paper 3D model. The results are very impressive given the low cost of the base material but at the time of going to press a costing for the colour print element was not available.

Powder binder 3D printing

Powder binder 3D printers are manufactured by Z Corp and Voxeljet. Invented at MIT[8] in the early 1990s, this process uses a plaster-based composite powder material in a bin, with a base that slowly drops one layer at a time as the object is built. A parallel feed bin full of new powder sits beside the build bed, and rises up to present new powder as the build bed drops. The object is built by ink jetting a binder into the build bed one layer at a time. As the bed drops after each layer, a new layer is rolled on from the feed bin. To create a solid object the inkjet binder causes a reaction with the plaster-based powder material and it hardens, thus creating

a solid object. When printing is finished the build bed is raised and the finished object is removed from the surrounding powder. The advantage of this process is that it again does not require a separate support material, as the object is supported in the bed by the surrounding powder, which can be reclaimed and used again for a fresh build.

The other advantage of this process is that it is possible to print in colour. In a multi-colour machine the single monochrome inkjet head is replaced with a four or five colour head, which prints either CMY or CMYK coloured binders as well as clear binder, thus creating an object that has a three-dimensional coloured surface to the printed part. Currently Z Corp machines

are viewed by some elements of the engineering community to be lacking in accuracy and part strength and incapable of meeting the necessary production tolerances. However, this is to be expected as they were never designed to be used by the engineering community. They are widely used in industrial design for concept modelling and in the ceramic and footwear industries as prototype design tools. They are used in the ceramic industry because the Z Corp machines produce concept models in white plaster, which is the same material the ceramic industry has traditionally used for its concept models from which they create plaster moulds. The advantage of 3D printing a concept model is that can be manufactured in a

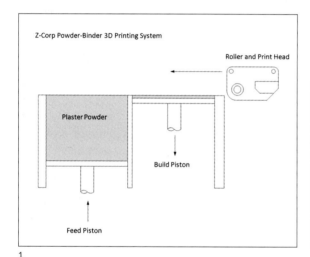

1

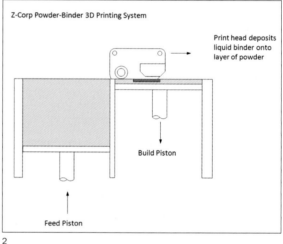

2

Z-Corp Powder-Binder 3D Printing System

Build completed

Feed Piston

Build Piston

3

1,2,3 Diagram showing how a powder binder printer deposits layers of powder and inkjets the object.

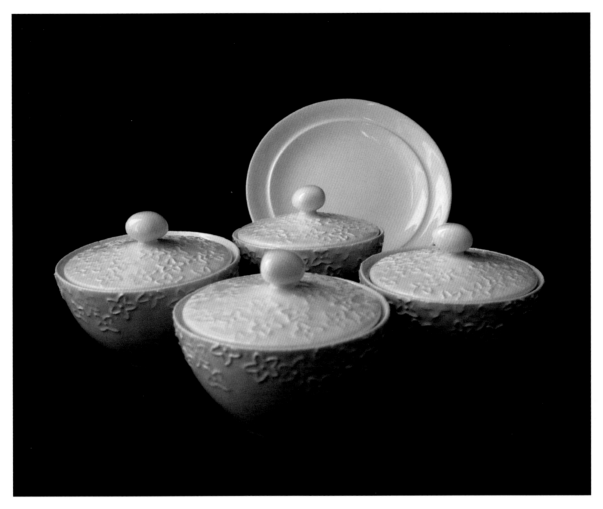

Ceramic-printed sugar bowl, designed by Denby Potteries and printed at CFPR. © CFPR Archive.

matter of hours, to handcraft a plaster model takes weeks, so the Z Corp technology is a natural choice. The footwear industry uses the Z Corp because they can print a design model in colour close to the final colours that will be used in the shoe.

Recently, the animation industry has taken to the Z Corp technology. LAIKA Digital in Portland, Oregon, US have just created all of the face parts for their new stop motion animation film 'Paranorman' using a Full colour Z Corp Z650 machine.[9] Because Z Corp technology is based on a plaster powder system and has therefore been taken up by the ceramic industry, many groups have undertaken research to use this technology for developing ceramic 3D printing,

including the original inventors of the process Yoo and Cima at MIT[10] who included the potential for this in their original patents. Mark Ganter at Washington State University, in Seattle, USA[11] has developed a system using ceramic powder and alcohol, to produce a low-cost material for his engineering students. John Balistreri – a practising potter at Bowling Green University, Utah, USA[12] – has developed a ceramic powder system over several years of research. The authors S. Hoskins and David Huson have also developed a patented system at the University of the West of England, Bristol[13] that has been successfully trialled in collaboration with the commercial ceramic company, Denby Potteries.

1

2

Voxeljet is another powder deposition system. Whilst Voxeljet is based on an inkjet system licensed from the original MIT patents, contrary to the Z Corp system, it uses a solvent-based binder combined with either a polymer powder or foundry casting material. Furthermore, because of the solvent binder and the large size (4 x 2 x 1 metres) of the printing bed Voxeljet is used mainly in the casting industry.

Manufactured by EOS in Germany, selective laser sintered powder is based on technology patented at the University of Texas,[14] which was further developed by the DTM Corporation who produced a production machine in 1992. The Fraunhofer Institute licensed the German research to EOS. A bed of powdered thermoplastic material is fused by a CO_2 laser, one layer at a time, with a new layer of powder pushed by a roller onto the build bed to create each new layer and at the same time supporting the built object in the powder bed. The most common of the SLS machines are manufactured by EOS and these machines produce the most robust functional and near industry ready parts in nylon. Some product designers such as Assa Ashuach use EOS technology for the manufacture of mass customised production items that need minimal finishing and are directly printed and available for sale.

1 Voxeljet VX4000. Note the build area of 4 x 2 x 1 m, which is the largest build area of any 3D production machine.

2 Eosint P800 laser sintered nylon machine by EOS.

3 MTT/Renishaw SLM 250 laser sintered titanium machine by Renishaw.

4 Detail of EnvisionTEC Perfactory Machine, opened to show a printed part.

Laser sintered titanium, stainless steel, cobalt, chrome and gold

Direct metal laser sintering (DMLS) machines are manufactured by EOS and MTT. This process is similar to the selective laser sintering technology but a fine metal powder is used instead of nylon. The model is built layer-by-layer in the same manner as the SLS machines. The powder is sintered and solidified by a laser beam that moves over each layer. After each layer is sintered a new layer of powder is applied in the same manner. However, unlike in polymer powder SLS, in metal DMLS support structures are necessary to keep the model structurally sound and supported during the build to cope with overhangs and thin walls. This system is capable of sintering a number of metals, most commonly titanium or steel, but silver and most recently gold can also be used in this process. Frank Cooper from the Jewellery Industry Innovation Centre at Birmingham City University, UK, recently explained that given the ever-increasing price of gold, to be able to create a gold ring with this technology allows jewellers to print the ring with a hollow internal structure and a series of ribbed supporting walls. In essence, Cooper can create a ring that to all intents and purposes looks like any other gold ring, except it is 70% lighter – using less than a third of the gold necessary for a solid ring – with a very significant cost reduction.

One of the problems of the process, one particularly common to artists and creative users, is that the metal support structures most commonly used have to be removed manually. Not only does this mean lots of finishing, but metal is very hard and takes a great deal of time to remove and clean up the parts.

Digital light processing

The digital light processing-based 3D printer is manufactured by Envision Tech. This process works by projecting a silhouette image of each layer onto a photo-polymeric material. This is an extremely accurate technology for producing small parts with good surface finish, as the build layer thickness is very small. It has been taken up by the hearing aid industry extensively, as it can make custom parts to fit individual ear shapes in a flesh-coloured material. Interestingly, this ability to print in a flesh-coloured material has made the Envision Tech the machine of choice for some parts of the stop motion animation industry and it was used by Aardman Animations for the 2012 film 'Pirates'.[15] Aardman ran two machines nonstop during filming to print over 500,000 different parts. Aardman also made the YouTube video 'Dot' for Nokia, which featured the smallest ever stop motion character.[16] The advantage of this technology is that it exposes an entire layer at a time making the process fast and accurate for small-scale parts.

3

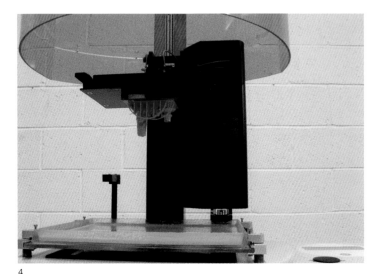

4

1,2 Objet Connex
Machine and
two-colour output.

1

2

UV cured photo-polymeric inkjet deposition

The UV cured photo-polymeric inkjet deposition process is manufactured by Objet. Objet grew as a company out of the Israeli inkjet company Scitex. Scitex created the groundbreaking 'Iris printer' – a continuous inkjet technology – in the late 1980s and early 1990s and it revolutionised the inkjet market for artists and without which there would have been no Epson or HP wide-format printers. The Objet technology draws on this experience and has created a very accurate process that uses a combination of inkjet technology and UV curing. A photo polymeric material is ink jetted onto a bed, which is then cured with UV light one layer at a time. The Objet system creates very accurate parts that have a high quality surface finish. Until recently the Objet offered the choice of either a hard material or a soft flexible material. Most recently they have launched a new material technology called Connex, which combines hard and soft materials. offering users the ability to print a range of flexibilities and different levels of hardness all in the same 3D-printed part. The Objet system prints a support structure in uncured resin, which surrounds the object during the printing process and is then washed away after printing. Once the support structure has been washed away, you are left with a finely detailed finished part. Due to its detail and ability to print fine layers and smooth surfaces without visual stepping, Objet was the 3D printing technology that was used in the first 3D-printed stop motion feature film, 'Coraline', made by LAIKA Rapid Prototyping department in Portland, Oregon, 2009.[17]

Most recent developments

Within the last two years there has been much consolidation in the marketplace and several large companies have either acquired smaller companies or partnered with smaller rivals. In the UK Renishaw, the manufacturer of high-end measuring equipment, bought MTT. MTT manufacture laser sintered metal machines, which are mainly used in the medical, engineering and dental markets. Objet has now merged with Stratasys. 3D Systems has been the most aggressive in this respect, buying the UK company Bits from Bytes, and Z Corp. This makes 3D Systems by far and away the biggest player in the marketplace and they now cover a large spread of the different 3D printing technologies.

However, a parallel expansion in the market has occurred in the area of the low-cost open source technologies, specifically in the arena of the low-cost printer market. It was noted in the recent 2012 Wohlers Report,[18] that at the 2012 'Maker Faire' there were 53 separate companies selling a version of the low-cost open source hardware machines based on the RepRap and Makerbot. On their website 3Ders.org listed 49 companies selling DIY printers in August 2012. Back in 2006 the cheapest machine readily available to buy for a new entrant was in the region of £15,000 or US$ 20,000. It is now possible to buy a machine for less than £1,000 pounds. It might require a great deal of patience, skill and endurance to produce anything of any worth from such a low-cost machine, but it does give you an idea of the rapidly changing nature of the market.

Bureau services

Many people predict that one of the future directions of 3D printing will be through the continued expansion of bureau services. Bureau services have played a vital role since the early days of rapid prototyping. However, more recently the presence of Internet-based bureaus such as Shapeways and iMaterialise have given these companies access to a wider customer base and have enabled them to dominate the market. It is already possible to send a file over the Internet to a central service whose printers are situated throughout the world and within a few days receive the complete and finished 3D-printed part through the post. The parts can be in any number of materials from full-coloured plaster, various forms of plastic and nylon – to ceramic, titanium, steel and silver.

It is becoming increasingly popular for artists and designers to use a bureau service to produce their work, and for good reason. There are no capital costs involved, no machinery to maintain and no constant need to upgrade to new technology whenever a new machine comes out. Recently, due to economies of scale and buying power, it almost costs the same to send a part to a bureau service as it does for an owner of a single machine to buy the materials in to run it. In fact, if one factors in depreciation and the cost of wasted materials, it is definitely cheaper to use a good bureau service than to run the machinery yourself. However, one must bear in mind that these services place severe restrictions on what they will print. For example, they will not accept files if walls are too thin nor will they produce delicate parts that may break in the manufacture or when removing the parts from machine and cleaning up. These services need to be able to turn parts around quickly, although it is possible to find services that will take the time and trouble over difficult parts, but at a cost!

On their website, the industry forum *Rapid Today* lists over 600 3D print service suppliers throughout the world. Nearly all of these services serve the industrial and engineering sectors, some of whom serve designers and architects. In England alone it lists nearly 50 3D print services and there are several more not listed. Therefore I will try and document only those bureaus and centres that have at least some previous experience of working with artists and have made a contribution to the field in terms of pushing the boundaries of arts practice or being a central location where arts practice may be found. A more comprehensive list of available services may be found from the *Rapid Today* website.[19] Therefore, let's call this list the primary players from a UK perspective.

Shapeways

Shapeways was started by Peter Weijmarshausen within the lifestyle incubator of Phillips in Eindhoven, Holland in 2008. In 2010, venture capitalists Union Square'[20] and Index Ventures financed a move to New York, where Shapeways has grown into the largest global 3D printing service. According to a recent *Forbes* article: "Shapeways has built the world's largest marketplace for 3D printable objects and makes thousands of unique objects every day."[21]

Shapeways tends to be the port of call for smaller objects. They run a very accessible front end to their website, powered by software which will assess your CAD model automatically and inform you of its suitability for printing and the cost. Alongside their printing services Shapeways (in line with other similar bureaus) run an online shop service where you can buy designs from anyone who cares to post them on the site. Shapeways will then print and deliver the part for you. Currently, Shapeways has over 6,000 independent designers selling its own products and has printed over one million items since its inception. Shapeways features well-known 3D print designers and artists on its website such as Bathsheba Grossman, who makes mathematical art pieces, and Nervous System, who make generative work based around natural forms.

iMaterialise

iMaterialise specialises in working with artists and designers. It runs an online gallery service very similar to Shapeways but also deals with larger specialist artworks. For example, the service printed the recent Iris van Herpen catwalk collection 'Hybrid Holism'. iMaterialise also prints a wide range of materials, from plastics to ceramics and metals. iMaterialise

is part of the Belgium company Materialise (MGX) who are one of the largest players in the industry, developing 3D print software and serving the engineering, industrial design and medical industry sectors.[22]

3T RPD

3T RPD[23] is primarily a bureau for the engineering industry, including the aerospace automotive and defence sectors. However, it also works with designers, architects and artists. 3T RPD works with designers such as Lionel Dean, Assa Ashuach and Alexandra Deschaps-Sonsino in addition to working with artists such as Heather and Ivan Morison.

One example of 3T RPD printing for artists, is the installation 'Little Shining man,'[24] 3T RPD worked with Queen and Crawford Design studio to realise this work produced by artists Heather and Ivan Morison. The design of the structure is based around the tetrahedral kites of Alexander Graham Bell, which were then multiplied out into colliding cubes based on cubic formations of the mineral pyrites. Queen and Crawford designed a nylon joint system, which would

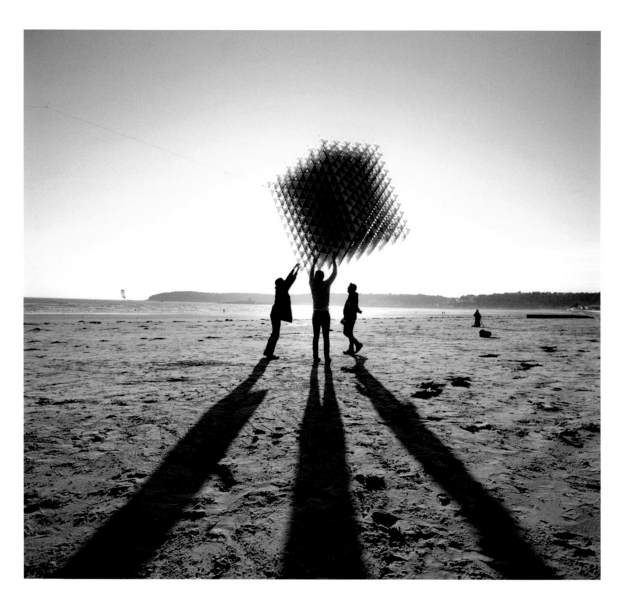

handle every connection in the composition. Working closely with 3T RPD in Newbury, the 6,000 individual joints were built using their SLS technology and printed in nylon.

The kites were then fabricated from carbon fibre rod and cuben fibre, a handmade composite fabric used primarily in racing yacht sails. This achieved the perfect combination of strength and weight. The visual impact of the fabric produced an ethereal sense of depth and refraction that gives the heavy mass the lightest touch.

The kite shown is one section of an arrangement of three that come together to create the final piece of sculpture that is suspended in an atrium at Castle Quay in St Hellier. It is taken down once a year to be flown on Millbrook Beach in St Aubin's Bay, Jersey. More than 23,000 individual components make up the complete structure.

Bureaus attached to academic institutions

Metropolitan Works

Metropolitan Works[25] is one of London's leading creative industries centres. They work with designers and manufacturers, develop ideas and bring new products to the marketplace through access to digital manufacturing, workshops, knowledge transfer, advice, courses and exhibitions.

At the heart of Metropolitan Works is the Digital Manufacturing Centre, housing a range of new technology for prototyping, manufacture, research and experimentation. The centre houses 3D print facilities and CADCAM and laser cutting.

Digital Manufacturing Centre (DMC) at the Bartlett

The DMC[26] at the Bartlett School of Architecture runs a bureau service for architects, artists and designers. Working alongside CADCAM and the Bartlett Workshop, the DMC promotes digital manufacturing techniques including 3D printing/additive layer manufacturing 3D scanning and free form haptic modelling.

1

2

Opposite and 1, 2 above: Heather and Ivan Morison, 'Little shining man', November, 2011. This is a new piece of work by Heather and Ivan Morison, commissioned by Dandara, and made in collaboration with fabrication design studio Queen and Crawford and architectural designer Sash Reading. Photography © Ivan Morison Matt Porteous. www.mattporteousblog.com

Centre for Fine Print Research (CFPR)

An extremely well-equipped university research centre dedicated to print and the physical artefact, located at the University of the West of England in Bristol, UK.[27] CFPR has been involved with 3D print as a research tool since 2005. In the last few years it has run a specialist bureau and consultancy service for artists, designers and creative industries – printing for artists such as Richard Hamilton, Tom Lomax, the designer Peter Ting and Aardman Animations.

CFPR studios provide laser cutting and wide-format printing alongside innovative 3D printing technology. Specialists in 3D ceramic printing and colour, CFPR also undertake 3D print related industrial research with companies such as Renishaw and Johnson Matthey Noble metals.

Conclusion

I said in the introduction that it is difficult to see where the technology will go in the next few years but my guess is that it will split into a number of different markets. The high-end machinery will be used by the top end of the engineering and aerospace markets and it will also be used for high-value bespoke markets such as medical, dental, sports equipment and jewellery. In the middle will be the bureau services. I have no doubt that given the high cost of the quality machinery the bureau services can provide they will continue to service those who need to keep costs to a minimum through economies of scale. I think the low-end machines will remain in two forms. The very cheap machines are likely to enter the toy market. But with recyclable materials slightly higher-quality machines will serve the geek, education and SME markets. If this market desires a better quality part they will first trial it on the cheap machine to make sure it works and is watertight and then send it to a bureau for a high-quality part in a known material. Some of those materials are already available, such as titanium, steel, silver – and now gold – in the metals, with a range of plastics including nylon and photopolymer materials that simulate the performance of ABS and rubber.

Other materials such as aluminium may never be used in 3D printing due to health and safety concerns. Materials are set to improve – in terms of strength, durability and quality of surface finish – and a wider range of materials will become available, including materials with thermal and electrical conductivity for functional applications such as 3D-printed electronics. Deposition technology will improve in quality and the cost of mid-range printers will continue to fall. Multiple material printers will enter the medium and lower cost sectors.

1 Beaman, J. et al., (1997) *Solid Free Form Fabrication: A New Direction in Manufacturing*, USA: Kluwer Academic Publishers.
2 Wohlers, T.T., (2012) Wohlers Report 2012. Available from: http://wohlersassociates.com/2012report.htm.
3 Wohlers, T.T., (2007) Wohlers Report 2007. State of the industry, annual worldwide progress report, Wohlers Associates Inc. Available from: http://www.wohlersassociates.com/2001-Executive-Summary.pdf.
4 Beaman, J. et al., (1997) *Solid Free form Fabricatio:n A New Direction in Manufacturing*, USA Kluwer Academic Publishers.
5 Hull, Charles, W., (1984) *Apparatus for production of three-dimensional objects by stereolithography*. Patent Specification no. 4575330. United States Patent Office, filing date 8 August 1984.
6 Crump, S. Scott., (1992) Apparatus and method for creating three-dimensional objects. Patent Specification

no. 5121329. United States Patent Office, filing date 1992.
7 Feygin, Michael, (1988) Apparatus and method for forming an integral object from laminations. Patent Specification no. 4752352. United States Patent Office, filing date 1988.
8 Sachs, Emanuel M.; Haggerty, John S.; Cima, Michael J.; Williams, Paul A., (1993) Three-dimensional printing techniques. Patent Specification no. 5204055. United States Patent Office, filing date 1993.
9 Roper, Caitlin., (2012) 'The boy with 8,000 faces', *Wired*, September 2012, pp. 104–109.
10 Yoo, J.; Cima, M.J.; Khanuja, S., (1992) Structural Ceramic Components by 3D Printing, The Third International Conference on Rapid Prototyping.
11 Marchelli G., Ganter M., Storti D., (2009) New Material Systems for 3D Ceramic Printing, (proceedings), Solid Free Form Fabrication Symposium Rochester Institute of Technology.

12 Balistreri J., Dion. S., (2008) *Creating ceramic art using rapid prototyping*, ACM SIGGRAPH 2008 talks.
13 Hoskins, D. and S. Huson., (2010) *A Method of making a ceramic object by 3D printing*. Patent Application 1009512.3. UK Patent Office, filing date 2010.
14 Deckard, Carl. R., (1989) Method and apparatus for producing parts by selective sintering. Patent Specification no. 4863538. United States Patent Office, filing date 1989.
15 Woodcock, J., (2012) 'How to Make a Pirate!' TCT Live, 20, 5. pp. 20-21.
16 Ewalt, David M., (2010) 'Aardman & Nokia Make 'Dot', The World's Smallest Film'. www.forbes.com, 18 October 2010.
17 Dunlop, Renee, (2009) *One step at a time for the puppet of a thousand faces*, 12 February 2009, CG society: Production focus. Available from: http://www.cgsociety.org/index.php/CGSFeatures/CGSFeatureSpecial/coraline.

18 Wohlers, T.T., (2012) *Wohlers Report 2012*, RAPID Conference, Atlanta. Available from: http://wohlersassociates.com/2012report.htm.
19 http://www.Rapidtoday.com
20 Labarre, Suzanne., (2012) 'Shapeways scores $5m from Union Square Ventures, aims to be the Kinko's of 3D printing'. Available from: http://www.fastcodesign.com.
21 Ewalt, Josh Wolf., (2012)' 3D printing shapeways and the future of personal products', www.forbes.com, 19 June 2012.
22 http://i.materialise.com
23 http://www.3T RPD.co.uk (3T RPD 2012)
24 http://www.morison.info/index.html
25 http://www.metropolitanworks.org/
26 http://bartlett.ucl.ac.uk/architecture/about-us/facilities/digital-manufacturing-centre
27 http:// http://www.uwe.ac.uk/sca/research/cfpr/

Crafts and craftspeople

This chapter deals primarily with craftspeople and how they interface with 3D printing. I will explore how the technology is changing the concept of craftsmanship with thoughts, observations and case studies.

Whilst it is difficult to come up with any firm evidence or overall statistics, I feel that 3D printing's influence should and will have a fundamental impact on the area of 'making' that has been traditionally known as the 'crafts'. Why do I argue this? Because until only very recently this area of the visual arts has had the lowest public profile for adopting digital technology – apart from a few rare examples such as the work of Michael Eden. In contrast, over the last 12 months there has been a plethora of digitally oriented craft exhibitions and curated shows which have included 3D printing, such as the Crafts Council touring show 'Lab Craft: Digital adventures in contemporary craft'[1] and the 'Power of Making' Exhibition[2] at the Victoria and Albert Museum in 2011. These exhibitions begin to tackle the problem of how we move beyond the virtual screen representation of an artefact to how we create it in the physical world using digital technology.

Normally, when showing a craft object or artefact the knowledge and craft skill inherent in the work is a crucial part of exhibiting the artwork. At this point in time most 3D-printed artworks do not have any of those inherent properties or tacit knowledge that are fundamental to a craft piece. I am not sure if either the artists or the curators have been able to be sensitive to retaining the tactile properties of conventionally formed materials. To qualify this, I mean that the problem is inherent in manufacturing or displaying the artefact in a manner that would normally be central to the core essence of any traditionally crafted object. This is a new area of working through a process. To 3D print a successful artwork requires a high degree of skill, but at the moment, the material properties deny the craft skill. It presents not only a physical disconnect between the maker and the object, but also has the added disadvantage that this physical disconnect is mediated yet further through the digitisation process. By this I mean one first draws a virtual representation on screen, which is the first disconnect, then one sends this virtual object to the printer, where there is also a physical disconnect between the creator to the object's manufacture. Making the object twice-removed from its creator.

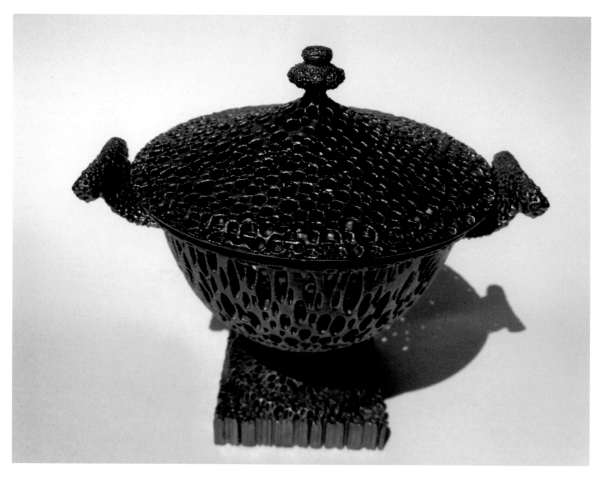

Michael Eden, 'Wedgwouldn't Tureen' silver test. © Michael Eden, courtesy of Adrian Sassoon.

These very attributes of 3D printing lead us to the following questions: firstly, is there a craft of 'the digital'? And secondly, how do we reconcile the craftsperson's tacit understanding of materials, with a process that removes the union of hand and eye normally associated with a craftsperson using a tool?

It is this tacit understanding of materials, only gained by the acquisition of knowledge through practice, that is essential to the creation of any good quality artefact to which we might ascribe a high degree of skill – whether it is a 14th century tin-glazed Majolica bowl from Deruta in Italy or a table from the contemporary furniture maker Fred Baier.[3] In this chapter I hope to present a series of examples, which will prove that in fact a number of people may have already solved these problems and if they have not completely solved the problem, they have at least found a solution that works for them.

However, to return to the fundamental problem or dichotomy: the issue is the reconciliation of learned tacit knowledge of materials, essential in the creation of a quality artefact, in any manufacturing process (whether analogue or digital) as against a 3D printing process that removes and automates the essential coordination of hand and eye. Additionally, 3D printing lays down a material in a new way, a way that bears little relation to the processes that have been used in the past to create an artefact. At this point I may be opening myself up for criticism for holding what in some circles may be regarded as an old-fashioned view: I firmly believe in a visual aesthetic and the need to learn craft skills in order to create art of value that combines both an appreciation of form and content. I am also in the same camp as

Richard Sennett in his treatise 'The Craftsman', in that I believe these skills have to be learnt by familiar understanding and repetition of practice.

All craftsmanship is founded on skill developed to a high degree. By one commonly used measure, about ten thousand hours of experience are required to produce a master carpenter or musician. Various studies show that as skill progresses, it becomes more problem attuned, like the lab technician worrying about procedure, whereas people with primitive levels of skill struggle more exclusively on getting things to work.[4]

Richard Sennett

How do I believe that the field of the crafts will deal with this problem and adopt these new technologies? I may need to qualify here what I mean by adoption. I have stated elsewhere that I do not believe that the early adoption of a process is representative of a new field. Early adopters tend to create artefacts that, at best, look as though they have been created with a very specific instantly recognisable technology, which they are using for the *sake* of using and not as a means of communicating an idea through an appropriate tool. The most innovative work is created when the technology becomes more commonplace and then the images, objects or artefacts are made using the technology simply as a means to an end and not as a means to represent the process or technology.

To illustrate this, I constantly compare 3D printing to the development of inkjet printing in the 1990s, which went through a similar new technology adoption process, to which, in the beginning, only a few had access. Then the adoption travelled through increasing improvements and developments to a state of familiarity, ubiquity and finally, acceptance. Inkjet printing is now a fully accepted part of the canons of printmaking and photography. Artists and craftspeople make work using an inkjet process that is common to everyday practice and therefore 'familiar'.

Workshop of Giacomo Mancini, majolica bowl, 1520–50. Tin-glazed earthenware, painted with colours. © V&A Images, Victoria and Albert Museum (2595-1856).

This same adoption process is yet to happen with 3D printing and craftspeople need to understand that adoption of new technology is not a negation of craft skills – quite the opposite. It is not possible to take on a new manufacturing technology without an inherent understanding of materials. I see the rise of this technology in the same vein as the introduction of mechanisation into the crafts during the Victorian era. This is perhaps best summed up by George Sturt in his famous text[5] *The Wheelwrights Shop* which documents the period between 1884 and 1891 when farm carts were still wholly made by hand, just before the general acceptance of machinery into the trade. This wonderful book makes the argument for an understanding of materials in order to make the best quality artefacts. Sturt's employees had a complete and tacit knowledge of all of the elements that went into growing, harvesting and seasoning the locally sourced timber they used.

However, we live in a different world: the knowledge required of today's skilled craftsperson is very different from the craftsperson of the past and this knowledge will face rapid change in the future. So, just as Sturt's time, when the knowledge and skill base that had not changed for centuries, rapidly changed within a few years we too may now experience similar rapid change, engendered by the introduction of a disruptive technology.

Sturt describes the transition of his family business to mechanisation:

But eventually – probably in 1889 – I set up machinery: a gas engine, with saws, lathe, drill and grindstone. And this device, if it saved the situation, was (as was long afterwards plain) the beginning of the end of the old style of business, though it did just bridge over the transition to the motor-trade of the present time.[6]

THE WHEELWRIGHT'S SHOP, FACING EAST STREET, ABOUT 1916

Sturts' Wheelright's Shop, Farnham, Surrey, 1916. © Sturt 1923.

Side view of a handmade cart from Sturts' Wheelright's shop. © Sturt 1923.

What is interesting here is that all of the machinery Sturt describes is a complete part of the modern craftsperson's toolkit. In fact, many craft woodworkers making furniture today – in addition to being completely *au fait* with powered hand and machine tools – would also possess a CNC router. The crux of this argument is simply that the adoption of new technology requires a new set of skills, without throwing out the skill and material knowledge inherent in all of the previous technologies. Crucially, it requires an understanding that these technologies are no more and no less than a new set of tools that require time to become familiar with. What they should not do is dictate the practice. All too often with the adoption of new technology, in whatever discipline, one can instantly tell a work that has been dictated and created by the simple constraints of a process. It will not possess any of the inherent material or aesthetic qualities that are obvious in a piece that is made so skilfully that it transcends the process. One instantly looks at the content whilst fundamentally understanding the level of skill that is required to create the piece, but without having to question its integrity or imperfections. For example, compare the classic Arne Jacobson bent plywood butterfly chair, which demonstrates inherent material qualities, and the low-cost IKEA Vilmar chair, which is built to a price point.

Sturt presents us with a further problem, his descriptions of a tacit understanding of materials are both insightful and unusual, in that he has real insight and practical knowledge of his subject, combined with the unusual ability to write and explain the view and understanding of a practitioner. However, Sturt is writing about the transition from handcraft to the advent of mechanisation (but at this point in history machines were still very 'hands-on'). What we are dealing with today is the transition from what we consider to be a 'hands-on' approach, to what can only be described as a 'hands off' or 'remote mechanisation' approach. Therefore, is it possible to use Sturt as an analogy for tacit understanding, when he is decrying even the process we are in the transition from? I believe that the fundamental tenet of Sturt's argument still holds and it could offer further insight: during a period of transition the comparisons that are made to the new technology, from the point of view of the old, tend by their very nature to be negative. As the technology matures a more rational understanding and acceptance grows until we reach the stage, as described above with digital inkjet technology, of its commonplace integration into everyday practice.

Philosophically, I understand the problem for the craftsperson at this point in the development of 3D printing. By the very nature of the 3D printing

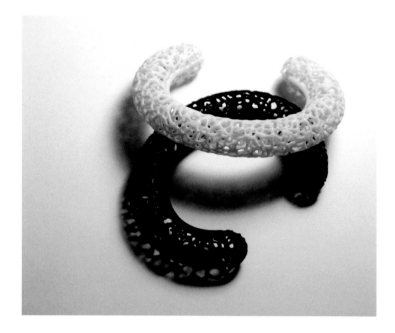

Nervous System
'Hyphae Cuff'.
Photographs by
Jessica Rosenkrantz
© Nervous System.

process, the range of materials available to the user is still extremely limited and primarily does not exhibit any of the characteristics available in the standard materials used in the broader disciplines of the skilled crafts. Why, therefore, use a process that offers none of the qualities inherent to your discipline?

The answer of course is that 3D printing offers the ability to create objects that would be impossible to create in any other way – this is the solution to the dichotomy. Whilst the quality of material often leaves a great deal to be desired, what can be done with the process is very seductive. However, has this also now become a cliché or gimmick of the impossible object? Maybe practitioners are beginning to work through this gimmicky phase in the same way that they did when inkjet printing was a novel and seductive process during which time there were a huge plethora of Photoshop gimmicks that have now died away. What all the arts disciplines have in common is the fact that most participants are waiting for the technology to take off. Only then will it be possible to marry the abilities of 'print on demand', in shapes that are integral to the 3D printing process, with materials that have the inherent qualities required by the artist–craftsperson. This means the objects will be aesthetically pleasing in themselves and will not exist merely as an expedient means of laying down a track to create a 3D print.

Thus finally, we will have to create objects in ways not currently possible, objects that possess the inherent material qualities so desirable to the experienced craftsperson.

Having argued that craft is in transition, there is no doubt that craftspeople have been using the 3D print process and that there is much blurring of the borders between disciplines. (Here I will also blame myself for the individual chapters in this book that define disciplines by chapter heading, when I personally do not see that there has to be any boundaries!)

However, there is no doubt that under the broader definition of craftsperson, people are integrating with the technology. I will expand further on these issues in Chapter 5 with examples from design collectives such as Nervous System or the independent designer Bathsheba Grossman, who have been making metal and plastic jewellery for a number of years. Again, the real test comes when the objects transcend the process involved. In fact, in my view, the above examples illustrate the early adoption of the process very well. Both of these practitioners utilise mathematic algorithms to generate natural forms, which are then 3D printed. This makes use of a factor of the technology that is immediately available and inherent to the way objects are conceived. The downside of this approach is that the objects created are completely subservient to the process, and therefore are instantly recognisable as 3D printed.

In the case studies I have interviewed three people, from diverse crafts backgrounds, who have dealt with the problems of limited materials. Each has a very different and particular approach to using 3D printing: Jonathan Keep and Michael Eden both share a background as practising potters. Marianne Forrest is primarily a clock and watchmaker. I also wanted to interview people who used the technology in very different ways. Jonathan has an extremely hands-on, do-it-yourself approach that starts with him building his own machine and, in essence, writing his own software, in order to build pots that relate to his practice as a thrower. Michael Eden's main aim, in his own words is:

to communicate an idea or tell a story in the form of a three-dimensional object and in order to do that in a lyrical way I choose the appropriate tools. It does not mater to me whether they are a computer, the potter's wheel, the 3D printing machine or the kiln; they are all tools and require a degree of craft skill to do the job well.

Marianne Forrest uses the technology as much as a designer than as a craftsperson, in the sense that it is a tool to enable her to achieve a desired result and it was not until she could print in metal that she began to use the technology.

JONATHAN KEEP

Jonathan Keep was born in Johannesburg, South Africa and educated at Natal University and the Royal College of Art. He is a well-known ceramic artist, he has shown internationally, been featured in the influential book on contemporary ceramics *Breaking the Mould* and has regularly shown at the prestigious Crafts Council 'Collect Fair'.

Jonathan describes his practice as an 'artist–craftsperson', although he has a background in fine art, Jonathan explains that: "In South Africa in the 1970s European cultural notions of fine art were being pulled apart". So he is happy to call himself a potter, "in a European context that puts you in the crafts but in a Southern African context being a potter was a mainstream artistic activity".

Jonathan's practice includes sculptural works and some functional thrown ware as well as 3D printing. In relation to 3D printing Jonathan's view is that "As far as I am concerned 3D is just another tool that enables your work with clay, sometimes I am throwing forms and cutting them up, other times I'm using coil building, other times I'm using 3D printing".

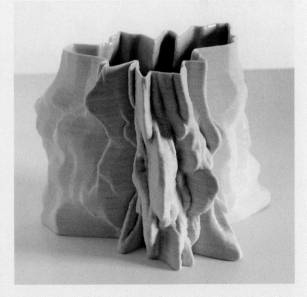

Jonathan Keep, 'Iceberg', 2012. © Jonathan Keep.

He first started to use 3D printing in 2011 as a result of seeing the work of the Dutch Design Company Unfold, who added a pressure-driven syringe to a Bits from Bytes RapMan printer in order to print clay. However, he first started using Computer Aided Design programing in 2002 after a residency in Denmark, where he then returned in 2003 for a workshop around digital work and ceramics. In 2007 he became interested in the sort of forms could be created through 3D software so went to another symposium around ceramics and digital form and it was there that he learned about using the Z Corp printers to print clay. However, Z Corp machines were expensive and he also learnt that more DIY-style home printing kits were available for less than £1000. Jonathan therefore purchased a Bits from Bytes RapMan self-build machine, with a converted print head to take a pressurised syringe, which is used to extrude ceramic slip casting clay through a nozzle.

Currently, around a third of Jonathan's work involves 3D printing, mainly for his more sculptural pieces, but he still uses throwing for making his range of domestic ware. Jonathan explained that he uses 3D printing as a way to realise forms that have been computer generated:

> *I am particularly interested in form and the natural evolution of three-dimensional shapes and how humans respond to form. The patterns and systems that go into making natural forms can be explored in computer code, and it is to realise this code as physical objects that I am using 3D printing. This is just not possible with traditional processes. However the printing technique I use is very close to the technique of traditional coil build pottery – it could almost be seen as mechanical coiling process. What printing offers is a new way of working that includes the computer as a tool that for me becomes much more integral to the way of creating forms.*

During my interview with Jonathan we discussed the lead-up to the actual process of printing. Jonathan made a comment that belied the notions of material qualities usually so important to a craftsperson:

> *The way of working is often more important to me and less so the qualities. Because I am interested in the mechanics of form, computer coding can start to give you an insight into that. I have taught myself basic Java coding so the actual forms aren't like the usual ones you would get in Rhino, but I am using code libraries for a cylinder for example then I can start distorting that cylinder through random mathematics etc. So I then get a mesh that I can capture on computer, then output to a printer and create a physical form, and there is no other way I could do that (by hand) or to do it another way would be pointless.*

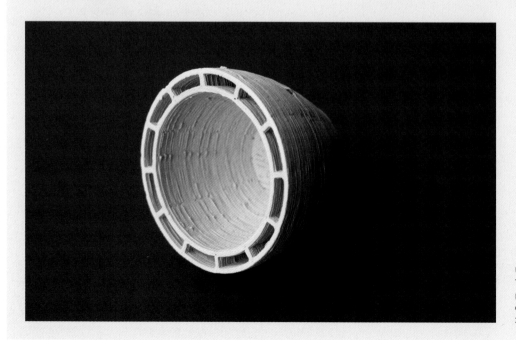

Unfold, 'Potje', 2009. The first vessel Unfold printed on their ceramic printer in 2009. © Unfold.

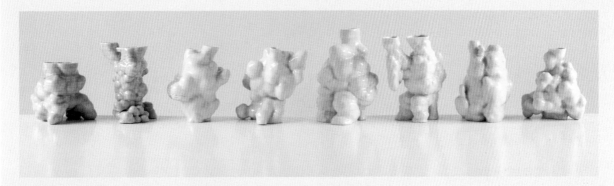

Jonathan Keep, 'Random Growth', 2012. Line of 3D-printed ceramic pots. © Jonathan Keep.

The computer code is written using 'Processing' – an open source programing language based on JavaScript. 3D files are captured or exported from these sketches and cleaned up in the open source 3D software 'Blender'.[7] In the Blender program Jonathan may adapt and recreate the initial mesh quite considerably. The 3D file is then further processed through the printer software, (Bits from Bytes, BfB Axon) to produce 'G-code'. G-Code is a programing language developed for CNC milling that is read by the Bits from Bytes 3D printer. Axon is a user-friendly version of Skienforge,[8] the standard freeware software for low-cost 3D printers. It may be helpful to provide a little clarification here. The Axon software slices the 3D model and generates a series of linear tool paths, which are sent to the 3D printer to control the movement of the print head. Jonathan configures the software so that it only builds the external surfaces. The infill information the software generates is excluded from the build. This means the object will be built with a wall thickness that is determined by the width of the syringe nozzle he is printing with, and cannot be varied. This is different to the normal process for a 3D printer, which is to create a virtual solid object in 3D software, with the option of a specified wall thickness.

In terms of physical hardware Jonathan has a Bits from Bytes RapMan with a converted head to take a syringe. He explains that he comes from a Meccano sets background, giving him the knowledge to undertake the fairly complex process of constructing a self-build 3D printer. Jonathan states that the physically printed ceramic forms are solely created with 3D printing, but thereafter only traditional technologies are used to fire and glaze the objects. However, during the build process he intervenes either with his hands – to keep a section supported whilst printing – or with a hairdryer, to quickly dry a section so that it will not collapse during the build process. In essence, Jonathan has a very interactive build process, synonymous with being a hands-on traditional thrower: "I don't go beyond 45 degrees but even then it bulges and I'm in there with a hairdryer drying it as quickly as I can, but I've given up – bowls just don't work".

Jonathan's 3D printer has been converted from a fused deposition modelling (FDM) printer (that uses liquid plastic) by the removal of the FDM print head and replacing it with a pressure system that drives clay through the nozzle of a syringe. He uses a syringe that deposits approximately 1 mm of clay width in the horizontal axis, with 2 mm in the vertical axis and runs the syringe at a pressure of 3bar. This means that Jonathan has to clean up the print as it finishes because you cannot just turn off the pressure. At the CFPR we print clay with a much finer auger system (a type of screw thread between the syringe and the deposition head) to create a more even flow and combat some of the start and stop problems. However, Jonathan has an interesting view on these issues:

> My attitude to the barriers of 3D printing is very pragmatic – I don't see them as barriers. I work within the limitations of what I've got. People [say] to me – aren't there other ways you can feed in clay to extend your syringes? and so forth (to make a bigger pot). What I do is I cut up the mesh in Blender and will do two or three prints to get more scale, then assemble them and because they fit perfectly you just put

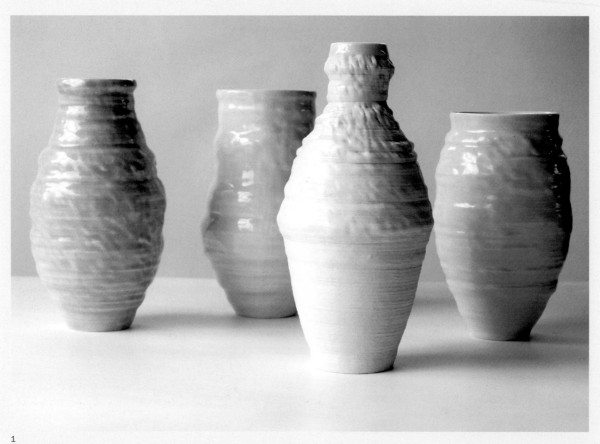

1

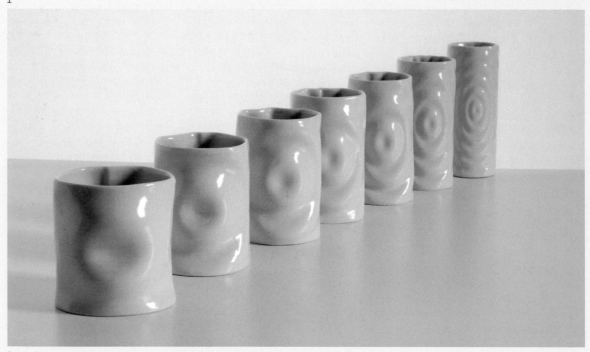

2

1, 2, 3. Jonathan Keep, 2012. 1. 'Britten', 2. 'Drop', 3. 'Salt Pots'. © Jonathan Keep.

3

them with the other half. I'm more concerned with the process than trying to re-engineer the machine every time. It's what you do with it that's the most important aspect, so once I saw the Bits from Bytes Rapman had a syringe on it I thought that's the one for me.

Jonathan can build two halves of an object, and using slip he can stick them together as greenware, quite easily, using a traditional craft practice. I would argue this is a really interesting solution using tacit knowledge of materials to solve a problem, by making the most of the inherent properties of clay. He elaborates on his process: "printing is a very small part – a bit like throwing – of the process. To get to the finished article there are all sorts of other traditional ceramic processes that take place first. You know, the glazing and the firing etc."

This is particularly true of ceramics and perhaps less so with some of the other processes and disciplines, but it is clear that all of the craftspeople I talked to have some form of intervention in the process of making. These aspects of Jonathan's practice seem to be at odds with his comments regarding progress on material qualities. For an established craft practitioner, known for his craft skills and obvious tacit understanding of materials, when it came to 3D printing I found it quite hard to work out where Jonathan's aesthetic sensibilities lay.

This may be because the process is still relatively new to Jonathan as well as to the discipline and he is still formulating his practice.

MARIANNE FORREST

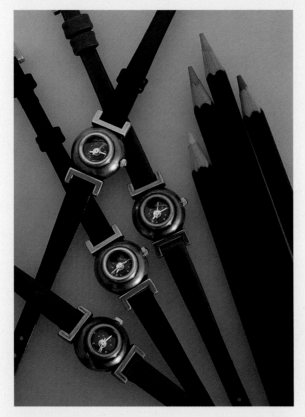

'Tiny titanium Drop', Marianne Forrest, 2012. © M. Forrest.

'Tiny watches',
Marianne Forrest, 2012.
© M. Forrest.

Educated at Middlesex University and the Royal College of Art, Marianne Forrest makes timepieces that range from the tiniest of wristwatches to huge architectural installations for urban spaces. During the course of our discussion, unlike most of the other interviews that were conducted remotely by Skype, Marianne and I met in person and handled many of her pieces, which perhaps explains the more hands-on nature of our discussion. She explains the inspiration for her work:

▬▬▬ *I have a fascination with scale, surface, form and function. I explore ideas about the nature of time and its transience and permanence. I try to re-define the traditional watch and the way it is worn by expanding its potential for hanging and draping on different parts of the body and clothing.*

Marianne calls herself a maker or 'designer–maker' and this fits her practice in the true sense of the words. Marianne articulates a problem common to many cross-disciplinary practitioners:

▬▬▬ *I tend to look at the person I'm talking to and pigeonhole myself for them otherwise people just look at you blankly, so I usually just say I'm a silversmith or jeweller. The craft/design associations have the same problem, because I make jewellery, watches and architectural pieces, so basically, I'm not a member of any of the associations.*

Her introduction to 3D printing technologies began around 2007, when direct metal laser sintering became available and Marianne started learning Rhino. She had played with the technology earlier, but clearly states there was

no incentive for her to use it until suitable materials were accessible. She learnt the technology by actually making a piece of work and working through the tutorials. (Here we discussed the Rhino Toy Duck tutorial, which almost everybody seems to have made as it teaches you some of the basics about how to build up objects and cut.)

When asked what proportion of her work was made with 3D printing, Marianne makes a number of 3D-printed items but has actually only made a few different designs. She explained that this is because she is too busy with other things. But this is modesty on her part, later on in our discussions she stated that she was able to create 70 watch cases for her miniature watch 'Sho', in one build. It is difficult to discuss with her if her works are solely 3D printed, as obviously the watch movements are not going to be printed (because at this point in time although it is possible to 3D print in metal, it is debatable whether it is even possible to print the delicate watch balance mechanisms, see below) and therefore only parts of her work are going to use the process.

However, in terms of the qualities that 3D print has to offer, Marianne is very clear when describing her most complicated work to date, the unique watch 'Paelolith'. She explained the complexities of the build process:

> Paleolith was actually built in six parts then welded together. Because it's a very different process (to making a piece by hand), especially with the support structure and the cleaning up required – this piece took me six months to clean up! However, one of the interesting things about it is I couldn't have physically made it like this by hand. Each one is made using a comb that I had stacked together and then cut, there is no way I would ever have made that by hand, it would have taken me a couple of years. So six months is really quite quick!

It is possible to see from the comb structure that it would have been impossible to get tools into the tight spaces in order to cut them, similarly, casting would not have worked

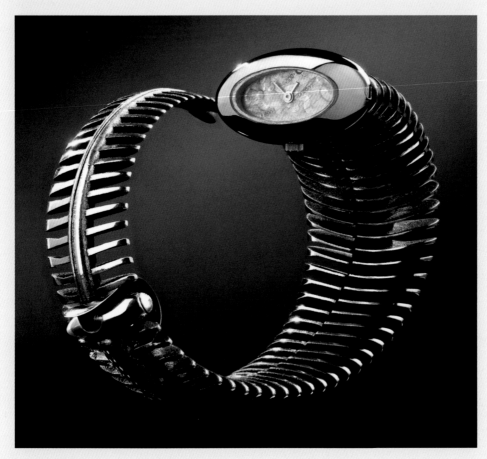

Marianne Forrest,
'Paleolith'.
© M. Forrest.

Marianne Forrest, 'Hyde Park Gate' wall clock, 2012. © M. Forrest.

as the moulds would have been far too complicated. As a counterpoint to the length of time and work required by 'Paleolith', Marianne created a series 'Sho', for which she designed the object parameters so it would require no cleaning up. She made sure that she specified the angles avoiding overhanging features of greater than 30 degrees, thus creating a deliberately self-supporting work which only had a tiny little spigot in the middle to connect it to the base of the build structure in the bed: "when I got it back from printing I actually didn't do any cleaning up – just gave it a quick polish and there you go".

She has created various versions of this watch as well as a ring watch made from the same 3D printed file. While discussing this a simpler series of work I asked her whether she made the watch movements herself or if she bought them in. Marianne replied that she did not make them herself, but she did make adjustments and alterations to the larger movements:

▬▬▬ *I buy them in. So my smallest watch is absolutely governed by the smallest manufactured movement. When it comes to the watch cases with the absolute smallest one I had to make it in Rhino software because you can't physically make it that small, which was interesting and a really good use of Rhino, as it was absolutely pared down – they also sell like hotcakes!*

Marianne explained in greater detail how 3D printing is

crucial to the whole process of getting the movements to fit:

▬▬▬ *I took each wall thickness right down to the last possible parameter – you can only do that in 3D prototyping you just can't cast it, it will shrink or move or lose something and then the movement doesn't fit; [it is] very logical. So I like the intensity of that tinyness but I also like the wear-ability.*

In complete contrast to the minute nature of her watches, Marianne then deliberately took on a larger-scale project with funding from London Metropolitan University in which she could work much faster: "I did a whole research project – the 'transformation' series – things made instantly or spontaneously, that was about speed of making as well as size".

Marianne also makes things on a much grander scale, grander even than the 'Transformations' series. Her method of describing the various areas of her working practice is therefore very ordered. She accords separate groupings to her works dependent on scale: "But then I go up again into the architectural stuff, which is always site specific and intended to be with the community. But I enjoy all that because it's different every time".

In relation to 3D printing and digital technology, the way she now approaches her practice is very different because

she uses Rhino to make models of the big things, which she finds much easier for visualisation purposes. She feels this is an interesting addition to what she has offered to clients before. When I asked Marianne about the barriers that prevent her from using 3D printing her response was interesting:

> I try to cut things like I would at the bench, I'm struggling with it at the moment, having doing the earlier pieces I'm back to the cutting and filing inside the computer. So I started with a box and almost everything was Boolean difference, but I'm trying to make it all subtractive manufacture. That paradox is quite interesting to me, and the paradox between the hand and the screen, as most people don't think of it that way (i.e. as an approach to the technology).

This seems to me a very interesting way of working, where 3D printing is in itself an additive process and the software therefore allows you to build the object in a similar additive manner. This makes working deliberately subtractively in an additive process seem unusual. I wonder if this is something that is only inherent to a person with many years of hand-craft practice who has then learnt digital technologies as opposed to a person who has grown up with both.

Marianne also comments:

Marianne Forrest, 'Liverpool Adagio'. © M. Forrest.

> Rather than trying to stretch the technology, I'm just trying to make things in different ways. What interests me is the way you use your hands and brain to make something. Most of the time that interface between hand and brain is lost because all you are doing is clicking. But when I am building something in the computer its very much using the same parts of my brain, I get really close to the screen and I am right there and in there with it.

Marianne showed me a cast watch she made by printing a plastic prototype for a mould on the Envision Tech. Marianne thought it had ended up slightly different to the way she had envisioned it – certainly it was weaker, and in addition, if she had made a watch by using the plastic as a mould the casting would have shrunk the piece again (maybe 6% less in terms of shrinkage), which on a watch is impossible – you would have to re-cut every single one to make the movement fit.

Marianne reflected:

> 'It's a nice piece but it's got problems. I made another one which was also resin and instead of trying to cast it, I thought, well how else could you make this a 'real thing' in real metal, because metal is really the key for me – although I work in all materials for this process I want to work in metal, so I made another one and then electroformed it afterwards. I thought the combination of electroforming and resin would keep it all together but it didn't quite – that one broke – but what an interesting way to do it!

This example led Marianne and I to a discussion of the structural integrity of electroforming on a 3D-printed core. Marianne said the model that she had shown me was plated very fast to give it a deliberately rough surface and I speculated that the result would therefore be weaker than a piece that had been plated more slowly. But Marianne's primary interest was the surface and the texture that produced a piece that looked more aesthetically pleasing and less digitally created. Structural concerns were secondary and were only important when the piece broke. In fact, Marianne used the electroplated pieces as bracelets because she felt they were never quite resolved as watches.

When asked where she saw the future of 3D print for artists, designers and craftspeople, her reply was very

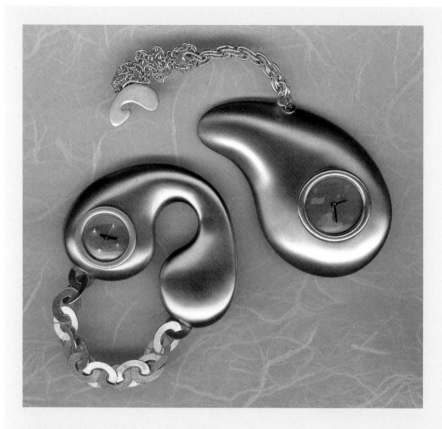

Marianne Forrest, 'Organism 2', 2012. © M. Forrest.

specific about her work as a jeweller and she commented on the tiny 'Sho' watch cases:

> *I have a variety of different pieces [that] I can use to make watches, around 70 odd – so really it's a manufacturing system. I mean it's only 70 that I got out of it but 70 watches is fantastic for me, I have piles of them back at the studio made that I haven't had time to finish. So after I made this one I was really interested. Going back to the making that this process, which is seen as a prototyping process – and I hate to say this! – could actually be the way that Britain could resolve some of its financial issues, in manufacturing terms.*

Marianne is perhaps slightly different to the other two case studies presented in this chapter in that she waited until the material properties were closer to her requirements as a craftsperson before adopting the technology. This means that she is specifically using the material properties of the metal in order to obtain the results she is seeking. However, it is clear that Marianne has had to adopt different working practices and develop strategies that take on board the particular material qualities of 3D-printed titanium.

Marianne Forrest, 'Big Watch', 2012. © Marianne Forrest.

MICHAEL EDEN

Michael Eden, 'Vinculum 11'. © Michael Eden.

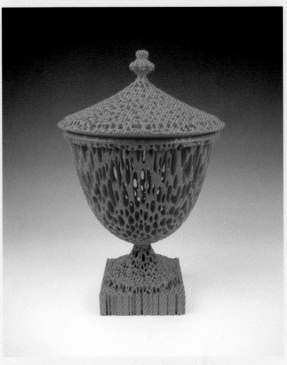

Michael Eden, 'Wedgwoodn't Tureen, Pink'. © Michael Eden.

After spending 20 years as a successful studio potter, in 2006 Michael Eden undertook an MPhil at the Royal College of Art in order to learn about digital technologies and 3D printing. His MPhil explored how an interest in digital design and manufacturing could be developed and combined with the craft skills he had already acquired. His work is inspired by historic objects and contemporary themes – at the same time exploring the relationships between the hand-crafted and digital tools. He also investigates experimental manufacturing technology and materials. This new way of working has allowed Michael Eden to extend his practice into other areas such as glass and furniture. The first 3D-printed work that Michael made whilst undertaking his MPhil was the work entitled 'Wedgwoodn't Tureen' in 2007.

Michael outlines his creative process and approach to his work in his article "Things machines have made":[9]

▬▬▬ *Redesigning an iconic object from the first Industrial Revolution, I produced it in a way that would have been impossible using conventional*

industrial ceramic techniques. The piece is loosely based on early Wedgwood tureens, chosen for their classic beauty and in homage to Josiah Wedgwood's role as a father of the first Industrial Revolution. The delicate, pierced surface is inspired by bone, referring to the natural objects used by Wedgwood and his contemporaries as the inspiration for many of their designs. My choice also refers to the artificial bone produced by AM. The technology removes the constraints of 'design for manufacture' where the processing of materials has an impact on the final outcome. In other words, there are only certain forms that one can throw on a wheel; gravity, centrifugal force and the material qualities of clay limit the possibilities. The 'Wedgwoodn't Tureen' demonstrates the removal of these constraints and the potential to create previously impossible forms that can creatively communicate new ideas.

The tureen was designed on Rhino 3D and Free Form software. The files were then sent to a Z Corp 3D printing

machine that 'printed' the piece. It was then coated in a non-fired ceramic material that simulates a ceramic surface, which was developed by the French company Axiatec and which Michael adapted to closely resemble Wedgwood 'Black Basalt.'[10]

Unlike many of the artists and designers that I interviewed for this book, Michael acknowledges that his experience of using 3D printers – and Z Corp machines in particular – is almost zero. Therefore Michael has collaborated with others for the production of much of his work. In a collaboration with Mark Ganter (at the Soldner Laboratory at the University of Washington, Seattle)[11] he produced a number of 3D-printed ceramic pieces. Mark sent the works to Michael in a biscuit-fired state which he then glazed and fired in his own studio to complete them: "In my experiments with Mark Ganter, the pieces he sent over to me I had to coat them in a vitreous slip first, fire them and then glaze them, that worked perfectly".

When asked about how he defines himself and his practice Michael describes being in a grey area between design, art and craft, which to him is interesting territory, partly because of the baggage of language. Michael wishes to circumvent the traditional boundaries and to be able to select and choose modes and methods of working from whichever discipline he chooses, and in doing so hopefully create some sort of dialogue or starting point

for conversations around language and territories. This led us into a discussion around what I call 'the craft of the digital' – whereby without tacit knowledge of materials and a fundamental understanding of process you actually can't makes things well in 3D. The current problem is that the technology is very removed from hands-on manufacture, which in itself creates tacit knowledge. Michael agreed with this view and provided some examples from the influential design commentator Geoff Hollington[12] and craftsman Fred Baier.[13] He comments:

▬ *Exactly, this is 1800 in terms of the first industrial revolution, to paraphrase Geoff Hollington. So it's still very early days, we don't have those intuitive interfaces and responsive or more tactile devices to engage with. Although Fred Baier's comments were written a few years ago now, so things have changed. The furniture maker Fred Baier is cautious about the use of computers by makers. He opines, "Unless artists can … push and pervert their software far beyond its expected parameters, they must accept having their role as author/composer downgraded to performer".*

In complete contrast to Baier, Michael's belief is that the most immediate benefit of 3D printing is the creative freedom it offers over traditional craft production methods:

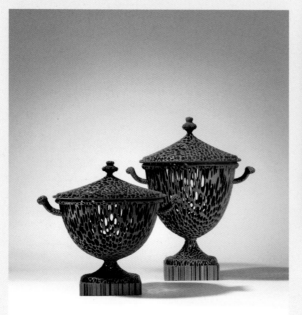

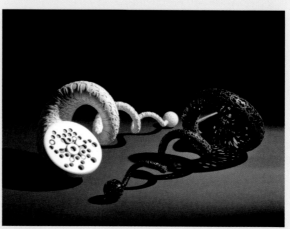

Michael Eden, 'Amalthea'. © Michael Eden.

Michael Eden, 'Wedgwoodn't Tureen, blue and green'. © Michael Eden.

Michael Eden, 'Babel Vessel', 2012. © Michael Eden.

I think the reason is that Fred Baier's comments link to the media of attraction, of being seduced by whizzy new tools. You have to choose the tools and materials and processes appropriately in order to communicate ideas or to solve a problem. You have to really embrace and get under the skin of what you are trying to achieve, and then go to your enhanced toolbox and choose the right way. If I want to make some espresso cups and saucers at the moment I will probably go back to the wheel and throw them.

Michael expands his argument with an example: given the current technological developments of 3D printing and his skill as a craftsman, if he needs to make a set of cups and saucers for a client, he can make them far more easily and quickly by traditional methods. In this case 3D printing offers him no advantages: "I want people to look at my stuff and be more interested in the stories, the 'why' not the 'how'. But having said that, if you look at handmade studio ceramics you are engaged as a user, viewer, buyer, with materials and process. You can't escape the process".

In order to qualify Michael's position further in relation to 3D printing and traditional craft skills, it seemed relevant to question what proportion of Michael's work was now 3D printed. He responded:

I haven't made any conventional ceramic pieces for some time actually. [...] having said that I've just been on the wheel this morning teaching a throwing class. But as I say, throwing is throwing and 3D is 3D. At the moment I take [my pieces] to a commercial company called 3T RPD but previously they've been made at the Bartlett's Digital Manufacturing Centre. In the past I have talked to the bureau service called 'Sculpteo' who have an interesting app on their website. I thought the technology that's behind that is quite amazing and just shows the potential of all this technology. That's what I like about it, that it's not resolved totally but it does have extraordinary number-crunching capacity.

In terms of the software the he uses, Michael mostly uses the beta Apple Macintosh version of Rhino3D, but has installed Parallels on his Macs so that he can access the Windows version and the T-Splines plug-in for Rhino. This allows for a more intuitive approach to modelling, though like all software, there is a lot to learn.

Michael needs to use proprietary software such as Rhino because the majority of his work is printed by 3D Bureau services such as 3T RPD, and these bureaus need to be able to read the files easily. "Occasionally they have to crunch some parts. The main problem with Rhino can be the Boolean extraction function so sometimes I have to send an object in two or three pieces within a file, and then the bureau repair it to make it watertight in Magics".

Michael comments on the barriers to the wider adoption of 3D printing:

Cost, learning software, it takes a while; it's a craft skill. Therefore it involves a lot of trial and a lot of error. Other limitations are the variety of materials available (but that is moving apace). If I am talking to students they are put off by the cost and having to learn the software. Those are the two main considerations.

Michael believes these barriers will be overcome, because the software will become more intuitive. He also argues 3D design students should be getting their heads around modelling systems. He qualifies this further:

"It's interesting seeing some students going through a transition period between 2- and 3D where they suddenly seem to understand how to

convert 2D ideas into three-dimensional resolved objects".

Michael believes craft skills are integral to 3D printing, commenting that he had found the process surprisingly seamless, but you do have to be determined:

> *I think it has it's own craft sensibilities and this overlaps between the traditional craft skills and the tacit knowledge that I have built up over the years, but I am having to adapt those skills and that knowledge and add to them. I feel as though I have been going through a transition and evolutionary process. I think I was of a disposition when I set out to want to learn and I think I have a fairly dogged nature to resolve issues, particularly in Rhino – 'it must be capable of doing this' – and I will work my way around problems. I guess some of the time I am using some fairly non-conventional ways to do things. I don't know if I am doing it correctly.*

When considering the future of 3D printing Michael predicts the sector is going to become more accessible with a wider range of materials. The technology will become commonplace and domestic over time. It will affect the distribution systems, have an enormous impact on the objects we see around us, both functionally and aesthetically. Michael illustrates his prediction with the example of the Aerospace company EADS in producing

door hinges for the Airbus with a weight reduction of 10kg, that could save $1000 of fuel a year.[14] Furthermore, he argues 3D printing is going to change large areas of life in quite unforeseen ways:

> *In terms of democratising design – allowing the individual to design well – just because you have Photoshop doesn't mean you should use it. You are not a graphic designer if you have Photoshop on your computer; you still need to learn to be a designer, so in terms of democratising design I don't think it will at all. Just look at stuff on Shapeways, it's grim most of it! But that is fine, I've absolutely no issue whatsoever, its great that people are engaging and throwing out this stuff.*

Michael concluded our discussion with a positive view of the future of 3D printing before qualifying this optimism with an almost apocalyptic view of what the long-term future of the 3D printer may hold:

> *If the 3D printer comes into the home and if you can print smaller domestic items in a range of materials or more complex manufacturing systems so that printer circuits can be integrated into the body of an object so you don't need to add that at a later stage – that's all going to come. Also the other area that I think is quite worrying really is the potential to print living/ biological material, we hear about being able to*

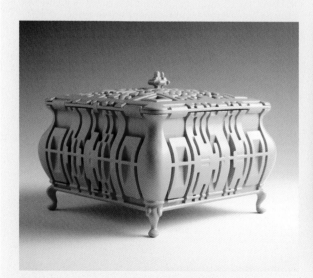

Michael Eden, 'Mnemosyne', 2012. © Michael Eden.

Michael Eden, 'Mnemosyne' viewed from above, 2012. © Michael Eden.

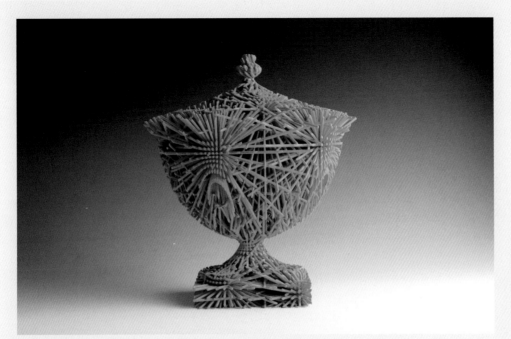

Michael Eden,
'Bloom-Green', 2012.
© Michael Eden.

produce new livers and kidneys and suchlike. As information becomes digitised and available as code then there is the potential to rewrite the A,G,T and C of cell structures. So the potential, if you have a digital version of the genome, has major ethical and moral issues that we aren't really engaging with.

Michael Eden entered the field of 3D printing much earlier than Jonathan Keep and Marianne Forrest but unlike the others he had to deal with materials that were not part of his personal practice. It is clear that the early works that Michael created were an interesting synergy of two processes. The 'Wedgwouldn't Tureen' was an excellent example of a Skeuomorph, which tends to occur from processes in transition. The ceramic vessel was not ceramic but used a material that closely resembled a glazed ceramic artefact. Michael Eden created a vessel that to all intents and purposes resembled a traditionally

manufactured 18th-century pot but in reality has a 3D-printed plaster-based core, which was then infiltrated with a ceramic loaded resin. I feel this work uses the current problems of 3D printing and presents them as a dialogue of the problems, where the pot is actually decorative rather than a functional ceramic object.

There is no doubt that both Marianne Forrest and Jonathan Keep have deliberately tackled the material properties and issues that arise from material properties more than any other of the practitioners I have interviewed for this book. In deliberately waiting until the technology developed Marianne could produce the result she was seeking. Jonathan achieved the result he wanted by treating the process as a malleable tool that he used initially in a very controlled digital manner and then intervening with his hands, using small lumps of clay as supports and a hairdryer; none of which are part of the toolkit as the manufacturer of the 3D printer intended.

1 'Labcraft: Digital Adventures in Contemporary Craft', Crafts Council Touring exhibition, 2012.
2 http://www.vam.ac.uk/content/articles/p/powerofmaking/
3 Fred Baier Associates, www.fredbaier.com, 2012. Interviewed in January 2007 for The Making website's 'Maker of the Month', http://www.themaking.org.uk/index.html
4 Sennett, Richard., (2008) The

Craftsman, London: Allen Lane, p. 20.
5 Sturt, George, (1923) The Wheelwrights Shop. Cambridge: Cambridge University Press.
6 Sturt, George, (1923) The Wheelwrights Shop. Cambridge: Cambridge University Press, p. 26.
7 Blender open source 3D software, the Stichting Blender Foundation, Amsterdam, the Netherlands. http://www.blender.org/

8 Skeinforge is a tool chain composed of Python scripts that converts your 3d model into G-Code instructions for Rapman. http://fabmetheus.crsndoo.com/wiki/index.php/Skeinforge. Bits from Bytes, 2012.
9 Eden, Michael, (2010) 'Things machines have made' in Craft Research, vol. 3, issue 1, May 2012.
10 Axiatec UK, http://www.axiatec.com Cleveland/Paris/St Etienne. 2012.

11 Ganter, Mark, (2009) '3D printing hits rock-bottom prices with homemade ceramics mix'. Science Daily, 10 April 2009, http://www.sciencedaily.com/.
12 Hollington, Geoff, (2007) 'Designing for the F**K You Generation', Interior Motives (3).
13 Sculpteo, www.sculpteo.com/en
14 Thryft, Anne, R., (2012) '3D printing flies high'. Design News. 15 October 2012, http://www.designnews.com.

The Fine Arts

In some senses, by the inherent nature of the discipline, the Fine Arts are one of the hardest areas to quantify. Practitioners within the discipline try to create new ideas and imagery that is deliberately different from their peers. Therefore any coherence within the discipline is going to be due to the restrictions of the process, rather than any deliberate intention on the part of the artists.

It is possible to argue that fine artists have engaged with the medium of 3D printing as a commercially available process almost since its inception. By commercial processes I mean beyond those situated solely within research departments. As demonstrated in Chapter 1, sculptors were creating 3D-printed works almost at the same time as the first commercial machines entered the market. (The first documented example I can find is the work of Masaki Fujihata in 1989,[1] which is within three years of the first commercial machine, Charles Hull's SLA1 from 3D systems.[2]

However, there is always a distinction between the earliest adopters of a process and a point when it gains more mainstream acceptance. This begins within the development cycle, when a new printing or manufacturing process is introduced and it begins to be adopted by artists as a creative process. One of

the indicators that a technology is gaining credence and creates artwork of standing, is the point at which artists begin to use technology as a means to an end, rather than for the demonstration of what the process itself can achieve.

I have stated before that early adopters tend to create artefacts, which, at best, look as though they are using a very specific technology. The most innovative work occurs when the images created use the technology as a means to an end. One of the earliest works that could be said to demonstrate this concept is 'People 1: 10' made between 1997 and 2001 by the German artist Karin Sander. Sander explains her creative process on her website.[3]

Karin Sander, 'Dietmar Glatz 1:10', 1997. 3D-bodyscan of the living person, FDM (fused deposition modelling), ABS (acrylonitrile-butadiene-styrene), airbrush, scale 1:10; c. 18 cm high. Collection Rebecca and Alexander Stewart, Seattle. Photo: Karin Sander ©Karin Sander 1999.

Karin Sander,
'Gerd Hatje 1:10', 1998.
3D-bodyscan of the living
person, FDM (fused
deposition modelling), ABS
(acrylonitrile-butadiene-
styrene), airbrush, scale 1:10;
c. 18 cm high. Collection:
Landesbank Baden-
Württemberg, Stuttgart.

People are laser-scanned using a bodyscanner that employs a 3D photographic process originally developed for the fashion industry. Their data is then sent to an extruder, which recreates their body shape slice-by-slice in plastic. It is a lengthy process, but it results in an exact reproduction of the person in question – a three-dimensional self-portrait in a pose chosen by the subject at one-tenth scale. The figure is produced entirely by mechanical means, and the replica stands in the middle of the exhibition as if transposed directly from the real world.

The models were scanned with a laser scanner, then printed by fused deposition modelling (FDM)

using an acrylonitrile-butadiene-styrene (ABS) plastic – once printed the models were then airbrushed and finished to match their scans.

The real proof of my argument is that Sander was interested only in the final result and the means to get there. In no circumstances are the models a demonstration of the process, they have been sprayed and finished after printing, so it is not possible to know how they are made unless you are told.

If one looks at the work of other artists it can be more difficult to quantify, for example, Rachel Whiteread's 'Secondhand', made in 2004. Here Whiteread had scans made of a set of vintage dollshouse furniture, which were then outputted at the same scale in laser sintered white nylon. Whiteread has a history of making monochromatic works that reveal the sculptural form of an object, but it is difficult to move away from the fact that these have a look of laser sintered 3D-printed nylon (this has a white appearance with a slightly ribbed texture). One is left to ponder: is Whiteread just using the process to her own ends or is that sentiment overridden by the inherent qualities produced by this particular aspect of the 3D printing process?

This highlights one of the problems that occur when articulating how fine artists interface with the medium. In fact many artists do not themselves interface with the medium at all and rely upon the skills of other specialists for the production of a one-off commission. This is not a criticism of such artists but merely highlights a difficulty in defining those that use the technology in a book such as this. Conversely those artists who collaborate with others to use the technology – precisely in those one off commissions – are often the very people who push the technology to new limits. I have tried to highlight some of these in both this chapter and at other points in the book.

1

1,2 'Secondhand', Rachel Whiteread, 2004. Stereolithograph of laser sintered white nylon. 11 x 16 x 10 cm. Produced by 3TRPD, Newbury, Berkshire. © Rachel Whiteread, Counter Editions.

2

The Centre for Fine Print Research (CFPR) has printed in 3D for a wide range of artists for the last seven years and the best exemplar of the work we have undertaken is, in my view, the 'Medal of Dishonour' for the late Richard Hamilton.[4] In 2006 Richard was commissioned by the British Arts Medals Trust to make a medal of dishonour for the British Museum as part of the exhibition, 'Medals of Dishonour', to be held at the Museum in 2009. Richard came to the CFPR as he wanted to transcribe a photograph of Tony Blair in relief onto one side of the medal and a photograph of Alastair Campbell on the other. In his discussions with the foundry, he found that they had no means of digitally transferring a photograph to a relief surface, apart from sculpting the medal by hand. (The foundry may have not been aware but creating a relief surface from greyscale image is a widely known and standard technique.) Richard wanted to see if we could 3D print the master matrices for casting. The very nature of this process harks back to the photo-relief imaging of the Woodburytype process. Over the course of two years we tried every 3D printing process we could obtain access to including wax printing, Envision Tech, Z Corp, Objet, Stratasys and EOS. Whilst all of these had some advantages, none gave the quality of finish that Richard was particularly striving for; the technology at that point was simply not capable of producing the desired result.

However, what the visual appearance of the 3D-printed versions did achieve was to help both Richard and the CFPR team to resolve what the final piece should look like. Finally the piece was CNC milled in model board and the moulds were made from these milled matrices. This does mean that in reality the piece was not 3D printed, but as I have already said it is the path that one takes and the intention one has to create a good piece of art that is important!

One of the difficulties within the Fine Arts is the dichotomy between concept and process. In the second decade of the 20th century most artists are more concerned with concept and the means of production has become almost secondary, which can make it difficult to find artists who are consistently using particular technology.

Richard Hamilton, 'The Hutton Award' (Tony Blair), from the series 'Art, Technology and a Medal Designed for Dishonour', 2008. Collaboration with CFPR 3D Print Lab.

Richard Hamilton, printed trials from the series 'Art, Technology and a Medal Designed for Dishonour', 2008. Collaboration with CFPR 3D Print Lab.

Screen grab of bump map rendering for Richard Hamilton's the series 'Art, Technology and a Medal Designed for Dishonour', 2008. Collaboration with CFPR 3D Print Lab.

Richard Hamilton, 'The Hutton Award' (Alastair Campbell), from the series 'Art, Technology and a Medal Designed for Dishonour', 2008. Collaboration with CFPR 3D Print Lab.

1 Rick Becker, 3D-printed small-scale maquette for Vietnam War Veteran's Memorial, San Diego. © Rick Becker.

2 Rick Becker, Vietnam War Veteran's Memorial, San Diego. © Rick Becker.

One example of an artist who will use the technology whenever it is expedient is the American figurative sculptor Rick Becker. Rick's most recent commission was the 'Homer Simpson Memorial Bust' for the Fox Broadcasting Company, to celebrate the 500th episode of The Simpsons. I also suspect that Rick is just one of many artists who use the technology in this way, almost without being aware that they are using 3D printing processes. In early 2006 Rick supplied the Centre for Fine Print Research with a set of scans that had been made by his foundry in New Mexico. These were scans of a maquette for a large bronze sculpture, commissioned by Vietnam

War veterans, including a group of men who had been POWs, in San Diego as a memorial to their fallen comrades colleagues. The scans had been made by the foundry in order to scale the maquette to a full size 14-foot high sculpture. In the meantime the veterans wanted to sell copies of the maquette, to raise funds in order to cast the full-size sculpture.

Initially Rick came to us with the scans to produce a 12 inch plaster 3D-printed Z Corp model to show the veterans what the maquette would look like. The unexpected bonus for Rick was that because the model was made in plaster he could rework the maquette beyond his original model in order to further

achieve what he had intended with his first models.

Rick started his sculpture in the traditional manner with pencil sketches, then moved to a more detailed clay maquette that was about 18" in height, which made it small enough to quickly sculpt and modify. Rick works small to finalise the important aspects of the composition, which would be much harder to change at full scale. Once they saw the maquette, the veterans asked if Rick could make them a small replica of the monument for their fundraising. He was able to scan and print the maquette at a small size for plastic casting, since the clay maquette had been 3D scanned anyway for the armature enlargement. The clay was scanned at Cyber FX in Burbank near Hollywood in California. Cyber FX does lots of work for the TV and film industry, scanning live actors for wardrobe, special FX as well as sculpture enlargements etc. Rick explains:

When I received the 3D prints from [the CFPR] I saw some items I wanted to modify for both artistic reasons and for moldability. One of the materials carved much like plaster, nice and smooth. I made the modifications on this print. I also added hard plasticine clay in areas I wanted to build up.

Tom Banwell at Cyber FX in Northern California made the plastic figures via silicone moulds. Rick says:

Tom created a faux bronze patina – copperish colour with a rubbed blackish wash. They were a bit dark but the blackish wash stuck in the STL-induced recesses making it hard to burnish back to a lighter colour. In hindsight, I would have sealed or smoothed these better prior to melding.

Commenting on the results from the final finished piece Rick says:

The American Ex POWs added the little statues to their website (www.sdpow.org) offering them for donations of above $50 I think, and gold versions for bigger donations. They sold several hundred I believe. These little statues were instrumental in their very successful fundraising and political support/networking, enabling them to fund the major 14ft statue that now stands in San Diego.[5]

Mark Wallinger's 'White Horse' provides a further example of 3D laser scanning which is then transcribed to a small model. The model functions both as a maquette for a larger piece and as a sculpture that can be editioned in its own right. To quote from his gallery press release.[6]

In 2009 Mark Wallinger was awarded the commission for a monumental sculpture for the Ebbsfleet Valley development in Kent. His winning project was for the erection of a white horse, 50 meters high, realistic in all detail – a thoroughbred stallion of immense proportions, standing in a field in the countryside.

The sculpture has yet to be built as the costs have risen from £1 million to £15 million. The small-scale work made using the scans for the large sculpture was undertaken by Chris Cornish, who runs the scanning service Sample and Hold.[7] Sample and Hold were asked to 3D scan the thoroughbred racehorse 'Riviera Red'. This posed a number of unique challenges relating to the local and overall movement of the subject – made all the more critical by the requirement to capture the horse in a specific pose. Two different capture techniques were employed: an infrared handheld scanner and a white light photogrammetry method to instantaneously capture a 3D cage of reference points and to anchor the more detailed scan data. Once the scan had been adjusted to make it watertight, the mane and tail were then drawn and added to the scans. Next, a solid 3D print was produced using an Objet printer from which the final mould was made. The sculptures are 1:10 scale of the real horse and approximately 1:250 scale of the final landmark.

It is clear that, these days, a large number of successful fine artists are used to having their work made for them. So the ability to 3D print and scan armatures and small-scale models and to have them scaled up to large sizes is something of value that artists and sculptors – in particular those who produce large-scale work for public commissions. In the 21st-century we have moved away from the (still commonly-held) view that the fine artist works in isolation in his or her studio. I am aware this is a gross generalisation – in the case of sculptors this has almost always been the case, it is not possible

to make a very large-scale work in isolation and few sculptors can afford the luxury of their own foundry or forge. Additionally, the underlying armature or structure of a sculpture has nearly always been created by an assistant and it was only the final surface that was finished by the master.

However, even if the work is made for you, there is a clear distinction highlighted by the choices that are now created between traditional craft processes and the new more hands-off or apparently remote digital technologies. The traditional craft process offers the artist full personal control over all aspects of the process and utilises physical hands-on experience, to gauge the quality and feel of the work. The new technologies offer a remote hands-off process that is quicker and easier and frees the creator from the responsibility of construction. This is perhaps slightly different in its theoretical or philosophical approach from the craftsperson's traditional understanding of materiality, highlighted in Chapter 3. For example, these processes may offer more to artists such as Karin Sander where the tactile and material qualities are perhaps less important than conveying the conceptual context of the work.

I believe there is still a need to understand fully the inherent and tactile qualities of the material being processed, even if you are working with it in a more remote fashion. However, I now think there is a distinction between those artists who want to use the material qualities as they are working and those artists such as Jeff Koons who feel they can rely on others to convey that tacit understanding of materials for them.

By the late 20th century, separate to the advent of 3D printing, even that final finishing undertaken by the master had been handed to others. Examples of this can be seen in the work of Jeff Koons, who deliberately seeks out craftsmen who make a particular range of commercial objects and then has large-scale versions made by those craftsmen – there is no intervention from Koons himself. Damien Hirst[8] also employs a large band of artists to create his spot paintings and prints. Hirst stipulates a range of colours in order to create a palette and then leaves the studio artists to select

from the palette and paint or print the images to their own colour choices.

During the course of writing this book I have interviewed a wide range of artists, designers and craftspeople to gain knowledge of a practitioner's approach to 3D printing. Rather than repeat these transcriptions verbatim, I have summarised the interviews and tried to maintain the flow of our discussion around a set of prompt questions (see interview questions in Appendices).

In light of the above discussion, for this chapter I opted to interview two artists who are fully involved in the creation of their own work. This may seem like a contradiction when discussing 3D printing – because 3D printing removes 'the hand' from its manufacturing process. I have clearly articulated that many fine artists are making their work remotely – without making the actual work themselves. The artists included in this section began their digital practice in the early days of personal computing and its relationship with art and they both have a hand on traditional sculptural background. Professor Keith Brown from Manchester Metropolitan University has been cited in Chapter 1 as an early adopter of 3D printing for his sculptural practice. Tom Lomax began to make 3D-printed sculpture through his research into the subject of computers in art at the Slade School of Art, University College London.[9] However, Tom was first introduced to CAD and CNC milling as an engineer in the late 1960s and started using CAD software in the late 1980s. Therefore both of these examples are long-term users of digital technologies and I hope I can convey an understanding of how they approach the process from an informed user perspective.

KEITH BROWN

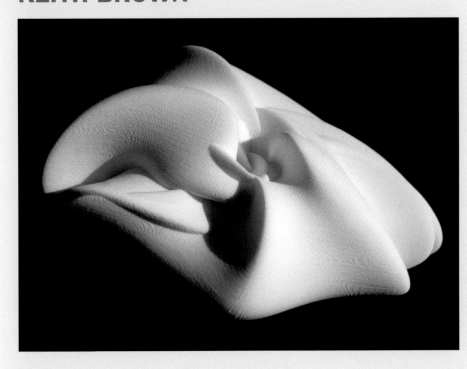

Keith Brown, 'Continuity of form', from the 'Calm Project', 1997. 7½ x 6 x 3¾ in, SLS. CALM PROJECT © Keith Brown

To sculptor Keith Brown, computing technology is an essential aspect of his creative practice and is indispensable to the conception, content and quality of the artwork. His main concern is with what he describes as 'Real Virtuality' or 'Cyberealism' – rather than 'Virtual Reality' – thus reversing the usual order between the cyber and the real. It is not his intention to emulate reality but instead to explore the possibilities made available through computing technologies and to bring these to a form of "manifest actuality", resulting in the production of a "new order of object", presenting us with new forms, realities, experiences and meanings in what can be seen as a paradigm shift within the discipline of sculpture.

We began our discussion by outlining how Keith started using the computer as a design tool in 1981. At that time he was lucky enough to have access to a Quantel PaintBox,[10] which was shared between Manchester Polytechnic and Blackpool and Stockport Schools of Art. Each had one year's access at a time on a rotational basis and the machine finally ended up at Manchester in Keith's office. (The machine was one of only three in the UK, the other two were at the BBC and Hornsey College of Art). Keith says:

The PaintBox was capable of 24-bit colour, real-time graphics via keyboard or touch sensitive tablet and had a whopping 160 MB hard drive (to put this in context, the Apple Mac had yet to be invented and this was the year that IBM introduced their first PC that ran MS Dos 1.0). Although primitive compared to today's terra byte world, it gave insights into the potential application of computer graphics as a sophisticated design tool.

Before Apple's visual interface with symbols, drag, click and point GUIs, followed by Windows on the PC, the prompt line required learning a disk operating system, which for many artists, including myself, presented somewhat of an obstacle. In the early days, before Windows, the Mac was primarily a DTP device and not much use for 3D applications. I was forced to use the PC and had to get to grips with DOS and PC software, which offered a higher degree of versatility and functionality for 3D computer modelling. To place Keith's comments in context to this early use of powerful computing, the first Mac that most people had access to (in 1986) was the Mac-plus with a 9-inch screen and one megabyte of total memory. In 1984, the

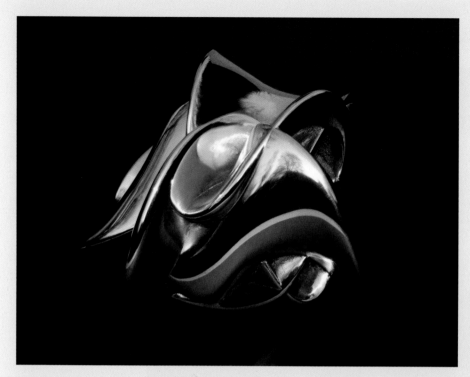

Keith Brown, 'Bough', 1999.
7 ½ x 7 x 5 ¼ in. ThermoJet
wax print; burnished bronze.
© Keith Brown

first Mac had only half a megabyte of memory and cost over £2,000.

Having used the computer as a design tool in the mid-1980s, with the dramatic increases in speed and capability of both software and hardware, combined with powerful graphics engines, Keith began to realise that the virtual digital domain was a medium in its own right. So by the early 1990s his work had become completely virtual and for a time he ceased to make "real objects". His main output at this time took the form of 3D computer-generated animation, video and installation. This was further enabled in the 1990s by access to SGI 3D graphics engines and advanced software offering real-time functionality. After making a presentation on 3D graphics and VR (virtual reality) at the first Computers in Art and Design Education (CADE) conference in Brighton in 1995, Keith was invited to join the HEFCs Higher Education Funding Council, JISC, JTAP (see Glossary) steering committee as an adviser for the CALM project (Creating Art with Layer Manufacture). The CALM project introduced art and design academics from throughout the UK to CAD and RP (rapid prototyping) technologies. As a result of working with CALM in 1997 Keith had his first 3D print 'Continuity of Form' printed in SLS as part of the project, thus bringing his work back to the physical object.

All of Keith's work begins within the digital domain and a high proportion of the work is intended to be output via 3D Printing and RP when the opportunity arises: "I now have countless sculptures on disk waiting to be made manifest via additive manufacturing processes." He estimates about 90% of his work is intended to be output this way. Perhaps 10% is directed towards augmented realities, large-scale 3D integral image projection into true space, lenticular integral imaging (similar to holography) and 2D digital print. Keith argues his work would be impossible to envisage and make using traditional means, either with machine tools, or by hand; it is completely dependent on the computer and related output technologies. He advocates that the incredible versatility of 3D printing offers artists and designers the ability to generate and make otherwise impossible objects.

As a very early adopter of the technology it would be easy to place Keith in the same arena of artists who make works that look as if they are made with the technology. I feel this view is disingenuous, since as others adopt the technology these images of impossible objects, such as 'Klein' bottles, become ubiquitous and mask the work of those who, like Keith, have been working with the technology for many years and have worked through its limitations.

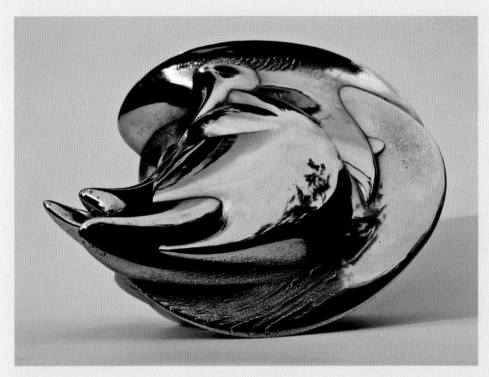

Keith Brown,
'Revolver', 2001.
7½ x 9¾ x 7¹/₈ in.
ThermoJet wax print;
cast bronze.
© Keith Brown.

When asked if all of his work is solely 3D printed, Keith takes my question literally, answering that he does not combine 3D printing with other technologies to make his works. The very nature of his activity derives its qualities from the medium and processes involved in its production. However, he has taken detailed casts from 3D prints and cast them in bronze (a more traditional way for fine artists to make a 3D print). As much as possible the detail of the RP process is retained in the finished cast object. I assume that to cast from a 3D-printed item is a combination of technologies much as the earlier examples of Mark Wallinger and Rick Becker. However, that may be taken as a purist definition of 3D printing and I understand that Keith has taken me literally assuming that the object is not 3D printed if its taken from a cast that has been 3D-printed not the object itself. I believe that much of the future of fine art is based within these combinations of utilising the technology.

When we discussed software packages he told me that he has used Autodesk 3ds since version 2 (before 3ds max) which is a surface modelling software used a lot by animators and in the gaming industry. He also uses 3ds max 2013. It gives him the tools he needs for his work and after using it for so long it has become very intuitive, having established an understanding of its parameters, limitations and capabilities:

For software reasons I've used the PC since the 1980s and I now run Windows 7 on a dual Xeon Mac Pro with a good graphics card and 12GB DRAM (dual random access memory). My software doesn't run on the Mac OS, but dollar for dollar I get more for my money from the floating point than I would from a PC. Most of the geometry is handled by the CPU and I'm very familiar with Windows XP 64.

Our discussion moved on to focus on the barriers to the wider adoption of 3D printing. Keith argues that this depends very much on what you want from the technology:

Selecting the appropriate hardware and software necessary to meet your needs requires some understanding of the range available; all have their pros and cons, advantages and limitations, and it also depends on how deep your pockets are. Cost is still one of the greatest barriers, and like all printing technologies consumables are very expensive.

One notable exception to this is the MCor Matrix300 which uses inexpensive A4 laserwriter paper and an inexpensive bonding agent, boasting costs at one-fiftieth of their nearest rivals. He points out that:

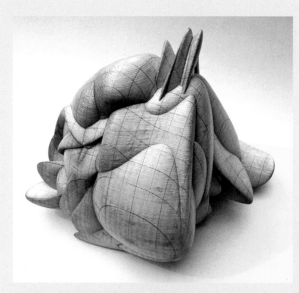

Keith Brown, 'Geo_04', 2003. 16 x 16 x 14 in. Paper (LOM). © Keith Brown.

will obviously be an important factor when it comes to sensibility. Much of this resides with the artist. For me the art occurs in the modelling process, where one's sensibilities are applied intuitively, along with emotion and intellectual accompaniment. Like all material processes 3D printing does have its qualities – there's an increasing variety of materials and processes becoming available as RP moves towards AM [additive manufacturing]. It's not so much the qualities of the processes or materials themselves but rather what one does with them.

Keith believes that the sculptures he creates could not be conceived of outside the digital domain and that the only technology available to actually transpose many of these extraordinary compositions into a material form is 3D printing. He argues that the ability of 3D printing to faithfully emulate the most complex of object surfaces, with a very high degree of accuracy, totally transcends what is possible by hand or achievable with other technology. He maintains this is especially true where intricate internal cavities, complex meshes, and 'deep convoluted undercuts' prohibit access by hand or other tools such as multiple axis CNC milling machines. As a professional practitioner of some 45 years, Keith has worked with a wide range of sculptural processes, materials and techniques: from miniature to monumental. In all of these, including 3D print, it is his belief that the 'art' (whatever that might be) transcends the 'medium':

> There's a big difference between paying £100 or just a couple of quid for the same 3D-printed object. Scale, being related to machine time, plus material costs – for anything of size this becomes very, if not prohibitively, expensive. Doubling the size of a 3D object multiplies the volume by a factor of eight. A one centimetre cube might cost as little as £1 but a one metre cube on the same device might set you back as much as £10k.

He sums up the issue perfectly by arguing:

> For first time users the software can seem to be overwhelmingly complex with some applications having thousands of adjustable tool parameters; navigating a multidimensional virtual space requires a particular 3D mindset and like many other mediums it requires patience, practice and perseverance to understand and master.

We then went on to explore the issues around whether Keith, as an artist, thought he was giving up his traditional craft skills, or if he thought 3D print has begun to develop its own craft sensibility.

> I don't think 3D printing has a sensibility in itself, since this only applies to sentient beings. Depending on how the technology is applied

> However, in many instances one must acknowledge (in the Marshall McLuhan sense) that the medium is the message. In facilitating the creation of objects never before possible, this is certainly the case with 3D printing, whatever is made with it; the good, the bad and the mediocre. For me it's not so much giving up traditional craft skills as it is embracing the possibilities made available through this amazing new computing technology.

We concluded our discussion by exploring where Keith saw the future of 3D print for artists, designers and craftspeople. His position is that to predict the future of an art form or artistic technique is always a problematic, if not futile activity. He argues:

> It might be safe to say that with the invention of 3D printing and its continued and rapid development since the early 1980s it is

reaching a point now in the second decade of this millennium, where, due mainly to plummeting costs at the top of the range, which offers high resolution and speed, to the recent emergence and proliferation of new, low resolution, DIY systems that afford low-level entry for just a thousand pounds or so, we are witnessing a sudden and massive take-up at all levels.

Keith subscribes to the view that now that the domestic computer has become ubiquitous, and CAD freeware readily available to download, the user base is growing rapidly with enthusiastic amateurs able to afford to enter a field previously only accessible to a privileged professional specialist. He expects within this decade 3D printing will follow the path of 2D desktop colour printing in the 1990s, becoming commonplace and with a vast variety of applications. Keith believes that the impact this will have for manufacturing is enormous:

> *With relatively modest outlay the freelance artist, designer, and craftsperson, equipped with a computer and 3D printer, will be able to offer their services and wares to an international clientele through already well-established international ordering and distribution systems made possible via the World Wide Web.*

With the continued development of 3D printing technologies, many currently in R&D, with the capability to deliver a broader range of permanent materials (some with build envelopes extending to several meters), with exciting implications for architectural and engineering applications, current material size restrictions will no longer be an issue. In conjunction with the ability to simultaneously print multiple materials at either micro or macro levels, the sky is the limit and the mind boggles! Additive manufacturing has come a long way since the invention of the coil pot and the humble brick, and no doubt it has an exciting future ahead.

In contrast to my view, Keith sees the drop in price leading to more universal access of the technology. I do not believe the cheap desktop will be capable of printing materials to an acceptable standard for general consumption. This view may well see the dominant future in the mid range of technology adoption and I could see artists and designers offering their services as an interface between the consumer and the production bureaus.

However, I do firmly agree that there is an exciting future ahead with a real potential for artists, designers and craftspeople to be central in the adoption and use of this new technology.

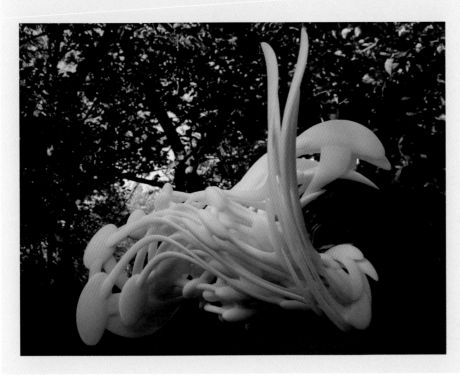

Keith Brown, 'Crest', 2009.
11 x 16 x 14 in. ABS plastic.
© Keith Brown

TOM LOMAX

Tom Lomax, 'Anael', 'Angels' series, 2011. Printed at CFPR 3D Print Lab, Bristol. © Tom Lomax.

I place Tom Lomax's work in the tradition of Marinetti and the Italian Futurists. Tom himself says he comes from a fine art background and would place his influences even further back than Marionetti, towards the Suprematicists. As he makes pieces in the 3D software he is always thinking of relationships to fine art practice and fine art objects, both historic and current. He moves between figuration and abstraction – although the 3D colour pieces printed at the CFPR have been totally abstract. Tom views his work from a modernist point of view – looking at the formal aspects but also in the more contemporary context where there are illusions and allusions within the pieces – all are steeped in the sculptural tradition. Although he qualified as an engineer, Tom went on to study painting at Central School of Art in London and continued his postgraduate studies (also in painting) at the Slade School of Art, University College London. Tom explains

his design sensibilities come from his early days as an engineer, before he went to art school and at that time he was very interested in objects that were very functional and how they were made. Therefore he currently sees his main practice is that of a sculptor:

It's all from a sculptural point of view, I still paint and I still make painterly images – but the colour, if you like, is the thing that underpins the relationship with the paint and the painting. When I was making my bronzes I would paint them with wax pigments or I would make patinas that were colourful rather than just a kind of oxidisation or a way of holding a form together – I would want the colour to play an aesthetic role within the piece. So I use polychromatic colour in the way that the Greeks or Romans used to do it.

In some ways this view is reflected in the coloured work he now makes with 3D printing as you can see from the examples below in the illustrations of Tom's work.

Initially, however, the engineering aspect of Tom's early career laid the basis for his digital work. He describes how he first encountered early computer numerical controlled machines (CNC) in the early 1960s:

> *I first came across a CNC machine in 1962 when I was working down in Weybridge – it was huge and was used for cutting the wing sections out for DC10s (aeroplanes) when I saw it in operation and saw it just automatically bolting the wings together I thought 'well this is the future.' So from that type of engineering I've always had that interest in the numerical world and how it linked with geometries and how you positioned things in space.*

Tom got involved with CADCAM to bring these ideas into the world, but his practice is still studio-based: he still makes small bronzes, and he still uses plotters, mechanical cutting tools etc. So the early foundry and engineering aspects have laid the foundations for his current work. His practice has taken on this understanding of referring back to sculptural activity through geometry and through the way things orientate and place themselves with one another. In that sense his work is very much of a sculptural tradition and in line with contemporary fine art practice.

Tom is a pragmatist and explains how he first started to use computers in his work. He was in France doing drawings for a project where he was working in a big open barn, the wind blew and as he dragged the drawing board slide down the paper, all of the dust that had collected underneath created a dirty mark right across the drawing. At the same time his son was using Paint on his computer indoors. Tom went in to the house and just by sticking

Tom Lomax, 'Raphael', 'Angels' series, 2011. Printed at CFPR 3D Print Labs, Bristol. © Tom Lomax.

Tom Lomax, 'Cafiel', 'Angels series', 2011. Printed at CFPR 3D Print Labs, Bristol © Tom Lomax.

and pasting re-did all the design that he had done on the drawing board in a very short time (and in comfort) on his son's computer. Following this breakthrough Tom tried AutoCAD (at the time used by architects) but found it too difficult. In around 1992 he discovered the Bentley MicroStation, available in Microsoft Windows, he clicked with it straight away. Tom began to use the MicroStation to do all his public art and engineering projects and became aware that as an engineering CAD package, the Bentley MicroStation had to have other qualities. He started to notice that the design of the programme was not restricted to tight engineering requirements i.e. you could get into it and 'mess about', the parameters were open rather than closed. So although it was very difficult, Tom started to understand that you could actually pull the software apart and do other things with it outside of engineering. It was at this point that Tom started to think of the programme as a good sculptural tool that could be improvised.

In 2000, Tom was granted a two-year Henry Moore fellowship. By then he had about 15 years of CAD experience and was still using Bentley MicroStation – but a more advanced MX version, that had become quite sophisticated for Tom's purposes. In fact Tom prefers it to Rhino because, in his opinion, Rhino seems to be trimmed and slightly predictive. So although he finds

Bentley MX a bit messy it is also more open and allows him to explore more possibilities. He was also making parts on CNC machines as they had one at the Slade for research. Therefore he started to look at the various physical applications and how he could use the way the geometries worked to his benefit. He started to see that CNC machines were interesting in a sculptural carving type of way. He first glimpsed a 3D printer when he saw a television programme about the design company Seymour Powell which created the Bioform Bra using a 3D printer.

... and you saw this co-polymer liquid and a tiny bit of string and then the laser beam started going round and then it pulled the object out and the object formed on top of the co-polymer as it pulled it out and I thought, 'well that's like the CNC magic that I saw in the 1960s' [...] that point [is] when I started to think, 'well this is the future of sculpture'.

Tom currently uses Bentley MicroStation, Magix and Rhino but tends to leap between Rhino and Micro station. He uses Magix a lot because he can dissect, extract and extrude really well with it in a way he cannot in MicroStation.

Currently, the most important tool for Tom in CAD is Boolean extraction. He argues that Boolean extraction is a sophisticated form of sculpture tool where you extract things and manipulate objects easily:

> The thing I really like about CAD is that it gets you away from that thing in traditional sculpture where you have to pay homage to the armature, you're always trapped by the armature – so it's a sort of modern modelling thing where you get it all done in your mind and on the page and that's how I came to make these forms.

Tom explains:

> Computer drawing for me is two things: one is articulating form as your brain and eye co-ordinate things, and the second is as a tool for thinking. I agree that you have to go through that hand–brain process inherent in using a pencil, so you won't recognise it on a computer, as its just going to be a line on a page in a computer. But what it won't teach you is how, by engaging the hand and the brain, you explore space. Even simple software like SketchUp which are very easy to use have no manipulation of space in a dynamic way. I think that the later software packages, which have been developed recently, are more interesting for me as they begin to bring that drawing sensibility to it, and allow you to discover the possibilities.

Whilst teaching at the Slade School of Art Tom found that people would come to him and they would treat him as a service, i.e. "I want this made in three dimensions" and so on and he would have to tell them that he couldn't. He would have to explain to his students:

> Yes you can scan it and yes you can reproduce it but you've got to learn all that – you can't just have it, and that's where we had a real problem because the students wouldn't sit down and do the work! The students don't realise that you've been doing it for 10 years – sat up late at night racking you brains trying to make it work and they just want it all instantly. Do you think somehow somewhere along the line that we've deluded people by saying that its easy?

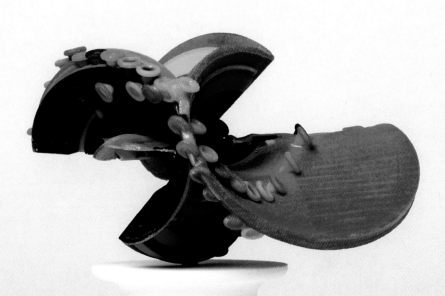

Tom Lomax, 'Michael', 'Angels' series, 2011. Printed at CFPR 3D Print Labs, Bristol. © Tom Lomax.

For Tom, what is interesting about this technology is that it allows people to make things in a very imaginative way, especially with 3D scanning, and the latest developments in that area. For example:

▬▬▬ *Chris Cornish and I scanned Mark Wallinger's horse. He got in touch with us at UCL and Chris and I went down to these racing stables that [Mark] has down in Epsom. He had this horse called [Riviera] Red and we scanned this horse. As you can appreciate things that are alive like that, they don't co-operate with you. To scan a horse was going to be virtually impossible and some of experts said you won't be able to do it to any high degree of quality. And then this new scanning machine came out that could scan in real time and as it was scanning the horse, whenever the horse moved, it registered that it moved it would stop and start again, optimizing the form almost like a 3D video, going around it, and every time it stopped we knew we had a different set of data then and a new set of geometries to work with. Now [that] Canon has brought a camera onto the market that does this soon everyone will be able to do this 3D.[11]*

We concluded the discussion by looking to the future of 3D printing and whether he felt it has its own sensibilities. Tom believes that 3D printing definitely does have its own sensibilities:

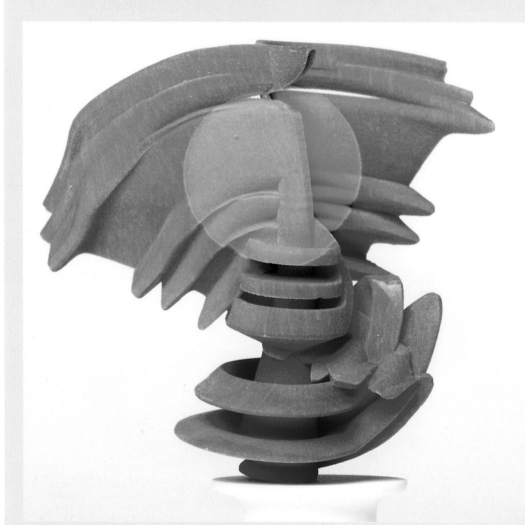

Tom Lomax, 'Gabriel', 'Angels' series, 2011. Printed at CFPR 3D Print Labs, Bristol. © Tom Lomax.

Tom Lomax, 'Sachiel',
'Angels' series, 2011.
Printed at CFPR 3D Print
Labs, Bristol.
© Tom Lomax.

▬▬ *... there are no 'ifs' and 'buts' about it and as I said I still keep up my traditional skills of making bronzes and I still draw and paint. I would say about 70% of my practice is taken up with 3D print or CAD, 20% is with 2D prints, and making bronzes only about 10%. At the moment I don't combine 3D print with anything, I like the purity of it, I like the illusion of it too where its split into hundreds of layers and that's enough for me. I think the technology will only get better and it will be unique as it is ... sometimes I get tempted to do reverse engineering and making a print then electroplate it but that's still in my imagination.*

And on the future of 3D printing? Tom's view of the future, quite understandably, relates to his personal practice, therefore he would like to be able to print both larger, faster and in better, more permanent materials.

Tom's own art relates to the figure so in the future he would like to have the ability to more easily capture scanned imagery and then work with it, and where he can rely on a file that is watertight and printed without having to patch it up is very important.

▬▬ *In the future I think once they perfect these 3D sintering materials like titanium and stainless steel with enamel powder it will open up a whole new area of coloured sculpture that is just too expensive at the moment. Voxeljet now make a machine four metres by one metre. Also the scanning and CAD disciplines are overlapping to produce new and exciting forms and that is what I am looking forward to.*

There are obvious similarities between these two artists in that they have both been involved with computers in art for the last 20 years and they both make work concerned with form and movement. However, I think that they are fundamentally quite different. To me, Keith Brown has been more concerned with the development of computer and digital technology. I think his concerns are how this development has philosophically influenced his approach both to the art and to how he approaches the technology which is core to his personal practice. Tom Lomax, on the other hand, is much more of a direct user and the technology is only an expedient means for him to create his art.

1 Masaki Fujihata. Personal correspondence by email, July 2012.
2 Hull, Charles, W, (1984) *Apparatus for production of three-dimensional objects by stereo lithography.* Patent Specification no. 4575330. United States Patent Office, filing date 8 August 1984.
3 Karin Sander, July 2012. http://www.karinsander.de/index. php?id=e5

4 Attwood, P. Powell, F., (2009) *Medals of Dishonour*, London: British Museum Press, pp. 96–97.
5 Rick Becker. Personal correspondence by email, September, 2012.
6 Anthony Reynolds Gallery, (2012) Press Release, 7 November 2012. Available from: www. anthonyreynolds.com/news/documents/ PressRelease.pdf.

7 Chris Cornish, 'Sample and Hold' http://www.sampleandhold.co.uk/, 2012.
8 Singh, Anita, (2012) 'Damian Hirst: Assistants make my spot paintings but my heart is in them all'. *Daily Telegraph.* 12 January 2012.
9 Tom Lomax, http://www.ucl.ac.uk/ slade/research/staff/archived-research/ project-7

10 Pank, Bob. *The Digital Fact Book Converged* Media, 20th Century Anniversary Edition, www.quantel.com, 12 November, 2012.
11 Canon camera and Pico Scan, http://www.4ddynamics.com/3d-scanners/picoscan, 13 November, 2012.

Design and designers: case studies from contemporary designers

Designers are among the greatest users of 3D both in terms of the volume of individual practitioners and experience of exploiting the technology. Therefore, in order to explore the way designers use 3D printing, I have decided to split the various design disciplines into two categories – industrial designers in large corporations and lone or small studio design entrepreneurs.

The first category, of industrial designers, is composed of those designers who work within larger corporations, where design is integral to the company product line. In this arena 3D printing for rapid prototyping has been the norm for the last 10 years, which is primarily due to the larger resources of big companies. Formula 1 racing teams such as Lotus Renault and Red Bull and the luxury multi-national car companies such as Aston Martin and Bentley[1] all use 3D rapid prototyping to experiment with new body shapes and parts. Footwear companies from Adidas to Clarks[2] use 3D design for both shoes and different sole types and patterns. Ceramic companies such as Denby Potteries and Costa Verde in Portugal have also used the technology for a number of years.

Toy companies such as MakieLab and Disney also use 3D printing as it allows them respond quickly to market demands or the latest craze and try new designs without having to create specialist tooling:[3]

Children's entertainment giant Disney are currently researching the role of 3D printing in the creation of a new kind of toy. The research focuses on developing interactive devices with active components, with these devices created as a single object rather than assembled from individual parts. The team of researchers at Disney's Pittsburgh lab have used 3D printing technology to create "light pipes" which provide flexible alternative to optical fibre. By printing the pipes to fit a toys specific form it was possible to place and light pipe intersections with greater ease than would have been possible with traditional lighting fibres.

Denby 'Halo' teapot, cup and saucer. © Denby Pottery.

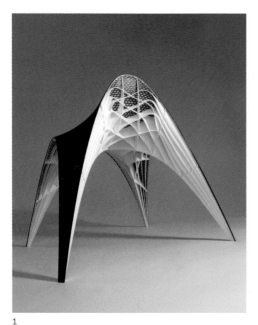

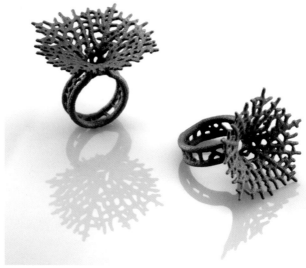

1

2

Whilst this may only cover a small number of companies and a relatively small number of designers – this group is by far the biggest user of 3D technology measured by production volume and influencing the development of the sector.

In the second category are the lone designer entrepreneurs who are typically making artefacts for sale direct to the public. This category of design is exemplified by Assa Ashuach, Lionel Dean and 'Freedom of Creation'[4] who have been making 3D-printed items and selling them directly via their website since 2001. Freedom of Creation are probably best known for their iPhone 4 cases and the Gaudi Chair, which was one of the first pieces of furniture to be printed in an SLS (selective laser sintered) nylon and carbon fibre. They now make a whole range of design items from lamps to tables and chairs to jewellery. As a result of their success through this model they now sell more conventionally through their four shops in Holland and other outlets such as the Apple store in the US.

Another group of designers that I have included in this lone designer category are the jewellery makers, who define themselves as designers rather than craftspeople. Jewellers often use 3D rapid prototyping because the economics of producing many small parts in one build make it more viable to use expensive technology and materials. I have also chosen to differentiate between classic jeweller/ silversmiths and craftspeople such as Marianne Forrest (where material qualities and craft skills are essential to their practice) and designers who make bespoke jewellery using 3D printing – one of the best examples would be the Boston-based duo Nervous System. Nervous System was founded in 2007 by Jessica Rosenkrantz and Jesse Louis-Rosenberg. They are a design team who trained in architecture, biology and mathematics at MIT. They mainly make laser sintered nylon and metal jewellery but they also create puzzles and lamps. Their work is available online and through specialist outlets such as the San Francisco Museum of Art store. Nervous System jewellery designs are often based upon self-generating mathematical algorithms and complex mathematical jigsaw puzzles. I would argue that Nervous System make jewellery not because of the material qualities inherent in the material it is made from, but to create an object that is economically viable but which still contains the qualities they are seeking through a 3D-generated, digitally conceived work. In the last five years Nervous System has built a successful web-based business that sells innovative

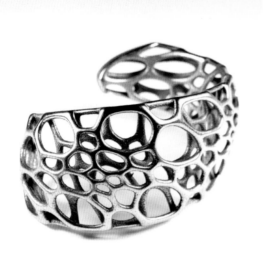

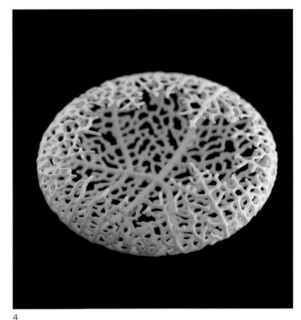

3

4

design that is 3D-printed to order direct to the public. Nervous System outline their core design philosophy on their website: [5]

We created Nervous System to explore a design approach that relates process and form in a context of interactivity and openness. Our trajectory focuses on generative design methods using both algorithmic and physical tools to create innovative products and environments. Formally we are attracted to complex and unconventional geometries. Our inspirations are grounded in the natural forms and corresponding processes which construct the world around us. From coral aggregations to interference patterns, a study of natural phenomena is an essential ingredient to our design process.

When approaching the topic of creative users of 3D printing, the first problem encountered is how these creative people define themselves. Designers are perhaps the hardest of the creative disciplines to categorise, specifically how they see themselves and their practice. I interviewed a range of designers for this book and noted how similar design practitioners variously described themselves to have roles ranging from industrial designer to artist. However, it is clear that some categorisation can occur if one looks

at the approach taken to designing a functional object. For example, Assa Ashuach uses 3D printing technology to create objects that are finished and functional straight from the printer and so can easily be reproduced as multiples. Conversely, Marianne Forrest produces works that can take an extraordinary length of time to finish after printing. In the case of her Paeleolith watch it took six months to clean a single one-off piece. Another example is product designer Dr Peter Walters who uses 3D printing both to make artwork for exhibition and as a means of producing one-off research models of flexible actuators and ceramic fuel cells – these are both elements of an ongoing arts and robotics collaboration.

Design as discipline has engaged with 3D printing the most from the visual arts sector. This is perhaps because they are taught to use CAD software from a much earlier stage in their education. Of all the

1 Bram Geenen, 'Freedom of Creation Gaudi Chair'. © Freedom of Creation

2 Nervous System, 'Hyphae Ring'. 3D-printed stainless steel infused with bronze. © Nervous System. Photo by Jessica Rosenkrantz.

3 Nervous System, '3D Spiral Cuff'. 3D-printed stainless steel infused with bronze. © Nervous System. Photo by Jessica Rosenkrantz.

4 Nervous System, 'Hyphae Brooch'. Selective laser sintered nylon plastic. © Nervous System, Photo by Jessica Rosenkrantz.

1

2

creative practitioners I interviewed about their use of 3D printing, it is the designers who are the closest to having an industrial philosophy in the way the technology is used. Many designers use the technology for prototyping to show to a client and resolve the visual and technical form details.

An early commercial example of using 3D printing for prototyping are the vases and lights made for the Milan Furniture Fair in 2000 by the designer Ron Arad,[6] 'Not made by hand/not made in China', the vases and lights were created from "virtual prototypes". The range of lamps comprised 12 items based around a spiral design. The 3D image on a screen could be animated by being literally bounced around and stretching the image into various shapes. Those frozen frames and the shape at the time became the template. The frame of the object was then built by SLS machine, potentially with an infinite number of variations.

A more recent example to cite here would be Denby Potteries, who use Z Corp 510 and 310 printers to produce all of their design prototypes in order to understand the aesthetics and form of a new shape. The Denby Pottery dates back to 1809 when the company started producing salt-glazed pottery and soon built an international reputation for its good quality bottles and jars. In the late 1800s Denby Pottery diversified by extending its kitchenware range and developed the richly coloured glazes that were to become and remain Denby's trademark. In recent years Denby have further diversified by producing a wide range of designer kitchen and household items beyond ceramics.

Before they adopted 3D printing Denby's designers would produce drawings, which were then transcribed to a clay copy, from which they made a plaster mould, of a handle for instance, that would have to be carved from a block of plaster. The timescale from conception to plaster prototype could be as long as three weeks. Denby can now print a concept model overnight and in fact they can print up to eight models at a time in one printing.

Denby chose Z Corp because, in essence, the Z Corp process prints plaster models – the closest 3D print technique to the Denby traditional prototyping process. Gary Hawley, Denby's senior designer, explains that one of the unexpected benefits for Denby is the ability to ramp up models for production, for casting items which use ceramic casting slip. In order to cut timescales from concept model to production they will take, for example, a handle that they had designed and then add feeds for the clay slip to flow into the mould during the casting process. They will embed the Z Corp plaster printed models into a plaster bat and from that make a silicone mould for casting. The moulds created are good enough to take into full production, thus further reducing design time and production costs. Denby run their printers every day and Denby now use 3D printing for designs that will be made in cast iron, wood and glass for kitchenware. They can also send models and STL files to their suppliers overseas, which can be prototyped quickly and gives them the ability to get designs into production faster and more easily than before.

For Denby, 3D printing is a design tool. If they can get 10 models out of the tank they see instantly what

they can do with a shape, they can then produce the same shape in several different sizes and with several different handles and spouts. They can also respond to any production problems with a shape in the factory very quickly. One advantage for Denby is that the design is safe, because they have the information backed up on their servers, compared to previously when breaking a one-off traditional model would be difficult and time-consuming to recreate. Now they can just print another prototype. Denby still use the traditional craftsmen and their skills whenever they can, and really benefit from their knowledge, but now 3D printing is an integral part of their design process, in addition to all of the benefits of all of those old techniques. Sean O'Keefe, Denby's Shape approval team leader, explains: "The process has made the turnaround from concept to manufacture much faster. Cutting out the need for drawings, templates, forming tools and many other parts of the previously long-winded process."[7]

The approach designers take to creating objects differs very little to any of the other disciplines interviewed for this book. The only difference may be a greater tendency to use standard industry proprietary software than the fine artists or craftspeople. Fine artists and craftspeople are often more prepared to use open source software or to write their own code to create a particular effect, and are not bothered with the need to communicate with others. Designers are also more likely to understand the need to pass on files to a third party secure in the knowledge that they can be instantly read, understood and printed out.

I would argue that any product or industrial designer under the age of 40 is going to have been bought up using CAD programs, and will have a knowledge of CNC technology, so the leap to 3D printing is a very small one. Additionally, most of the designers who use the technology see it either as a means to make prototypes for a client, or as mentioned above, as a route to make short-run specialist pieces for a commercial environment.

However, software users, especially creative software users, do not necessarily approach software in the way that the software houses assume they will when they design it. When inkjet printing was first introduced, at CFPR we did some workshops with a group of selected artists to test how they used 2D print software. Rather than simply taking a photograph and reproducing it, the artists would be very pragmatic in creating an image, going to great lengths from scribbling on something, scanning it, printing it, and drawing then drawing on it again, printing it then rescanning it to build a complex image for a project. Fundamentally, they were working in ways never imagined by the creators of the software.[8] My suspicion that artists and designers

1 Peter Walters, 'Flexible actuator', CFPR Labs. © Peter Walters 2012.

2 Marianne Forest, 'Tiny Titanium Drop'. © M. Forest.

3 3D-printed Denby cup handles used for creating moulds to slip cast handles in production. © Denby Pottery.

3

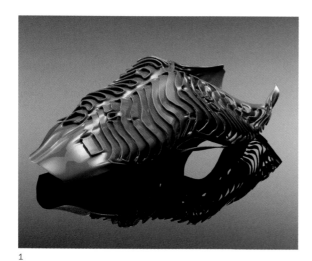

1

do not approach 3D software as intended seems to have been borne out in my interviews.

Much like all of the other creative users I have interviewed, designers have problems with the limited range of materials available and the material quality of 3D-printed objects. To some extent, designers have tried to deal with this by post-processing the material, for example Assa Ashuach both dyes and polishes nylon parts he produces. There is no doubt that the materials are beginning to change, exemplified by the work of the architect and designer

Professor Neri Oxman at MIT who has, from a visual perspective, moved the technology one stage further. Her latest works were made at the MIT Media Lab using the new coloured Connex materials from Objet, entitled 'Imaginary Beings, Mythologies of the Not Yet' and exhibited at the Pompidou Centre in Paris in May 2012. Whilst it was previously possible to print in colour, with machines such as the Z Corp 650 and the latest Objet Connex, dual colour material has pushed the abilities to design and 3D print in colour much further, offering a very different range of material possibilities and the ability to embed colour within a transparent support.

For the design case studies in this chapter I have summarised the transcription of our interviews and have tried to maintain the flow of our discussion around a set of questions that were sent to them prior to the interview (see Questionnaire in the Appendices). Rather than confine our interview to a rigid question and answer format we had a free-flowing discussion around the issues raised, which I feel increases the validity of each of the case studies.

The work of Assa Ashuach, Lionel Dean and Dr Peter Walters seem to represent the current direction that designers are taking in their use of 3D printing and offers a diverse view of the field.

1 Neri Oxman, 'Leviathan 1', 'Armor Imaginary Beings' series, 2012. Digital Materials Fabrication: Objet, Ltd. Neri Oxman, Architect and Designer, MIT Media Lab, In collaboration with Prof. W. Carter (MIT) and Joe Hicklin (The Mathworks) Centre Pompidou, Paris, France. Photograph by Yoram Reshef.

2 David Huson at CFPR Labs, 3D-printed coffee cup and saucer. © David Huson.

2

ASSA ASHUACH

Assa Ashuach,
'FLY' light.
© Assa Ashuach
Studio.

Assa Ashuach was born in Israel in 1969. He has a BA in Product Design from the Betzalel Academy of Art and Design in Jerusalem. Just after graduating, he opened a design studio that dealt mainly with design in co-operation with architects. In 2001 Assa moved to London where he continued to work on his studio's projects while completing an MA in Design Products at the Royal College of Art. Upon graduating in 2003 his work was bought by The Contemporary Art Society for the Special Collection Scheme in London 2004. Durring the London Design Festival and at the Frieze Art Fair in 2005–2006 Assa's new furniture and lights were featured in the atrium of London Design Museum and in its exhibition space *Tank*. He received the Design Museum and Esmée Fairbairn Foundation Award and the 'red dot' award for product design in 2006. Assa currently leads the MA Design Suite at London Metropolitan University.

In his personal practice Assa has harnessed the ability to print multiply-jointed objects that are pre-assembled. He creates objects that transcend the fact that they are produced in 3D and has managed to make a range of designs that people collect and find desirable. This gives a fluidity and flexibility to the objects he creates, which transcend the inherently rigid qualities of the nylon

materials that he uses. He first encountered CAD during his BA in Jerusalem:

> We were lucky to have access to Alias Lightwave on Silicone Graphics machines and I thought it was amazing to spin products onscreen in 3D – and at that time the software was mainly used by the Automotive and Film industries, the dominant technology was CNC and Surface modelling was new. I remember even the staff were not used to the technology, my teacher didn't accept me presenting virtual objects as prototypes. This was the beginning of my use of digital technology.

He embarked on his research career in the 1990s, at that time the dominant 3D printing technology was stereo lithography. Assa was lucky enough to be sponsored by Autodesk and Eos, while he was a student at the Royal college of Art:

> I come at one end from a classic design background, so I love materials and I am very excited by the opportunities offered by 3D printing. I don't see it as a different hybrid of design but as a natural layer or as a natural new opportunity if you like.

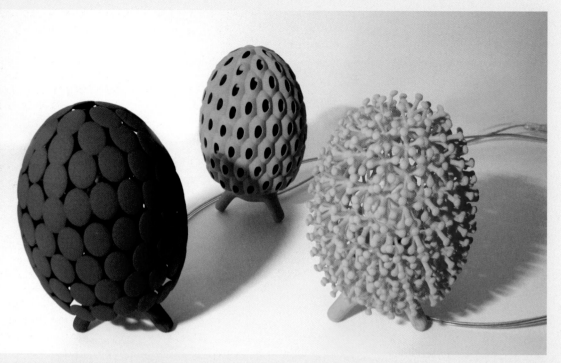

Assa Ashuach, dyed 'Bon Bon' light. © Assa Ashuach

In order to create his virtual models for 3D printing he uses three main software packages. Alias, which is NURBS surface modelling software primarily aimed at the film and animation industries; Autodesk 3ds Max (then 3D Studio Max); and SolidWorks for the jobs that require a harder engineering approach, with strict tolerances. He says that over the years in his furniture, for example, with its flowing curves he has found that Alias software has been very important to him in order to have the freedom to design fluidly. When he has finalised the designs he will use a bureau such as 3T RPD or Metropolitan Works for the printing.

More than 90% of Assa's work is now 3D-printed although most of the creative development, and therefore product development, happens virtually – for the finished designs it is probably more like 100%. He still uses the traditional prototyping process to make conventional prototypes, so he can examine things and check the boundaries of object, before sending them through the conventional routes using CNC cutting for milling prototypes. He also uses a lot of moulding, but fundamentally, all the processes begin with a digital file. At the same time he is mixing plastics and metals and experimenting with 3D printing. With the larger, more sculptural pieces he also uses fibreglass and carbon fibre. I asked about his

collaborations with larger companies like Nike, Samsung and Panasonic, in an attempt to understand how we can move into different ways of manufacturing.

> *At this moment, this is one of my biggest challenges – how do we move this technology that I am so familiar with – how do we use it to design better products? And this is not only about crazy lattices and crazy geometries, but it is about offering better products to the user.*

He is currently working very closely with EOS (the German SLS machine manufacturer) because he believes that at this point in time laser sintered nylon is the best product for mass customisation:

> *Nylon is more predictable, more controllable, it's robust and easy to finish. If you remove the cost element with nylon we can already create some good products, especially if you use post processing, like vibro polishing and dye dipping.*

> *The other product that is very good (but again very expensive) is laser sintering of metal, precious gold, silver, titanium, stainless steel, copper and simple alloys.*

Assa believes metals are is already of big value to engineering, but for consumer markets the big barrier is cost, but he believes this will change: "If you manage to characterise the material in a particular way you can analyse and predict and perfect those characteristics in the design, you are able to do things a different way – thicknesses … all sorts of things – it's all very interesting!"

We then discussed how the characteristics of 3D printing could be utilised to push the boundaries of design thinking:

> *I would like to see digital forming as a new design method, because I am designing objects which are in motion, they should be flexible in some way – imagine if you want to bend things – you don't want them to crack and even in the virtual environment when you shape and modify things you really want nice beautiful poly flow and lines of circulations – a bit like making DNA when you want the baby to be healthy… Because we are designing the object – we have to keep in mind that these objects will be modified.*

In terms of software he prefers StudioMax to create designs that keep geometric tessellation, which for his purposes has to be very organic and natural with no crude intersections so it all flows together. He uses the analogy of animation in gaming; in particular the way the face and the lifting of the face is programmed to convey emotions. Specifically the modules that re-design the facial expression of the characters, because they have to make sure that when the face expresses, deforms and speaks it happens in a beautiful and natural way.

For Assa, the barriers to 3D printing are the material characteristics, or lack thereof: "Primarily, its all made out of one material – in real terms, its just one solid block of material which has some issues, in one way it's a benefit, there's no assembly".

So he tries to make everything from one material by designing and using the natural flexibility of the nylon. Right now for example, he is designing a foldable chair – all from one printed object – with a gear mechanism inside:

> *So imagine you take [the chair] out of the machine and in one movement you can open it for the first time and sit on it immediately – so in one way the potential is huge because you don't have people in China (for example) involved in assembly, but this is also where sometimes you say 'OK but I need another material inside of there too' and its 'oh sorry that's not possible!'*

Arguing that the material properties are changing as new materials are being developed Assa also highlighted the Israeli company Objet who are marketing the Connex family of multi-material. However, in essence, this is just two main materials used together (a hard and soft variant of the same material). Objet cleverly use the software to create a different range of material properties from hard through to soft, rather than having to use a multiple set of materials to create the different properties.

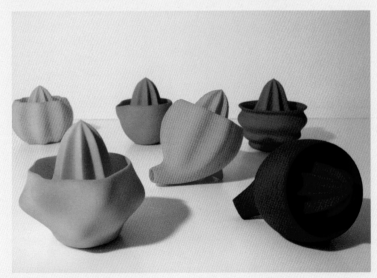

1

2

1 Assa Ashuach, dyed lemon squeezers.
© Assa Ashuach.
2 Assa Ashuach, 'Lemon&lime_trophy_with3TRPD_AM', computer visualisation.
© Assa Ashuach

Assa Ashuach, 'AI light'. © Assa Ashuach.

Assa is very clear about how to view the current hype and media interest surrounding 3D printing. He uses an analogy from his old University Professor Ron Arad to illustrate this: "be careful not to take yourself too seriously" – he often wonders if he is taking himself too seriously:

> *People are very excited by this concept of materialisation and we are coming to this with the urge to create, to fabricate [and] to materialise and such and I think we should also make sure we are not overexcited. I think for you and me its not 'news' and its funny that now suddenly it is all happening around this technology and I keep asking myself – why?– it's an ageing technology ... how come only now is it suddenly very 'interesting' – it's about how we can gain the most benefit form this technology – we should stay open to everything.*

He really believes in the concept of time: "if you spend all your time on something and you believe in it and you are passionate about it you'll gain a very good understanding of that territory, and you'll become an expert". Assa advocates investing time in things and that you should always learn and educate yourself. A good illustration of his argument is the example that given two technicians producing the same design on the same machine: "One will talk to the machine in a different way and configure the machine, the speed, the heat and the laser differently, so everything is different – so 3D printing really is not as we believe".

Assa believes the future direction for 3D printing lies in local manufacturing and what he calls "postcode production" –

> *It is all about how the city changes over time, local business, networking equidistant 3D printers in a connected city. The machine capacity is utilised to remove all the machines redundancy – Basically the ideal is the user can walk round the corner to get the product locally – turning the user into a partner and helping producers capitalise on their redundant production.*

DR LIONEL T. DEAN

Lionel Dean, 'Tuber 6'. © Lionel Dean.

Lionel Dean defines himself as a Product Artist and believes he was amongst the earliest designers using 3D printing in a creative environment. In the academic year 2002–2003 he undertook a design residency in rapid prototyping. Before this he had used rapid prototyping in 2002 for a European design competition. Lionel describes the design process of the first 3D-printed artwork he made:

—— The piece itself was destined to be injection moulded and I had to make a prototype of it. It was a clear piece with lots of facets and the only way to realistically do that was by RP. The process

used was selective laser sintering (SLS) and through a university contact who knew someone at 3D systems and they helped us out with the piece. It was getting that prototype part that was the revelation moment, suddenly opening a box and getting your fully finished design through the post – that was an amazing thing. So then I thought you've got to be able to do this for real products and how can you justify doing that? Then I got the opportunity to pitch for the design residency, which I did based on the idea that we'd use this process to create an extended series of one-offs and find some route between homemade craft practice and industrial production.

Lionel has an interesting and subtly different view to many in terms of the relation between materials and making, he argues:

▪▪▪▪▪▪ *You almost separate the creation of form from the making of the form. You do have to understand the processes and the materials to get the best out of the process, depending on what processes you are using – particularly when you get into the metals it is really important to understand the process, less so with plastic. But I think you can separate the two a little bit, in a way that you really can't making things*

physically. Using metal is much more of a satisfying experience as a designer because it is a 'real' material.

He goes on to argue that the technology has reached the stage that although it is capable of making real-world products, there are still some issues, for example: "lighting kind of works because you don't touch lighting, it hangs there and looks pretty but anything that involves handling the plastic really isn't up to it". He qualifies: "It's a temporary restriction and things have got a lot better. The plastic itself has got a lot better, the resolution of the SLS has got a lot better, there are more options in the plastic materials now".

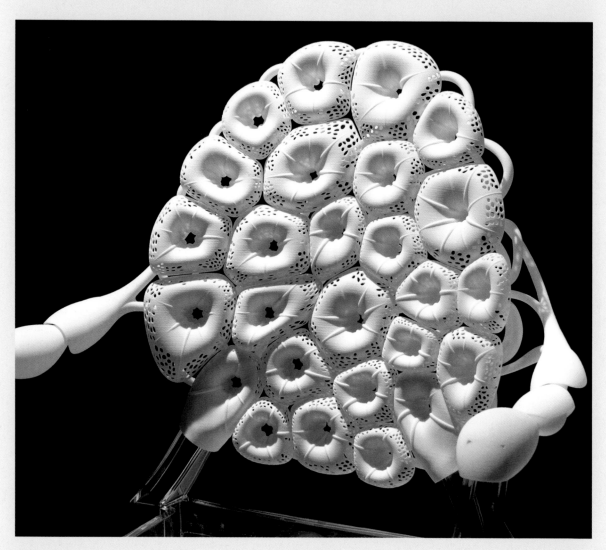

Lionel Dean, 'Holy Ghost'. © Lionel Dean.

Lionel gives the example of alumide (an aluminium powder doped resin) for SLS, available from the online print-on-demand bureau Shapeways: "That's a really pretty material. I've used it in jewellery and tumbled it to polish the surface and it has a real quality to it that the plastic on it's own doesn't have".

Unlike many designers who cite natural forms as their inspiration for creating 3D artworks that are then generated through digital algorithms Lionel Dean approaches this much more directly and combines natural forms in a very literal sense. For example, his elegant piece 'Blatella', which he describes as a floor pendant and wall sconce. 'Literally' is made up of a swarm of 3D rendered insects. He says: "A crowd of insects swarms around the light source, drawn by the glow, their bodies are bright with a translucent purity that belies associations with filth and squalor". Lionel also combines these more direct renderings of natural forms with chairs such as his 'Holy Ghost' chair made in 2010.

Lionel articulates how all his creative practice is now exclusively 3D printed. However, in common with the most of the designers I have interviewed for this book, the majority of Lionel's work is printed by a 3D bureau service such as iMaterialise or 3TRPD. He teaches part-time two days a week at the University of Huddersfield where he has access to an EOS Formiga P100 SLS machine. Having access to this machine has given him good practical knowledge and hands-on experience of putting the build onto a machine, which in turn, gives him a better understanding of the problems that can occur in the transcription from software through to actual build.

Lionel feels that understanding and knowing the machine gives him an advantage when sending files for manufacture to a bureau service. He articulates how bureaus have evolved from when he started to use them. I have covered Lionel's views on bureaus because he is a long term user of these services and most of the other interviewees either print for themselves, or do not have the same close relationship Lionel has when printing his work through a third party:

> Initially the bureau culture was 'we will take the file off you' and they didn't want to get into a further discussion about why something wouldn't work – it just 'didn't.' If possible they would change it for you and charge you, because that's part of the added value they bring to it – they aren't just packing the machine they are solving

> the problems, if you like. Generally bureaus were quite reluctant to involve you in the process. Since then I have built a good relationship with some bureaus, like 3TRPD, with whom I have worked very closely on the process and that has been quite a big shift in my understanding of the process and the results I've got from it.

He shares my own views about how artists and designers currently approach 3D printing and how this approach is reflected in the development cycle that the technology has reached:

> Sometimes you can tell if an object is 3D-printed because you can't tell how it can have been made any other way, but if it looks like it's 3D-printed in a not so good way then it is not as successful. There has been a kind of honeymoon period where designers and artists have got attention simply because they are using 3D printing, it's 'wow isn't this great!' And I am not being disparaging about anyone else, and I include my work here to a certain extent, but now we have to become a little more sophisticated, because you are not going to get a free ride just because the technology is new, you've got to be a little more discerning and say it's a premium process and are you using it to it's full capabilities. I think at the moment the material aspects lag behind its capabilities and at some point that will change.

Both of these statements bear out the general view that constantly occur throughout this book – that the biggest constraint for 3D printing is the lack of material qualities and options. To make his work, Lionel uses a variety of different software packages because one package will cover all of the stages necessary. Primarily he uses NURBS Surface Modellers, in his case Alias Studio Tools because of his background as a product designer, but he also uses Solid Modellers to get a decent STL output. He is increasingly using Polygon Modellers as well, "which as designers we used to think were a bit dirty, but now we are getting a little more into because of the flexibility that it brings".

Our discussion led to the problems that Lionel encounters with workflow in the software. This is one of the clearest articulations of the common problem encountered by most of the case studies included in this volume:

I don't think the software houses help us in that they are all trying to 'hook you in'. This thing called workflow, they try to tell you the industry works in this particular way and it doesn't really suit. Particularly if you have a hybrid practice where you are on the fringes of craft, art and design, it really doesn't help you. If you are an industrial designer, designing the sorts of products they expect, then they are fine. You seem to spend so much of your time finding 'work-arounds' for problems. Particularly dealing with complex designs that push the software and the computational power. It's as if almost half your time is spent fixing the problems rather than actually working on the design, which I guess is part of the design process in itself, but you always feel if you had infinite resources those wouldn't be the issues.

When considering further barriers towards the wider uptake of 3D printing Lionel considers it essential to articulate why this process is not just 'plug and play', which is the pre-conception that many people have when they first encounter the technology. For example, the additional software needed to complete the transcription of the file from conception to print, where you need to use Magics to sort out or repair the file, which he uses for fixing STLs. Currently Magics retails at about £3,000 with annual rental charge for a commercial licence. Lionel argues that that kind of price just for a filter for STLs – is a problem. Furthermore, Lionel argues, the overall cost of the process is huge – even when mitigated by using a bureau service, the costs can easily soar and all parties are aware that every build comes with significant cost in time and materials:

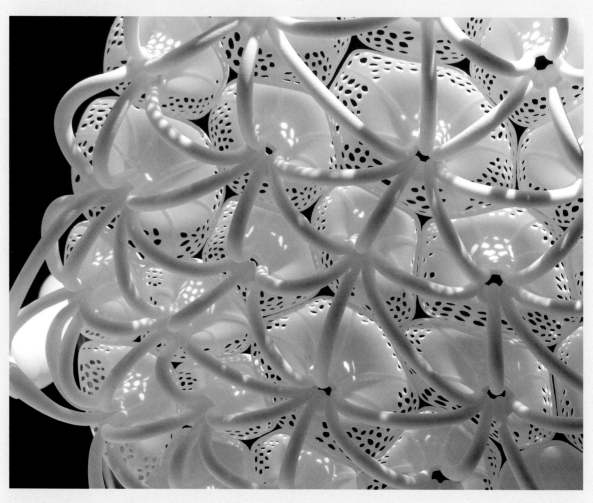

Lionel Dean, 'Holy Ghost' (back view). © Lionel Dean.

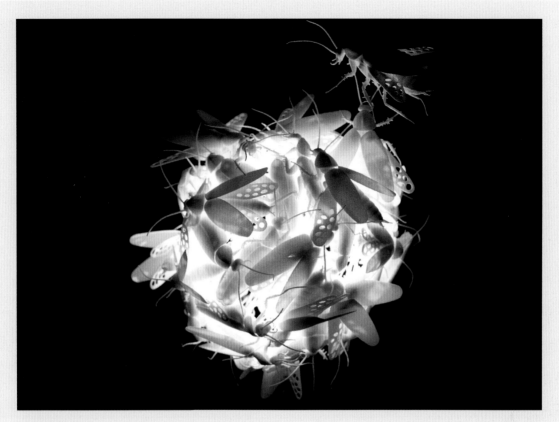

Lionel Dean, 'Blatella'. © Lionel Dean.

*When I first started working with iMaterialise
I thought – this is brilliant, here is this huge
bureau I am working for and we will be able to
turn out objects every day and just keep refining
them until we get it right! But they really didn't
want to commit to a build until the design was
absolutely right which fascinated me, because
they wanted to use it for commercial bureau
work and space was always a premium even
though it had huge capacity. And it's the same
now working myself, when I have to build
something it's quite a commitment, it has to be
right. So for visualisation using a Z Corp is fine. I
find if I am making one of the more expensive big
pieces that are going to cost £1,000 to £2,000
each it's got to be right first time and I've got to
be able to sell it. So I need to cheaply visualise
it first.*

In Lionel's view, the results from a bureau can depend
on the parameters they use, you can speed things up
and change the resolution, but it depends on what
those results are giving you. It also depends very
much on your set up, for example, with the metals
it is crucial how you set files up, because of the huge
cost and the time needed to clean the finished object.
The titanium is an aerospace grade that is incredibly
hard, but with plastics it doesn't really matter so
much. He further qualifies the need to collaborate
with and understand the needs of a particular bureau:

*It was the case, particularly in the early days
of 3D printing metals, there was quite a big
difference in terms of finish and some bureaus
would handle fine geometries better than others
but I think increasingly it's not such an issue.
And with plastics there is very little difference in
the sintering processes. I am familiar with one
process but I have had parts from other bureaus
who use a different process and pretty much it's
the same.*

He concludes with his views on bureau services and
metal printing, where he uses both of the direct metal

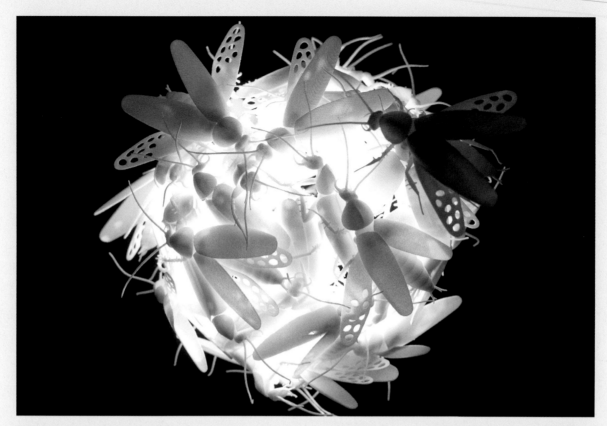

Lionel Dean, 'Blatella'. © Lionel Dean.

laser sintering (DMLS) machines – the EOS system, and the machine that was made by MTT, but is now owned by Renishaw. In Lionel's opinion, EOS is further ahead in development than MTT and Lionel thinks it will be interesting to see what will happen now that Renishaw have taken over MTT because they have backing and resources which MTT didn't have before.

I wanted to explore Lionel's views as to whether, as a designer, he felt he had given up any of his traditional skills to use 3D printing:

▰▰▰ *Yes – drawing. I used to teach drawing and I don't draw at all now because you end up with a translation between a sketch that you then move onto screen and there isn't any point. Instead you just start working straight on screen. I might jot something down so I remember it or to try and organise my thoughts but not really to develop the form in the way I would have done originally. Considering I still teach undergraduates and encourage them to draw*

everyday I am quite uncomfortable saying that! The same with making models, I clean up models but not sculpting in the way I would have before. I used to do a lot of clay work and I just don't do that any more, and that's a skill that if you don't practice all the time you will lose.

Lionel also has clear views on the abilities and shortcomings of haptic arms. Haptics are a 3D technology solution to the touch and feel that is missing when using a mouse to sculpt an object and were an attempt to create software that is intuitive. However, it Lionel does not believe that haptics actually help:

▰▰▰ *Haptics don't solve the problem, as first you have to learn the software, that's a pain barrier you have to go through, that's kind of saying 'you artists, you won't understand this so we are giving you this device to find a way around it because you can't cope with the software'. We can cope with the software we don't need a device. There is a place for it but not as the*

primary method for developing a form. It's almost like it's an additional tool but there are some things where if you had the model physically in front of you, it's not a question of constructing, you would get some filler or clay and just smooth it in with your thumb. And it's that little motion if you like, that is very hard to recreate constructing things in 3D. If you try modelling something from scratch with haptics it is so difficult because you don't have the references.

In terms of the future for the technology Lionel believes it's going to be pervasive:

▬ *If we look at what has happened in 2D design with things like Photoshop but also the availability of printing – we all print documents. When I was a lad having a printed brochure was a major thing. You had to send it off to a printers and now you just print it on your desktop. I think we will have our own 3D printers but the high-end print will always be a bureau service because you will always be chasing the technology. So you will get more and more printers at home but there will always be better ones in bureaus, certainly in the medium term. So we will be printing things ourselves and we will be going to places like Shapeways or commercial bureaus, [there are] almost three levels to it. I do think a lot of people will have a home printer but it will be very much a plaything. I don't know if this model of something will break down in your house and you print off a spare part will happen very quickly, maybe eventually.*

He concludes by commenting on students' desire to use a new technology just because it's new.

▬ *In terms of art and design practice it is alarming the speed with which it [3D printing] has taken off. A couple of desktop millers have come in, and a laser cutter, and students now can't cut things on a band saw. They will queue waiting for the laser cutter because it gives them a cleaner cut. And very often it's just a few right angles. Which is like using a hammer to crack a nut.*

Lionel Dean, 'Entropia' section. © Lionel Dean.

DR PETER WALTERS

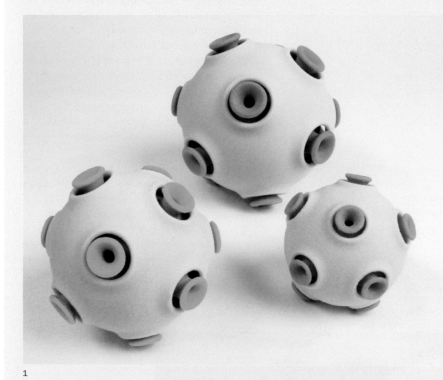

1

1 Peter Walters, 'Trumpet spheres', waxed, 2008. © Peter Walters.

2,3 Katie Davies and Peter Walters, 'Vela pulse', 2010. © Peter Walters.

4 Katie Davies and Peter Walters, 'Vela pulse', 2010. © Peter Walters.

5 Peter Walters, 'Smart tentacle with flex sensor controller'. © Peter Walters.

6 Peter Walters, 'Smart tentacle', 2012. © Peter Walters.

Dr Peter Walters is currently based at the Centre for Fine Print Research at the University of the West of England in Bristol. He trained and worked as an industrial designer in Sheffield, which gave him a solid grounding and understanding of technology within a visual arts context. Before taking his PhD, Peter worked for a design consultancy called the Advanced Product Development Centre, a design group that was part of Sheffield Hallam University. From Peter's perspective, industrial design is significant in that it brings together form and function as a creative discipline that marries the visual sensibilities of the visual arts with technology. As an industrial designer, Peter developed the skills necessary to work with 3D printing as a tool and a medium and he learned 3D computer-aided design (CAD) and therefore also learnt CAM, laser cutting and 3D printing technologies, because they were the tools of the trade.

In the last five years Peter has been working as a research fellow in the visual arts, in a role that allows him to continue to use his design skills and sensibilities, but in a broader range of creative disciplines.

Peter describes his personal practice as "the creative use of technology". He has always been fascinated by making and machines, and that which is technically possible to make. Peter tries to express this in his practice. He says:

> I also enjoy collaborating with people in other disciplines, to create work which is only possible through those collaborations; i.e. it could not exist if the practice was contained within a single discipline. So I work with a broad range of people and disciplines from fine art to engineers and robotics.

In one recent project, Peter collaborated with the artist Katie Davies on a sculptural piece that explored how data could be translated from one medium to another. Peter and Katie created a 3D graph, using data corresponding to the radiation beam from a pulsar, a high-speed spinning star. This graph formed the basis of the shape of a 3D-printed sculpture. The Pulsar sculpture, 'Vela', was exhibited at an exhibition in Boston, Massachusetts, called 'Mixed Signals', curated by Boston Cyber Arts.

2

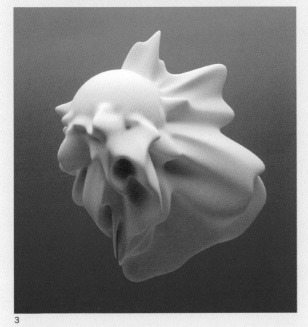

3

In a second project, Peter has been investigating applications for smart "artificial muscle" materials and 3D printing, which he employed to create the tentacle-like structures. The tentacle structures were 3D-printed in a soft, rubber-like material using the Objet Geometries 3D printer. The structures include internal cavities into which shape memory alloy artificial muscles were introduced. When stimulated by an electric current, the artificial muscles contract, causing the tentacle structure to move in a lifelike way. In collaboration with puppet designer and roboticist David McGoran, Peter created the tentacle-like active structures and a flexible controller, which allows tentacles to be 'puppeteered'.

Peter first used 3D printing in 1999 when he was a final year undergraduate student at Sheffield Hallam University, for one of his final year projects he had designed a clothes peg for keeping socks in pairs in the washing machine. He used stereo lithography to make a prototype model and this was then painted so it looked just like the real product. Peter was one of the first undergraduate students at Sheffield Hallam to use 3D printing. The 3D printer, a 3D Systems stereo-lithography machine, was based at the regional development agency in Rotherham.

4

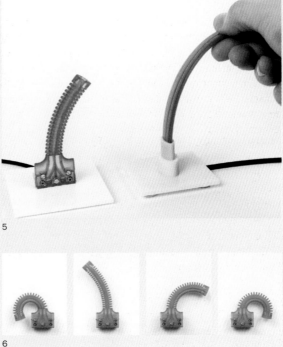

5

6

Almost 100% of Peter's work is now 3D printed. He says: "I am very lucky to have access to first-class facilities, which means I have been able to develop skills and an understanding of 3D printing as a process and the range of materials that are possible". He uses 3D printing because it is relatively quick and easy compared to making things by hand and it allows him to do things that would be impossible by other means. Having said that he is no longer interested in the novelty of being able to make impossible shapes. Peter articulates that it is a phase that most people go through with the technology – and naturally so – take, for example the ubiquitous Klein bottle. The 3D printing process allows him to create functional parts for example, which, whilst not impossible, would have been terribly difficult to make and would have required complex multi-cavity moulds. However, these parts are 3D-printed in soft material in a few hours, so he could try the design out very quickly and make any necessary modifications that were needed to make the device work.

In response to whether Peter combines 3D printing with other processes he replied:

> *Sometimes I use 3D printing directly but at other times it is both necessary and desirable to transform a design into other materials, and here I have used 3D printing to make moulds, for example, to cast silicone rubber because a design required the properties of silicone, which were not available in a 3D-printed material.*

Peter uses different software depending on the job in hand. He first learnt how to 3D model in 1993, using AutoCAD Release 12, since then he has used a range of CAD programs including Rhino, Pro-Engineer and SolidWorks. These days he favours Rhino most of all because he has been using it for a number of years and can treat it like a sketch book. It is very quick to model things up, but it does have limitations and so, sometimes, he has to transfer between software – for example, he may have to move from Rhino to SolidWorks to shell a part, in order to give it a wall thickness. It is worth noting however, that in the early stages of a project Peter still uses pencil and paper and plasticine to capture the first ideas prior to working them up in CAD.

In terms of the hardware he uses Peter says:

> *Most of all I use Objet because of part quality and range of materials. I am particularly fond of the Tango range of rubber-like materials. These have allowed me to develop my research and creative practice in soft robotics. I also like to use Z Corp for multi-colour printing and have often sent parts to be made by iMaterialise in laser sintered nylon (see Pulsar illustration) which offers strength and an excellent surface finish. In the workshop we have Objet, Z Corp and a RapMan that I have converted for printing pastes, including ceramics and foodstuffs.*

Contrary to what most people have said regarding the barrier of learning software, Peter has a slightly different take. He says that he is interested in why more people do not want to learn the software! It is actually not as difficult as people might think and compared to say life drawing or learning to play the piano it is "easy". Peter went on to articulate that in his experience of people learning the software, the first week or two can be tough, with a steep learning curve, but after that it becomes easier to the point where the interface and tools are second nature to the experienced user.

In the light of Peter's comments I myself wonder whether this reluctance to learning the software is akin to most people's relationship with maths, where the perception of difficulty is due to fear rather than the actuality. I also wonder if whether users of the technology are giving up traditional craft skills, or whether 3D printing has its own craft sensibility? Peter's view on this:

> *To begin with, 3D printing does not replace the range and breadth of traditional tools materials and technologies, which are still widely used by artists, designers, engineers and manufacturers. 3D printing is not a single process but rather [it] offers a range of materials and fabrication technologies that have many attractive advantages, but these advantages are not replacements for traditional tools and techniques. The areas in which 3D printing is viable as a manufacturing route are currently limited to high cost, one-off and small batch production, such as jewellery and dental. 3D printing really comes into its own as a prototyping tool, for creative artists, designers and engineers. It allows design ideas to be tested in the physical world and designers can rapidly iterate ideas and identify and resolve problems at an early stage in the creative process.*

1

2

1 Peter Walters, 3D-printed coffee cup and beaker. © Peter Walters.

2 Peter Walters, '3D-Printed Bodies', 2008. © Peter Walters.

A current limitation of 3D printing – in particular the low to medium cost technologies – are the range of materials that are available. When one compares the rich range of everyday materials found in any home and the range of aesthetic and functional affordances of these materials, 3D printing has a long way to go. The focus for future development in 3D printing must lie therefore in the development of a wider and more attractive range of materials. This is not a simple problem to solve because the fabrication technologies of 3D printing, such as inkjet, powder deposition, laser fusing and so on significantly restrict the range of materials that can be used.

Nevertheless, if we consider how far the technologies have come in the relatively short time that they have existed, i.e. since the first machine in 1984, in the next 20 to 30 years we can expect to see significant developments and exciting times ahead for 3D printing as a medium for visual artists and designers as well as engineers, medical technologists and even home and educational users.

Whilst each three of these case studies are designers, they comment on both the process of 3D printing and use the technology in very different ways. Assa Ashuach is perhaps the most concerned with transcribing a design aesthetic to 3D printing and what that might mean for the future. Lionel Dean is very much about using the technology and referencing what the theory may mean is visual terms, both literally and metaphorically, whilst Dr Peter Walters applies an industrial design sensibility to problem solving in order to extend a research philosophy.

1 3D printing News, (2012) 'Automotive components achieve pole position with Rapid Prototyping', www.3dprintingnews. co.uk. 23 July 2012.
2 Weaver, Tanya, (2012) 'Clarks steps up development of its shoes with 3D printing', Develop 3D blog, www. develop3d.com, 1 February 2012.

3 3D printing News, (2012) 'Could 3D-printed lighting be the next big thing for children's toys?', www.3dprintingnews.co.uk, 5 October 2012
4 Geenen, Bram, (2010) '3D-printed furniture by Bram Geenan', Freedom of Creation, www.freedomofcreation.com,

14 July 2010.
5 Rosenkrantz, J., (2012) Nervous System, www.n-e-r-v-o-u-s.com, 26 November 2012.
6 Arad, Rod (2000) 'Not made by hand/Not made in China', 6 April 2000. Available from: not-made-by-hand/-not-made-in-china/1103974.article http:// www.designweek.co.uk/.

7 Hawley, Gary, (2012) 'Towards a new ceramic future', Hockhauser Auditorium, Victoria and Albert Museum, London, January 2012.
8 Bodman, S. Johnson, L. Laidler, P., (2005) A Perpetual Portfolio. Bristol: Impact Press, Bristol.

6

The public face of 3D printing and its future in the arts: animators, hackspaces, geeks and fashion designers

Over the last two years 3D printing has grown rapidly in the public eye. Much of the publicity in the mainstream press has been about the disruptive potential of this new technology. The current popular perception is that soon, at the press of a button, anybody will be able to print anything from a broken part to a fully functional gun from the comfort of their own home.[1] This is patently not true but in this chapter we need to deal with how that public perception impacts the broader visual arts as a discipline. The easiest way to examine this is to look at those sections of the creative arts that have the biggest audience profile.

Three obvious visual arts' candidates have a widespread and popular public appeal. Firstly, we will look at the fashion industry, one of the high profile arts communities that uses 3D printing, which has a very large public following through both the mainstream press and catwalk shows. Secondly, we will look at animation – in particular big budget mainstream stop-motion animation. Thirdly, we need to address those areas of the 3D printing community that have grown due to the combination of readily available low-cost machinery and the global social network and community aspects of the internet. Together all of

these aspects have an influence on the perception of the visual arts and 3D printing.

To place this chapter in context and to articulate some of those popular misconceptions I will begin by reflecting upon examples from current literature about 3D printing that have reached a wide public audience and cite some examples of popular press publicity. Having reflected on the most public aspects of 3D printing in the visual arts we also need to deal with where the technology might go in the future. In order to make any sort of future prediction we have to begin with some case studies dealing with the areas of cutting-edge research

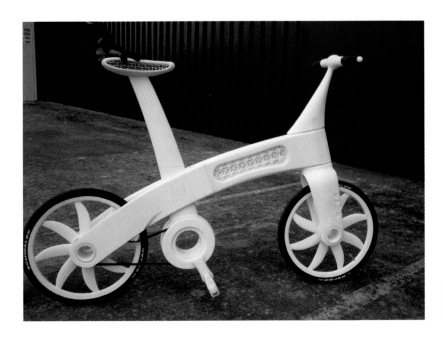

EADS, 'Airbike' white nylon bike, 2011.
Entirely printed by laser sintered nylon.
© EADS.

currently taking place in relation to the visual arts.

To begin with, public perception. Within the public domain over the last few years several novels have documented the growth and influence of the 3D printer, in particular *Makers* by Cory Doctrow[2] and *Kiosk* by Bruce Sterling.[3] Whilst Sterling's *Kiosk* presents a dystopian view of the future, it has one distinct truth and advantage over much of the other literature: it presents a view of 3D printing that is entirely black! Not just in outlook but also in its physical presence. Sterling presents us with the "Henry Ford" view of the future – to paraphrase, you can have anything you wish for as long at its black – in this instance in black carbon nano-tubes. I would argue this is very close to the current view of what the future may hold for 3D print, in that it clearly demonstrates its limitations and then makes a feature of those very limitations, i.e. the current ability to only print in a single material.

Makers covers the rise of a "geek culture", using 3D printing to create alternative models of business that are not constrained by the traditional big-business model. Whilst it describes these alternatives very well and much of what is described may well come to pass in some form in the near future, one of the problems the book generates, in tandem with the image of 3D printing presented by the general press coverage, is an expectation that these new processes are capable of *anything* and all objects can "just be printed". In *Makers*, Doctrow espouses the ability to print a complete fairground, all sorts of functional objects and even guns. In addition, it assumes the machines are easy to operate and maintain, with the ability to just leave them overnight to make everything! The most interesting aspect of the book is its exposition of completely new models of business trading – which may be the closest descrption of how business trading will work in the future. The reality of course, is that in real terms all of these 3D processes are very limited in what they can actually achieve. In the main they lay down a coil of liquid or a layer of powder that has to be glued to the layer above and then dried. To return to the age-old problem that is ignored throughout Doctrow's book, anything that has to be glued to the layer above is by its very nature going to be crude and in a single material. Apart from some of the metal sintering processes perhaps, there is a very long way to go before we can create objects that are really useful. Most of the objects currently made are designed to fit the limitations of the process and to my knowledge there is no machine yet that will lay down multiple different types of material, and nothing that provides high-quality printing in combinations of everyday materials such as metals, glass, ceramics, wood etc. The Holy Grail in terms of 3D printing is to

be able to print in multiple materials simultaneously, as very few traditionally-manufactured objects are produced from a single material. Currently, the nearest is the Connex machine which will lay down both hard and a soft photo polymeric material, but it has none of the material and aesthetic qualities that are necessary to make the technology universal.

There is a similar problem in the mainstream press, who primarily follow each other in reporting developments. The mainstream press and television have covered 3D printing extensively in the last two years, including *The Sunday Times*,[4] *The Economist*,[5] *The Guardian*,[6] *Forbes Magazine*,[7] and TV programmes such as Newsnight,[8] QI[9] and Have I Got News For You?[10] However the majority of this coverage is mainly drawn from the fairly simplistic view that virtually *any* object can now be printed in three dimensions.

There are, however, some very helpful examples that have received broad coverage:

- The global aerospace and research company EADS generated much coverage with its printed bicycle.[11] This had the benefit of being a real object with a definite objective: to create a completely printed object that could be used and would function as a bicycle. EADS made it clear that this was a piece of research and, although it was possible to ride the bicycle, it certainly did not look comfortable or even functional for a distance of more than a few metres and it should not be mistaken for anything approaching a production machine.

- Much of the other press coverage concerns low-cost printers such as the RepRap and MakerBot. Here the coverage tends to cover the more fanciful predictions of where the technology might go in the future. Many of these articles predict that in the future every home will have a 3D printer and people will be able to print anything they need at the touch of a button. I do not feel that this is likely to come to fruition, primarily because of the need to be able to print in multiple materials. Even if it was capable of printing them, a home printer would need to have a large stock of different materials, stored in the home.

Fashion

However, there are many areas within the broader context of the visual arts where 3D print is beginning to have a real influence. I could have included fashion in the chapter on designers, but I feel this is one area that is pushing the technology into interesting new territory. For example, take the work of Iris van Herpen who presents stunning new work that is definitely pushing the boundaries of the technology in order to create functional wearable garments. *Time* magazine named Iris van Herpen's 3D-printed dresses one of the "50 Best Inventions of 2011". Van Herpen is based in Amsterdam and studied under Alexander McQueen. Her 3D work is made in collaboration with the Belgian 3D printing bureau service iMaterialise. In a recent interview with *Wired* magazine she states: "3D printing freed me from all physical limitations. Suddenly, every complex structure was possible and I could create more detail than I ever could by hand".

Lady Gaga and Björk are both recent clients of her work. For her recent collection 'Hybrid Holism' she made nine 3D-printed pieces, manufactured in materials ranging from plastic to rubber and metal. For her first couture show in Paris, van Herpen worked with architect Daniel Widrig and used rapid prototyping technology to create her 3D-printed collection 'Escapism Couture'. Her designs were printed using a nylon polyamide material. However, van Herpen believes that fashion should be an artistic expression, not just about new and innovative techniques, so instead she combines handcrafted pieces with 3D printing.[12]

It is easy to see why a fashion designer of bespoke garments would want to use 3D printing to make clothes. This brings us to Professor Neri Oxman from the MIT Media Lab who makes wearable objects that make us think about what we might be wearing in the future. I have already mentioned Neri Oxman in Chapter 5. Oxman is the Sony Corporation Career Development Professor and Assistant Professor of Media Arts and Sciences at the MIT Media Lab – where she founded and directs the Mediated Matter research group. As technology increasingly becomes interdisciplinary, so too do the people that use it. Oxman is a good exemplar; a well-respected architect, designer and now fashion designer, having recently

created the 'Imaginary Beings, Mythologies of the Not Yet' exhibition at the Pompidou Centre. Before this Oxman and her team were working on a series of body armour based on human tissue. When describing part of the project 'Carpal Skin' on the MIT website Oxman explains:[13] "'Carpal Skin' is a prototype for a protective glove to protect against carpal tunnel syndrome, a medical condition in which the median nerve is compressed at the wrist, leading to numbness, muscle atrophy and weakness in the hand".

In an article for the web-based magazine *Popular Science* Oxman expands on the reaction diffusion systems at the core of the project: "Most patterns in nature – whether scales or spiderwebs – have some kind of logic that can be computationally modelled". The editorial explains that to build some of her armours, Oxman and her colleague Craig Carter formulated equations based on reaction diffusion systems. From these Oxman created bitmaps. She then feeds these bitmaps into the printer (Objet Connex) to construct functionally graded materials (FGMs). These are the opposite of most manmade materials, which are homogeneous and have the same hardness throughout. The materials have differing flexibilities built in, by constructing her armour in minute layers, her creations are as multipurpose as our pores: "Our skin is structured not unlike FGMs: on our face our pores are large, for filtering, while our back pores are small, to form a more protective barrier".[14]

Similarly, the well-known couture designer Hussain Chalyon – whose work also pays homage to Alexander McQueen – used 3D printing as part of a cross-disciplinary art installation, 'I Am Sad Layla', that he installed in 2011 at the Lisson Gallery in London. In a video interview with Greg Hilty, the Curatorial Director of the Lisson Gallery, Chalyon explains that he 3D-printed a white female figure, using a laser sintered nylon, wearing one of his own garments onto which he projected a film of a singer performing the Turkish song on which the installation was based.[15]

Animation

A completely different field to fashion, stop-motion animation is an area within the animation industry

'Coraline', the first 3D-printed feature film, 2009. © LAIKA Digital.

'Paranorman', printed with Z Corp colour printer. © LAIKA Digital.

that has taken 3D technology on board and is rapidly becoming an integral part of the toolkit. The big budget mainstream stop-motion companies have the resources and imperative to invest in high-quality 3D printing. There is a commercial drive to reduce costs and cope with the logistics of running multiple film set stages simultaneously, in order to speed production times. The initial impetus seems to have been financial: it would be cheaper to print the individual parts in 3D than pay someone to sculpt them by hand. But I suspect we are now beginning to see a new toolkit for creating animation that will have a different sensibility to the traditional hand-crafted plasticine, and will slowly develop into a genre of its own.

There is no doubt that 3D printing is having a significant influence on stop-motion animation and that it is growing into an important area of the creative arts. Animators are increasingly using the technology from the simplest of machines to the most sophisticated. Not only have the big-feature animation studios realised the benefits of printing character (puppet) parts in 3D – to reduce production costs and speed up the animation process – but also the process was found to offer creative benefits, and in doing so gave the studios greater creative

freedom. For example, they could make many more mouth shapes, to achieve greater expression in the characters. The first company to produce a full feature film using 3D printing was LAIKA Rapid Prototyping department with Henry Selick's film 'Coraline', which was released in 2009. LAIKA developed a technique of first making the models in clay, then scanning them into Maya (industry-standard software used for 3D animation rendering) then remodelling them for 3D printing whilst trying to retain as much of the detail of the hand-crafted process captured in the scans as possible. The models were printed using an Objet Geometrics machine and then painted after cleaning. However, this was just the beginning of the process; printing 3D models requires file formats that are capable of being output as STL files and then printed as solid models. To quote from an article in *CG* magazine, which gives a very good description of the process involved in the film:

The CG modellers that were hired for the film came expecting a more or less traditional pipeline, but found they needed to retrain themselves for 'Coraline'. Although you never see it, behind each face is an elaborate registration system and custom engineered

eye mechanics. Here, instead of creating a model for digital rendering, the 3D printing was the rendering process, so new rules needed to be considered. The skin had to have thickness throughout rather than just being a digital shell. Teeth were modelled to be snapped in and out through the back of Coraline's head. The interior of her mouth included the ulvula, tongue, and the space under her tongue, something that would have been too time-consuming if sculpted through traditional methods. Those details were in every face even when they weren't visible. To increase the total number of available expressions, the faces were modelled and output through 3D printing in upper and lower halves split across the bridge of the nose, yielding 207,336 possible facial positions for Coraline, allowing for extremely subtle animation. LAIKA estimated that to accomplish this without the CG and 3D printer process would have taken ten sculptors four years to complete.[16]

Two things are clear from this passage, that although 3D printing can speed up the animation process enormously, it can also create extra problems. Firstly, all of the animation created has to be corrected digitally after filming to remove the join lines in the faces – in this case across the bridge of the nose. Secondly, there is the logistical problem of tracking many thousands of printed parts, which might be needed to create just a few seconds of animation. LAIKA has since released its second full-length 3D-printed feature film, 'Paranorman' (released October 2012). Interestingly this film is printed on a Z Corp 650 full colour printer, which prints using a plaster-based material. LAIKA prints all the parts in the standard Z Corp material and then strengthens them using the Zbond cyanoacrylate resin to harden them.

To an informed 3D print user it may seem that that the Z Corp process offers less definition of feature and parts are inevitably much less crisp with poorer surface quality. However the Z Corp offers three major advantages to the animator. The first is obviously cost, i.e. the materials are less expensive overall. However, the other two advantages are particularly interesting for the visual arts: colour printing and a textured surface finish. The Z Corp will print in colour but the colour range (gamut) is restricted in terms of what we are used to with modern 2D inkjet printing. LAIKA has turned this to its advantage and used the colour to create a particular atmosphere. Animators can use any colour they want to create a perception

'Pirates! In an Adventure with Scientists'.
© Aardman Animation.

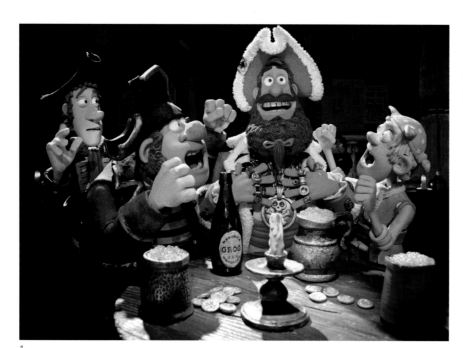

1

of reality – it does not need to *be* real to *look* real.

This brings us to the third and final point; the surface finish of a Z Corp model. When viewed closely, the surface has a textured appearance that could almost be termed "fluffy". Again, the LAIKA animators have made a virtue of this aspect and used the surface appearance much more widely across the whole film to create a particular raw feel. This slightly textured surface and feel moves the appearance of the characters away from the slick plastic look of both the Objet and Envision Tech printed models used in LAIKA's 'Coraline' and the new Aardman production 'The Pirates!' Both films have a look that is somewhere between stop motion and CGI which I would argue loses some of the hand-rendered qualities of plasticine. This new LAIKA look brings back some of that softer, more viewer friendly appearance.

3D printing is now a fixture in stop-motion animation and it is only a matter of time before a good quality short animation appears using the cheap FDM machines – much in the manner that Bob Godfrey who revolutionised the traditional analogue animation cell by using marker pens to draw 'Roobarb'[17] in 1974. Already there is a short YouTube video using a MakerBot, 'The Right Heart'. Although it uses only some parts built on the MakerBot and is snapped together, it received very wide coverage.[18]

Aardman Animations has also entered the realms of 3D-printed feature films with 'The Pirates!' directed by Peter Lord and Jeff Newitt (released in March 2012). The puppets for 'The Pirates!' were printed using Envisiontech machines. Aardman ran three of these machines full-time during the filming, producing an estimated 500,000 parts. Aardman chose to use Envision Tech due to its ability to print in a flesh-coloured material, thus reducing the amount of painting necessary in order to produce camera-ready parts. Aardman has also used 3D printing to create 'Dot', the world's smallest animated 3D character, who was just nine millimetres tall. The film was created to promote the Nokia N8 phone and the Cellscope, a diagnostic-quality microscope that was invented by Daniel Fletcher at the University of California, Berkeley, that turns a mobile phone into a microscope.[19] The figures for 'Dot' were again printed on the Envisiontech and hand-painted, but in this case it was not possible to create either articulated figures or figures with snap-on parts, so each animated movement required a complete printed figure. 'Dot' can be found on YouTube.[20]

2

The open source hardware community

The development of low-cost 3D printers has already been mentioned earlier in this book, particularly in Chapter 3 where we saw the example of 3D-printed ceramics made using an extrusion system to create digital coil pots, exemplified by the practitioners Unfold, Jonathan Keep and Peter Walters. In order to make the case for the influence of low-cost printers on the visual arts, we must first look at how this new field of the low-cost 3D printer came into existence and gained such a large global fan base. I think three mutually beneficial factors have come together in the last few years.

Firstly, the creation of the RepRap project by Dr Adrian Bowyer at the University of Bath. Dr Bowyer's original intention was to prove the concept of a self-replicating machine that could build parts of itself. The outcome was a cheap open source 3D printer built around the FDM technology developed by Stratasys and available to all. The plans are downloadable for free, and have since been taken up, modified and improved throughout the world. In July 2012 53 different versions of the RepRap or

RepRap-inspired machines were available and these low-cost machines continue to go from strength to strength as the market expands and more knowledge of 3D printing becomes available through the popular press and the web. The latest entrants into the market are two 3D printers based on very different concepts to the RepRap FDM technology.[21] The 'Form 1' is a photopolymer-based system using the original stereo-lithography technology and the Rostock[22] which is still based on FDM technology but uses a triangular DELTA robot platform design very different to the straight XYZ platform and potentially allowing much faster build speeds with the possibility of building vertical as well as horizontal walls.

The second factor to contribute to this explosion in low-cost 3D printing was the introduction of affordable laser cutting technology. Many of the cheaper CO_2 laser cutters were developed for commercial use in areas such as the textile garment industry, where patterns could be cut and trialled quickly and easily. The technology was taken up by the arts community and has now become commonplace. Laser cutting technology has worked as a bridge to introduce new users to digital material fabrication technologies. They are much more ubiquitous than CNC milling technologies and many are much more user-friendly.

Therefore users were already aware of some of the benefits of using this sort of technology before starting out with low-cost 3D printing machines

The third factor was the development of the FabLabs, which were a 'spin out' from MIT initially intended for poor and deprived areas, in order to give those communities access to new technology. A FabLab has to meet certain given requirements and must have the following equipment:

- A lasercutter, for press-fit assembly of 3D structures from 2D parts.
- A larger (4 x 8 in.) CNC machine, for making furniture- (and house-) sized parts.
- A sign cutter, to produce printing masks, flexible circuits and antennas.
- A milling machine, to make three-dimensional moulds and surface-mount circuit boards.
- Programing tools for low-cost, high-speed embedded processors.[23]

The movement has spread rapidly from the first FabLab in Boston in 2001. There are now 90 worldwide at the time of writing (November 2012), with more labs planned to open in the next year. FabLabs should be placed alongside other maker communities, these include the Maker Community, Hackspace, Dorkbots and TechShops. A TechShop is an American open source community workshop facility where members pay to use the TechShop on a commercial basis. There are many Dorkbot communities worldwide for electronic hobbyists ("geeks"), who meet together to work on collaborative open projects for the fun of creating new things as a group. The breadth and size of these movements and the excitement they generate can be gauged from events such as the recent San Diego 'Maker Faire' which was attended by 120,000 people over the three days. This is just one of a large number of such events that take place regularly across the globe.

As can be seen from these large numbers attracted to 3D printing a new phenomena is occurring that springs from the notion of the open source software community – the most cited example being the creation of the Linux open source operating system.[24] A new open source hardware community has developed that co-operatively exchanges information and developments via the web and face-to-face through local and global meetings. These groupings have no central core or traditional structure. To an outsider it can be hard to envision a definite, coherent and relevant direction to the future of the visual arts. However, it is possible to cite a number of examples that indicate where the future may lie:

1

1,2 CandyFab,
a 3D sugar printer from
Evil Mad Scientist
Laboratories, 2009.
© Evil Mad Scientist
Laboratories.

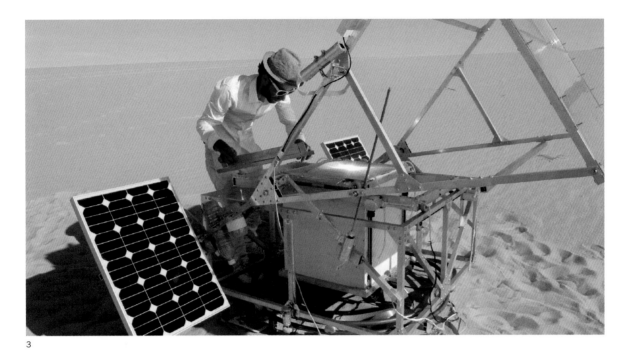

3

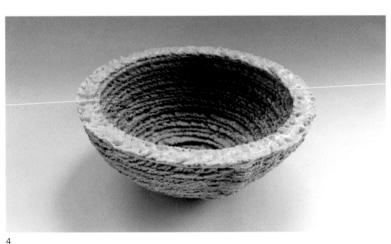

4

3 Markus Kayser,
Solar sintering machine.
© Markus Kayser Studio.

4 Markus Kayser,
Solar sintering pot.
© Markus Kayser Studio.

● One of my favourite examples is the CandyFab, a delightful 3D sugar printer that uses heat to fuse crystalline sugar. The results can be found on their website: www.candyfab.org.[25] The latest incarnation of the machine has been featured on their website since 2009. You can also find an earlier web video that shows the printing of a giant screw in hot melted caramelised sugar.[26] The range of possibilities of this 3D sugar technology are endless, transient and amusing.

● Another example of this open source 3D maker culture is the work of Markus Kayser, a Royal College of Art (RCA) design graduate, his solar sintering 3D printer.[27] Kayser first built a 2D solar powered laser cutter that was used in the Egyptian desert. The next machine he built was a 3D sand-sintering machine, which harnesses the power of the sun's rays to sinter (melt) sand – much in the manner of a laser sintering metal 3D printer such as the EOS or Renishaw MTT machine.

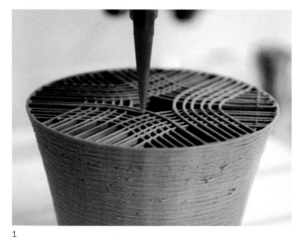

1

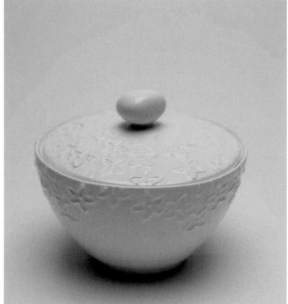

2

1 Unfold, 'Artifacts of a New History',
one of a series test prints for printing
complex structures in clay. © Unfold
2011.

2 Denby sugar bowl design, Z Corp 3D
print in plaster-based material, 2011.
© CFPR, UWE Bristol.

● The Belgian design team, Unfold,[28] has also made an interesting contribution to the development of the technology. By replacing the fused plastic with a stepper motor, an auger and a plastic syringe, the Belgians have been able to print in ceramic material with some very impressive results, which they are very happy to publish in an open forum in the Creative Commons approach.

● The original RepRap project team have made huge strides in developing a multi-coloured FDM printer. To achieve this they are using multiple heads that feed into a single heated chamber, where the separate colour feeds blend in the single heated print head, which then deposits the hot melted coloured plastic.

Functional coloured parts are one of the Holy Grail achievements that will contribute to the future influence that 3D print has on the broader society. To date the Z Corp (3D systems) Z650 has improved colour printing to a much greater degree

than previously possible. This is evidenced by the 'Paranorman' film and the fact that it is the only printer capable of printing in four colours. The main problem is the material it prints with is plaster-based which, even if it is impregnated with epoxy resin, is not yet sufficiently durable to create a functional part. To be fair to Z Corp they have only ever described the process as a tool for producing prototypes. There are some further developments in the field of 3D colour printing particularly with the introduction of multiple-coloured materials for the Connex system, which can be seen in the latest works by Neri Oxman. Other examples include Mcor (see Chapter 2) which has developed a system of laser printing a stack of office copier paper with a sliced 3D colour image. All of this demonstrates that the 3D colour printing field is rapidly changing and developing.

Collectively these examples show that as it develops artists push the technology into new and innovative areas. Other exemplars may be gleaned from current visual arts research, for example the work undertaken by Centre for Fine Print Research (CFPR). Research at the CFPR into 3D printing has

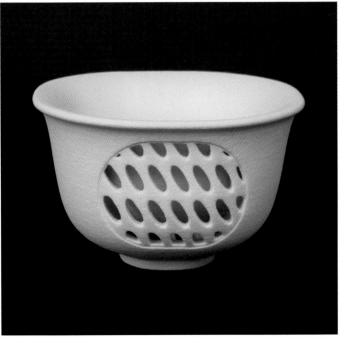

3

3 Peter Ting, CAD drawing of a
double-walled-lattice bowl. © Peter Ting.

4 Peter Ting, 3D-printed ceramic
double-walled-lattice bowl. © Peter Ting.

4

been influenced by the need to be able to print objects in real materials on machines that are at least within the budget of university art departments. By this I mean not only the cheap machines described above, but also the mid-priced machines in the £10,000 to £60,000 price bracket, made by companies such as Z Corp, HP, Objet and Stratsys. I have described elsewhere that it is possible to print in metal, sintered alloys and nylon but even these materials do not offer the same properties and qualities of conventionally-formed metals and plastics. Funded by the UK Arts and Humanities Research Council, our initial remit was to undertake a survey of the potential of 3D printing for artists, craftspeople and designers (which led to this book). In addition we also developed a number of case studies and started printing for a number of artists.

We also believed that it was possible to print ceramic materials, and to prove this the team have developed a patented 3D printable ceramic powdered material[29] that can be printed in a Z Corp machine. A further development was to work with Denby Potteries to produce full ceramic prototypes rather than the plaster versions they had been capable of previously (see Chapter 3).

At the CFPR, in common with many of the other research projects that we undertake and in order to test the parameters of the project, we work with a number of artists and designers to create bespoke artworks using a process. Peter Ting is a spokesperson for the Crafts Council and a member of the Board of Trustees. He has created works for Aspreys, the Queen and topiary designs for Prince Charles at Highgrove. Peter was keen to create a 3D-printed piece that could not have been created by any other means. He has an excellent understanding of industrial casting and moulding techniques for ceramics, therefore was particularly keen on producing a double-walled pierced bowl that could not have been thrown, cast or moulded by any conventional technique. The final tea bowl, created in unglazed porcelain is a delicate and gentle piece that, at first glance, belies its sophistication and crucially does not look in any way 3D-printed until one considers how the piece might have been created.

1

1 Workshop of Giacomo Mancini,
Deruta bowl, 1520–50.
© V&A Images, Victoria and Albert
Museum, London.

2 Stephen Hoskins, 3D-printed
Deruta-style bowl, 2012.
© Stephen Hoskins.

2

When approaching my own practice for a case study, I wanted to create a work that had all of the attributes of a fifteenth-century Renaissance Majolica bowl from Deruta. The reason for choosing this form was that it suited the 3D printing process and could be fairly easily created with a simple support structure to keep its form during firing. It was then decorated with a standard white glaze and a stock "on-glaze" transfer, that bore a passing resemblance in colour and form to the fifteenth century bowls. I was striving to make a work that could be mistaken for a standard piece of domestic ceramics, yet was based upon a fifteenth century design and made with the very latest digital technology – so the very opposite of trying to create an impossible object.

In the context of 3D printing none of these developments would be possible without the knowledge and understanding of ceramic materials and processes. At the CFPR David Huson exemplifies this tacit material understanding. David has over 30 years of experience in the ceramics industry; he was a ceramic industry company director and ceramic engineer. He brings tacit knowledge and experience of the day-to-day handling of physical materials to our research. We at the CFPR specialise in practice-led and applied research, in the case of 3D printing our success with ceramics has not been just in material development. We conduct research into how to embed that new material knowledge into a traditional process that will function from the perspective of the end-user. The nature of printing ceramics in 3D means that essentially we are gluing particles together before they are fired. Therefore, in order for them to hold together in the kiln and follow the normal ceramic process, they need to be supported in ways that would not be necessary for a conventional

3

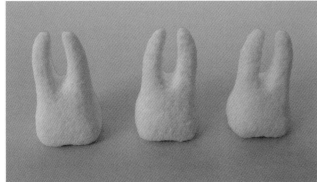

4

3 David Huson at AHRC Digital
Transformations Moot, November 2012.

4 Peter Walters, David Huson and Debbie
Southerland, CFPR 3D Lab, 'Sugar Teeth'.
© CFPR 2010.

5 Peter Walters, extruded ceramic pot.
© Peter Walters 2011.

6 Peter Walters, CFPR, 3D-printed icing
sugar, 2011. © CFPR.

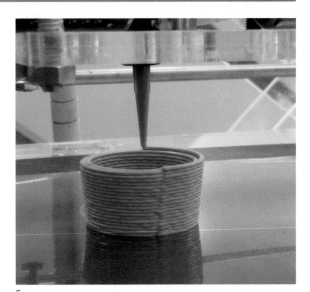

5

material. It is only with an inherent knowledge of materials that solutions to these particular problems can be worked out. It requires a combination of past knowledge and innovative thinking and very little of that knowledge is about the 3D printing process in isolation.

In order to better understand the potential of the cheap or desktop 3D printers for visual artists and designers the CFPR has adapted a RapMan from Bits from Bytes to have a pressure head and an auger to print pastes and viscous liquids in surprisingly fine detail.

With this machine Dr Peter Walters has managed to print using many different types of material, including icing sugar, chocolate, clay, potato starch and edible batters. In collaboration with the artist Debbie Southerland, Peter and David Huson produced sugar teeth and lace pancakes.

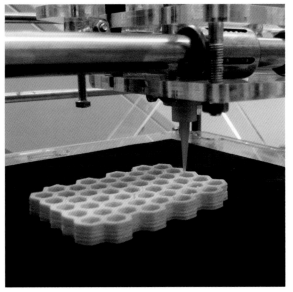

6

Perhaps the items that Peter and the CFPR have produced that have stimulated the most interest was 3D-printed "meat and two veg". To achieve this a liver paté was used alongside mushy peas and mashed potato. The serious intent behind this research was to prove that it was possible to 3D print a full meal albeit one that wouldn't win any Michelin stars for culinary excellence!

My personal view of the future and, by association, the view of the research centre is to a large extent coloured by the research we are in the process of undertaking. Currently the team has secured funding for a new project to 3D print a self-glazing ceramic. In other words, to be able to print a ceramic material in one go, that when taken from the printer and placed in the kiln will vitrify to a biscuit state and glaze all in a single firing. This research is based upon the ancient Egyptian technique of faience, which was the first glazed ceramic material produced around 5000 BC. This ceramic material contains mineral salts that effloresce to the surface and create the distinctive colour and appearance. Most people recognise the turquoise colour usually seen in small mummy statues, hippo sculptures or funerary beads and necklaces.

In fact faience can come in many colours depending on the metal content added to the salts. In the New Kingdom at the latter stages of the Egyptian Empire, the Egyptians used a process known as cementation – a process that was still used until the 1960s in Qom in Iran where the donkey beads they made were packed into glaze material in a sagger and fired. When the kiln was unpacked the glaze material would still be friable apart from where it had been in contact with the Egyptian faience beads. At this point of contact the material would form the glaze on the surface of the faience. It is this process that we feel we could replicate with 3D printing and would give us the ability to first print an object, leave it packed in the powder, then remove the object from the printer with the powder still supporting it and fire the whole block in a single firing. Theoretically we could then remove the fully glazed and fired work from the friable build material.

In addition we at the CFPR see 3D printing for artists as a tool to produce bespoke artworks for everyone, whether designer, craftsperson, artist or artisan. The future of many manufacturing technologies lies with the ability to mass customise to an individual customer requirement. Mass customisation of 3D printing allows objects to be created *en masse* but with each one having individual and separate modifications to the object printed next to it. One of the future paths of this technology is the ability to tailor each and every object to individual customer needs and desires.

1

2

1 David Huson and Katie Vaughan, CFPR Labs, 3D-printed faience hippo. © CFPR 2013.

2 David Huson and Katie Vaughan, CFPR Labs, a bloat of 3D-printed faience hippos. © CFPR 2013.

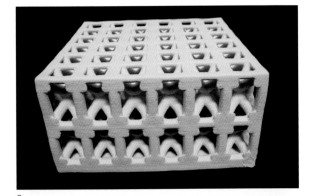

3

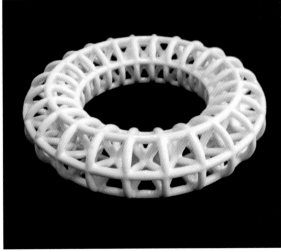

4

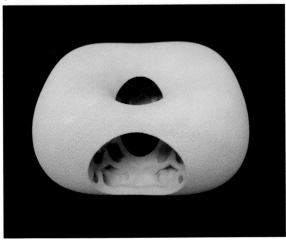

5

3,4,5 David Huson, CFPR Labs,
3D-printed ceramic lattices.
© David Huson

1 Hotz, Alexander, (2012) 'Download, print, fire: gun rights initiative harnesses 3D technology', 26 September 2012, *The Guardian* online, www.guardian.co.uk.

2 Doctrow, Cory, (2009) *Makers*, London: Harper Voyager.

3 Sterling, Bruce, (2007) 'Kiosk'. *Fantasy and Science Fiction*. January, Vol 112.

4 Appleyard, Brian, (2012) 'Makers: The new industrial revolution by Chris Anderson', *Sunday Times* online, www.thesundaytimes.co.uk, 16 September 2012.

5 N.V., (2012) 'Difference engine: the PC all over again?' *The Economist*, online, www.economist.com, 9 September 2012.

6 Hotz, Alexander, (2012) '3D printers shape up to lead the next technology gold rush', *The Guardian*, online, www.guardian.co.uk, 5 October 2012.

7 Faktor, Steve, (2012) 'How HP could reinvent 3D printing…and itself', *Forbes Magazine*, online, www.forbes.com, 15 October 2012.

8 BBC, (2012) 'Newsnight: 3D printing- a new industrial revolution?' http://www.bbc.co.uk/news/technology-20137791. 30 October 2012.

9 BBC, (2012) 'QI: Joints' Series 10,

Episode 6 BBC. British Comedy Guide http://www.comedy.co.uk/guide/tv/qi/episodes/10/6/.

10 BBC, (2012) 'Have I got News for You', Series 44 Episode 6. British Comedy Guide http://www.comedy.co.uk/guide/tv/hignify/episodes/44/6.

11 Graham-Rowe, Duncan. (2011) 'Bike 'printed' using layers of powdered nylon', *New Scientist*, blog, www.newscientist.com 7 March, 2011.

12 Venkataramanan, M. (2012) 'Couture built layer by layer', *Wired* Magazine, June 2012, p. 45.

13 Oxman, Neri. (2012) 'Carpal Skin', MIT website www.media.mit.edu, 27 November 2012.

14 Bradley, Ryan, (2012) 'Bio-Armor: Printing protective plates from patterns in nature', *Popular Science*, www.popsci.com, 17 April 2012.

15 Chalayan, Hussein; Hilty, Greg, (2011) 'Hussain Chalayon talks with Greg Hilty at the Lisson Gallery', Vimeo http://vimeo.com/14824329, 7 September 2011.

16 Dunlop, Renée, (2009) 'One step at a time for the puppet of a thousand faces CG Society of Digital Artists'. 12 February 2009. Available from: http://www.cgsociety.org/index.php/CGSFeatures/CGSFeatureSpecial/

coraline.

17 Giddings, D., (1974) 'Roobarb' (Bob Godfrey's Movie Emporium), IMDb http://uk.imdb.com/title/tt0071043/, 27 November 2012.

18 Makerbot, (2011) 'The Right Heart', 27 November 2012. Available from: http://www.youtube.com/watch?v=oRXpfnCAlM8.

19 Frawley, R., (2008) 'The Cellscope is hot', Berkeley: Bioengineering, University of California, www.bioeng.berkeley.edu, 27 November 2012.

20 Zyga, Lisa, (2010) 'World's smallest animation character shot with smartphone camera and microscope' (with video), www.phys.org, 'Dot', http://www.youtube.com/watch?v=CD7eagLl5c4. 24 September 2010.

21 Flaherty, Joseph, (2012) 'Formlabs creates low-cost 3D printer', *Wired* magazine www.wired.co.uk 27 September 2012.

22 Rocholl, Johann, C., (2012) 'Rostock Delta 3D printer', RepRapWikki, www.reprap.org, 27 November 2012.

23 MIT, (2012) 'FabCentral', MIT Center for Bits and Atoms, www.fab.cba.mit.edu, 27 November 2012.

24 Linux, (2012) 'What is Linux: An

overview of the Linux Operating System', www.linux.com, 27 November 2012.

25 Windell, (2009) 'The CandyFab 6000', Evil Mad Scientist Laboratories, http://www.evilmadscientist.com/2009/the-candyfab-6000/, 27 November 2012.

26 Windell, (2007) 'Solid free form fabrication: DIY on the cheap, and made of pure sugar', Evil Mad Scientist Laboratories, 9 May 2007. Available from: http://www.evilmadscientist.com/2007/solid-free-form-fabrication-diy-on-the-cheap-and-made-of-pure-sugar/.

27 Kayser, Markus, (2011) 'Solar Sinter'. Available from: www.markuskayser.com/work/solarsinter.

28 Unfold, (2012) 'Stratigraphic Porcelain', http://unfoldfab.blogspot.be, 7 April 2012.

29 Hoskins; S. Huson; D., (2010) UK Patent Specification W020111547732, filing date 6 July 2010.

30 Wulff, Hans E.; Wulff, Hildegard S.; Koch, (1968) *Egyptian faience - A Possible Survival in Iran*. Archaeology AATA Number: 7-1221, Volume 21, Issue 2, pp. 98–107.

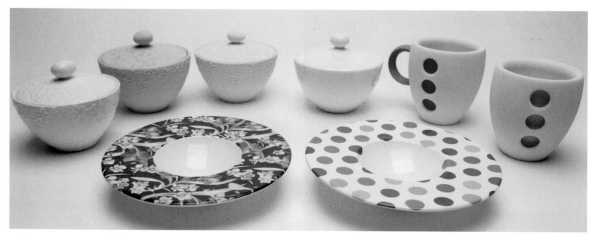

Collection of 3D-printed trials for ceramic cups, plates and bowls made at the Centre for Fine Print Research. © CFPR 2012.

Conclusion

In concluding my examination of 3D printing and the visual arts, the usual form would be to round up the state of the current technology and try to make some form of future prediction. In this case that is somewhat of a problem. Firstly, I have already given an overview of the current state of the technology and outlined the early history of the process, both in terms of the machinery and visual arts users' interface with 3D printing. Therefore only a fool would try and make any concrete predictions of the technology's future. I have clearly stated that I am a fan and advocate of 3D printing and firmly believe that this is a disruptive technology that will change the face of manufacturing.

However, this is a book about the interface of the visual arts with 3D printing technology and it is that interface from which I shall draw some conclusions. I think the future is exciting and we believe its development is similar to that of the revolutionary changes in 2D digital printing technologies, in particular wide-format printing as an extension of desktop. For the creative industries I believe that 3D printing will develop into a mature technology that becomes a major part of the artist's toolkit. Interestingly, many of the discussions of 3D printing in the media are concerned with the issue of originality and intellectual property; who owns this process – or even the files? What will happen to the integrity and intellectual property of an artist or designer when it is possible to just press a button and print a digital facsimile? This 'old chestnut' has equally taxed the 2D print market with the introduction of digital technology. In this arena people realised that the amount of work necessary to produce an accurate facsimile still required a high degree of craft skill to make the copy look accurate. Most people are too lazy to replicate an image or a designer product themselves as it is already possible to buy perfectly good facsimiles. What's more, the vast majority certainly do not possess the necessary skill to create such copies. Another factor is provenance: 90% of us know that they are copies because the provenance that comes with them, i.e. cost, quality of manufacture or place of purchase are all clear indicators of copied goods. The same factors will occur in the 3D print marketplace.

We also need to address the amount of hype that surrounds 3D printing and manage perceptions of what it is actually possible to create using such processes. It is not possible for a 3D printer to print itself, a gun or a car as claimed online, nor in fact is it possible to replicate almost any object to order.

Let us deal with each of these myths separately. The self-replicating 3D printer as demonstrated by Adrian Bowyer and the RepRap project, which originated from Bath University engineering department, has not only revolutionised the field of low-cost open source printers, but in fact the department created it. However, the printers can only self replicate and print those parts of the machine that can be made from ABS plastic. In total this probably comes to 25% of the total parts of the whole machine and certainly does not deal with the stepper motors, electrics, computer chips and boards. So the machine cannot be self-replicating. In research terms the project proved the potential for a self-replicating machine, but it has never been more than a potential. Likewise with the mythical gun, it is possible to print the gunstock and theoretically one could print a barrel in stainless steel, but this would have to be milled and heavily post-processed before it was functional, if one trusted the capability of 3D-printed steel to carry the forces of an explosive charge. Creating a 3D-printed working car is just not possible even theoretically at this point in time. As we have stated elsewhere, the primary reason is simply that most objects are made from multiple materials and at a basic count there are at least 50 different materials in the average car and over 10,000 parts. At this point in time there is no printer that will print a combination of materials such as metal and plastic.

What I am saying is that the perception is way ahead of the reality. Currently there is a 'hype curve' that is published annually by Gartner.[1] Their 2012 Hype Cycle for Emerging Technologies places 3D printing very firmly at the top of the curve. This is not to say that the technology will not catch up with its perceived potential – I am sure that it will eventually. For example, in a recent film made by the Arts and Humanities Research Council about CFPR's 3D ceramics I stated that I believed that it would be 15 years before 3D-printed ceramics became a commercial reality. This is a comment that, as an academic, I stand by. The only reply made from 10,000 individual viewers on YouTube was that I was being too cautious and the reality was much sooner, but it is my job to be cautious and reasoned.

So what do I feel about the conception and processes involved in making works of art using 3D printing in the future? As an arts practitioner with nearly 30 years experience in the field of the arts – my primary view for the visual arts is that the technology is still very limited in its material qualities; this means that the potential for creating good art is also very limited. As I stated in Chapter 4, which examined 3D printing and the Fine Arts, this is not a material with which artists would have a natural affinity – if you print in a raw white nylon material, the resultant print looks like raw white nylon. The designers such as Assa Ashuach who are polishing and dying it, are giving this single material a much greater range of visual appearance and physical properties, beyond the actual raw printed material, but I would argue this is still a material that has very little visual appeal or interesting surface characteristics in its own right. Until materials come onto the market with more interesting or variable surface characteristics that have greater visual appeal this will always be a problem. Some of the examples that I have cited, such as Karin Sander's miniature people and the Morison's kite structure, overcome this problem by hiding the actual 3D-printed material as part of the object's construction process: Sander sprays her work and Morison covers the joints in kite fabric.

The truth is that until it is possible to print multiple materials together such as metal and plastic, or at least until the tolerances are more controllable and material developments have progressed to the stage where several machines can print individual parts in different materials for final assembly, a much greater uptake of the technology in the field of the visual arts is just not going to take place.

Before I move onto the benefits that I believe that 3D printing will bring in the future we also need to cover the other downside of the current technology – software and the way that users interface with it. I think this is one of the barriers that will always inhibit the technology becoming universal for all.

When I first taught art students over 30 years ago I used to divide students into groups of two-dimensional thinkers and three-dimensional thinkers to assist them in their future career choices. In simple terms, I divided them into painting or sculpture students. Unless you can actually think in 3D you cannot visualise in 3D. So for example, if you can't see in your mind what's hidden behind a table

Table drawn in perspective showing hidden fourth leg. Illustration. © Peter McCallion 2013.

Turbo Squid, 'Rose', 2013. Image captured and downloaded from www.turbosquid.com, a stock 3D Image website.

or a block of wood, you won't be able to draw it. It is about looking at the table and knowing there is a leg at the back of the table that you cannot see, but you know it exists.

If you can't think your way through this, then you will struggle to work in CAD. In addition you also have to learn the software and at the moment this requires learning not just one programme but several, and each has their own difficulties and interface quirks from the user perspective. This will change as most of the software is currently morphing to adopt all of the features that are offered by each of the individual programs at the moment. In the future there will probably be just one or two standard software solutions.

The obvious solution to the software problem is that you will just download the file from the likes of TurboSquid (a web service where you can purchase cheap pre-made files). However, this removes the big advantage of 3D printing, which is the ability to print an individual product tailored to your personal requirements without the need to tool-up for mass production beyond the ability to create the individual file.

To turn to the positives for the future, the gestation for this book has been approximately 12 months. At the start I wrote that the future predicted by the popular press was unrealistic and would not develop as quickly as some assumed. Twelve months on and the material technology has moved rapidly in research terms. But we are still at an early stage and

I am now constantly revising my expectations of this disruptive technology.

In the last week of writing this book at the CFPR we have been trialling the printing of a cellulose nano-material derived from vegetable waste that has the potential to be stronger than steel, but is also biodegradable. We have also printed ceramic fuel cells for future use in renewable energy applications and in which the microbes produce clean water at the end. All of these are a big leap from the 'straight' 3D-printed ceramic tableware and printing for artists where we began.

In summary, I think that 3D printing technology has enormous potential for the visual arts and undeniably it will influence our future. I return to the fact that I do not know what that future will look like, except that a lot of it will be 3D printed. I am also heartened by the increasing return to making. Some of which will be a definite backlash against 3D printing and digital technologies, much as the resurgence of letterpress against digital 2D printing technologies (such as Yeehaw Industries and Cannonball Press). What I hope will happen is that the analogue and digital thinking will merge and we will end up with a new craft of the digital, where skilled creative practitioners will use 3D printing where necessary and analogue techniques where they are particularly relevant.

1 3edrs (2012) *3D printing identified in Gartner's 2012 Hype Cycle for emerging technology*. www.3ders.org, 17 August 2012.

Glossary

123D
Free 3D CAD software for modelling, rendering and 3D output, by Autodesk.

3D Studio Max
3D software for modelling, rendering and Animation by Autodesk.

3D Systems
The first and largest 3D printing company, which has bought out many of the smaller players.

3D Tin
Free, easy-to-use web-based 3D software available under Creative Commons.

A

ABS
(acrylonitrile-butadiene-styrene) a lightweight thermoplastic used in FDM printers.

ai
Vector file format used by Adobe Illustrator.

Alias
A 3D surface modelling software, used mainly in automotive and industrial design.

Alumide
A nylon material for SLS printing doped with aluminium powder.

Armature
The central support structure for sculpture or an animation puppet.

Auger
A screw thread for cutting or forcing material along a channel. Can be used for extruding material through a nozzle.

Autodesk
A 3D modelling software company that makes 3ds Studio Max, AutoCAD, Inventor, 123D, Alias and Maya.

Axon
A user-friendly interface for the open-source Skienforge software programme, developed by Bits from Bytes (Now 3D systems) for its RapMan 3000 printer.

B

Bentley Systems Microstation
3D CAD software used widely in architecture.

Bits from Bytes
A 3D printing manufacturer, now owned by 3D Systems.

Blender
An open-source 3d modelling software, used mainly for visualisation and animation.

Boolean difference
A solid modelling operation in which 3D geometry can be modified by subtracting the overlapping areas of one 3D object away from another.

C

CAD
Computer-aided design.

CALM
There are currently two CALM projects in relation to 3D printing in the UK, CALM (Centre for Additive Layer Manufacture) led by Exeter University and the older CALM (Creating Art with Layer Manufacture),a HEFCE (Higher Education Funding Council for England) funded project from the mid–late 1990s.

CAM
Computer aided manufacture.

CCD
Charged coupled device. Sensor in digital camera used for capturing image data for photography.

CNC
Computer numeric control – these days referring to a CNC mill which subtractively carves away a block of plastic or metal.

Corel Draw
PC-based vector 2D drawing software.

Creative Commons
A means of publishing research and Intellectual Property (IP) that uses the results for the common good whilst acknowledging the contributions of the original authors, this is important in the area of the low-cost open source 3D printers such as the RepRap project.

Crowd source
Outsourcing tasks to a large number of people.

Delcam
A company developing 3d CADCAM software and applications including ArtCam aimed at visual artists, designers and jewellers.

Die
A metal mould or forming plate, for casting or extrusion.

Disruptive technology
A technology that fundamentally changes the course or direction of a process or product development. For example, the mobile phone or PC.

DMLS
Direct metal laser sintering. This process is similar to the selective laser sintering technology but instead of nylon, a fine metal powder is used.

Dorkbots
People doing strange things with electricity.

DWG
DWG ('drawing') is a file format used for storing two and three-dimensional data. It is the native format for AutoCAD.

DXF
A file format that is common for 2D vector files and 3D polygon meshes.

Envision Tech
A 3D printing manufacturer of digital light processing based 3D printers.

EOS
A 3D printing manufacturer of selective laser sintering 3D printers.

Fab Lab
A digital fabrication laboratory originating from MIT which promotes access to all to 3D printing and other fabrication technologies.

FreeForm
Software which is bundled with the Sensable Haptics device.

G code
Code that is commonly prepared for a CNC machine.

Geomagics
3D software used to process 3D scan data and to modify polygon mesh models, it can be used to translate meshes into CAD formats.

GOM
Gesellschaft für Optische Messtechnik, manufacturers of 3D scanning equipment.

Hackspace
A creative social enterprise promoting access to new technology for all.

Handyscan scanner
A 3D scanner.

Haptics
A computer modelling interface based on touch and feel.

IGES
The Initial Graphics Exchange Specification. A surface-based CAD format. Used by many engineering-based CAD systems to translate data from one software to another.

iMaterialise
3D print bureau service.

IP
Intellectual property.

Java
Java is a programing language originally developed by James Gosling at Sun Microsystems.

JISC
Joint Information Systems Committee, set up by UK universities to agree common standards of Internet and communications protocols.

JTAP
JISC Technology Applications Programme aimed at assisting the Higher Education Community get the best from its investment in IT.

L

LOM
Layered object manufacture. A 3D printer using thin layers of paper or plastic to build the object, which are cut, stacked and bonded together.

M

Magics
Software intended for cleaning and repairing files before printing.

MakerBot
Based upon the RepRap the MakerBot is a low-cost 3D printer. The MakerBot company was founded in Brooklyn in 2009 by Bre Pretis and is America's leading low-cost printer.

Maquette
A small model for a sculpture, used as a guide from which the large final version is made.

Mass-customisation
The ability to produce individually designed and custom objects by exploiting flexible digital manufacturing.

Maya
3D modelling and animation software by Autodesk.

Mcor
A 3D printing manufacturer, which makes the only LOM printer using paper currently on the market.

Meccano
Metal construction toy popular from the 1930s through to the 1970s.

Mesh editing software
3D software for modelling and editing polygon meshes.

MTT
A 3D printing manufacturer now owned by Renishaw, which makes a direct laser sintered metal printer.

N

NURBS
Non-uniform rational basis spline. Used in surface modelling, a mathematical model used in computational graphics for generating and representing curves and surfaces.

O

OBJ
A file format used by some surface modelling programmes such as Maya and Alias.

Objet
A 3D printing manufacturer which makes photopolymer inkjet 3D printers.

Open source hardware
Where the design and/ or specification of the hardware is made freely available for anybody to use or develop further.

Open source software
Software code that is left 'open' for people to freely use and adapt.

P

Paint
Early PC drawing software.

Pantagraph
An analogue drawing mechanism based on a parallelogram linkage for copying, enlarging or reducing 2D and 3D objects.

PC
Polycarbonate, which has high impact resistance and can be made clear. Used in FDM printers.

PDF
Portable document format. A file format used to transfer 2D documents safely so they do not get changed or altered in transcription.

Photopolymer
a polymer material that is sensitive to light and typically hardens when exposed to UV light.

Point cloud
A collection of data points generated by a 3D scanner which describe the shape of a 3D object and can be converted into a 3D polygon mesh model.

Polygon mesh
The shape of a 3D object using a mesh of planer surfaces and straight edges.

PPSU
(polyphenylsulfone). Has a greater chemical resistance and is stronger than other thermoplastics used in FDM printers.

Pro Engineer
3D CAD engineering software made by the PTC Company.

R

RepRap, also Fabster, MakerBot
Low-cost 3D printers based around the RepRap project initiated by Dr Adrian Bowyer from the department of engineering at Bath University in the UK. Developed from the original Stratasys FDM

technology. The idea behind the RepRap was to prove that a self-replicating machine was possible. The RepRap is capable of printing some of its parts in order to make new RepRap machines. Dr Bowyer has made the plans and idea of the RepRap freely available online. Many variations have been created from the initial very low-cost printer.

Rhino
A 3D surface modelling software widely used by designers, artists and engineers.

Routing
CNC routing has the usual computer numeric controls, but tends to refer to a cutting bit that has a either very low or no Z-axis. Usually used for cutting thin wood or plastics in low relief.

S

Sagger
Fireclay box in which ceramic items are packed during firing ceramics to control the heat, also used for packing with support material such as alumina to support an object during firing.

Sculptyo
A French-based 3D printing bureau service.

Sensable
A company making haptics hardware and software for 3D modelling.

Shapeways
The largest on-demand bureau service. Based in New York, Shapeways' web ordering service is available internationally.

Skienforge
Open source software that runs open source FDM type printers such as the RepRap.

SLA
Acronym for stereo lithography.

SLS (selective laser sintering)
A bed of powdered thermoplastic material is fused by a CO_2 laser.

Solid modelling
Modelling in three dimensions using solid geometry.

SolidWorks
The industry standard 3D solid modelling software used principally by engineers and industrial designers.

Spark Erosion
Uses an electric discharge to cut away a mould cavity from a block of metal.

STL
This stands for stereo lithography and is the original polygon mesh file format for rapid prototyping. The most common format for 3D printing files.

Stratasys
A 3D printing manufacturer which made the original fused deposition-based 3D printer.

T

Tech shops
An open access digital fabrication workshop community which typically enables subscribers to access to 3D printing, CNC milling and laser cutting.

Thermoplastic
A plastic that melts when heated and solidifies when it cools.

TSplines
3D modelling software plug-in for Rhino.

V

Voxeljet
A 3D printing manufacturer which makes large-format powder binder 3D printers in plastics and foundry mould materials.

W

White light scanner
A 3D scanner which projects a pattern of visible light onto the surface of a 3D object and captures the shape of the object by reading the deformation of the pattern as it falls on the surface of the object.

Z

Z Corp
A 3D printing manufacturer which makes inkjet powder binder 3D printers based on a plaster composite material. Now owned by 3D Systems.

Index

Interview Questionnaire

The following questions were sent to the case study artists before and during the interviews, in order to aid the conversation, provide a structure and give a sense of continuity across the different disciplines. These were used mainly for guidance and were not necessarily asked in the order that they are listed in here.

1

How would you categorise your professional practice? Here I was trying to ascertain how artists thought of their own personal discipline and approach to their own practice they undertook.

2

How would you describe your personal practice? I was trying to get the artists to describe the work they made in their own terms.

3

When did you first start using 3D printing and what led you into using it? The routes people take to a process are always interesting, in this case I was surprised to find that the fine artists I interviewed had both come through CNC milling technologies. Most of the case studies had approached the process through a need to create objects in a different way to traditional process.

4

What proportion of your work involves 3D printing?

5

Why do you use 3D printing and what factors/ qualities do you think it offers over traditional

6

If you use 3D printing in a piece of work, is it solely created with 3D print or do you combine it with traditional technologies? Very little mixed process practice seems to take place with users tending to solely make a piece with 3D printing. There is much post-finishing and some casting with the 3D print acting as a mould. I would have expected more work where the 3D print was one element of the final work.

7

What software do you use to create your work and why do you choose that particular route?

8

What hardware do you use to create your work and why do you choose that particular route? These are fairly obvious questions but did elicit good answers around

9

What are the barriers to using 3D print (i.e. software, skills, lack of knowledge, costs etc? Software and costs are the two obvious barriers, which is demonstrated through the answers given.

10

As an artist do you think you are giving up your traditional craft skills, or do you think 3D print has its own craft sensibility? This was a particular interest of mine and may become far less important as an issue as the technology matures. This has certainly been the case in the 2D print market where wide-format printing has been integrated into the canon of fine arts practice as another element or tool.

11

Where do you see the future of 3D print for, artists, designers and craftspeople. This was an obvious and self explanatory question, but some of the answers were not those that I might have expected.

These two questions were intended to ascertain what the experience of the case study interviewee was in regard to 3D printing and how they interfaced with the technology from a user perspective rather than just a technical discussion of how they use the technology.

These questions were intended to ascertain what the complex problem of having to learn a range of software solutions in order to create a good 3D piece.